InStyle
GETTING GORGEOUS

the step-by-step guide to
your best hair, makeup and skin

from the editors of **IN STYLE**

written by **JENNIFER TUNG**

design by **NUMBER 17**

illustrations by **RACHELL SUMPTER**

produced by **MELCHER MEDIA** for **IN STYLE BOOKS**
and **TIME INC. HOME ENTERTAINMENT**

InStyle Time Inc. HOME ENTERTAINMENT MELCHER MEDIA

table of

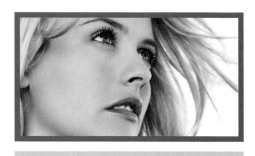

contents

IN STYLE

Managing Editor
Charla Lawhon

Executive Editors
Maria Baugh, Martha McCully

Beauty Director
Kim-Van Dang

Beauty News Director
Amy Synnott

Features Editor
Marisa Fox

Correspondent
Polly Blitzer

Editorial Assistants
Sue Chung, Meg Hemphill

Editorial Director, Books
Mary Peacock

Vice President, Development
Amy Ford Keohane

President
Stephanie George

Publisher
Lynette Harrison Brubaker

General Manager
Maria Tucci Beckett

Director of Public Affairs
Sheri Lapidus

Associate Director of Public Affairs
Paul Reader

TIME INC. HOME ENTERTAINMENT

Publisher
Richard Fraiman

Executive Director, Marketing Services
Carol Pittard

Director, Retail & Special Sales
Tom Mifsud

Marketing Director, Branded Businesses
Swati Rao

Assistant Financial Director
Steven Sandonato

Prepress Manager
Emily Rabin

Product Manager
Victoria Alfonso

Associate Book Production Manager
Suzanne Janso

Associate Prepress Manager
Anne-Michelle Gallero

MELCHER MEDIA

This book was produced by Melcher Media, Inc.,
124 West 13th Street, New York, NY 10011

under the editorial direction of Charles Melcher.
www.**MELCHER**.com

Project Editor
John Meils

Editorial Assistant
Lindsey Stanberry

Publishing Manager
Bonnie Eldon

Photo Researcher
Amy Pastan

FRONT COVER

Fashion Feature Photo Editor
Kellie Lindsey

Photograph © 2004 by Torkil Gudnason

Hair
Renato Campora

Makeup
Tina Turnbow

Model
Fabiane Nunes/NEXT

Design by
NUMBER SEVENTEEN

Art Directors
Emily Oberman, Bonnie Siegler

Designer
Denise Sommer

With In Style's unique access to Hollywood's top style makers and their star clients, we've been bringing readers the best advice on hair, makeup and skin care for over 10 years. Now, imagine all this information, plus lots of new research, collected in one place. On the following pages you'll find the most important principles of looking great every day, the best explanations of the basics, and the newest information, so you can use this book every time you shop for products or attempt a new technique. Whether you're trying to solve a problem or create a whole new look, *Getting Gorgeous* will be indispensable.
— Charla Lawhon, Managing Editor, In Style

Know thyself.

If you've ever felt that beauty is unattainable—a lucky perk other women are blessed with at birth, take a deep breath and relax. You're not alone—and you also happen to be in for a very pleasant surprise. Just take a look around, and you'll quickly see that there's no surefire (or genetic) formula for looking great. For every perfectly symmetrical face on the movie screen, there's a dazzling, original smile (Julia Roberts), an explosion of curly hair (Nicole Kidman), or a spray of freckles (Lucy Liu) that is unmistakably gorgeous. And you, too, have a handful of unique features that add up to a special beauty of your own. The trick is learning to bring them out and let them shine.

The first step? Know thyself. Take a long, hard look in the mirror. Determine your true skin tone, hair texture, face shape and figure, then vow to celebrate your unique good looks rather than chase after an unrealistic ideal. Second, embrace the transforming powers of good hair and makeup: It's easy to dismiss them as superficial, but the truth is they're guaranteed to make you feel as wonderful as you look. Think about it: When you feel beautiful, sexy and healthy, you radiate confidence, and others pick up on it instantly. Ultimately, beauty truly does come from within; add-ons like shiny hair and glowing skin simply jumpstart the process. Beyond that, the details are easy.

Caring for your complexion should involve a customized regimen. Seek out makeup colors that complement your skin tone, and don't waste time on trendy looks unless they also look beautiful on you. Jennifer Lopez may look gorgeous in glossy beige lipstick, but if you have fair skin, the same lipstick will wash you out. Instead, take a cue from Nicole Kidman, who spotlights her porcelain complexion with cool pastels and a berry-stained mouth. A flattering haircut is one that works effortlessly with your face shape and hair texture, but play with

Shop smartly.

highlights and hot curlers, too. Madonna and Sarah Jessica Parker are two famous hair chameleons: Madonna has dyed her tresses every color under the sun (and expertly altered her makeup to match), and Parker shifts easily between big, bold ringlets and stick-straight locks pulled tightly to her crown. And remember to shop smartly: Try on foundation in natural light, read ingredient lists on skin creams, and test fragrances for at least a few days before buying.

This book will guide you through the intricacies of getting gorgeous, from helping you learn how to play up your favorite features to pointing out some of the best products and tools available. To ensure that every lotion, shampoo and eye shadow recommended on these pages performs beautifully, we've culled them straight for *InStyle* magazine. Many products are drawn from the results of the magazine's annual "Best Beauty Buys" feature, which enlists more than 100 beauty experts and dermatologists to vote for their favorite, most reliable and effective items in categories ranging from facial cleansers to foot cream. The items listed here have been elected consistently for two, three or more years, or earned newcomer cult status because they're so effective and innovative. Additional product recommendations in this book are the editors' best all-around choices in their categories — some old favorites, some discoveries well worth making. Rest assured that we've weeded through thousands of products for you. All you have to do is select the ones that suit your needs.

Above all, this book should be considered a source of inspiration and a springboard to your ongoing efforts to look and feel your best. Each chapter offers detailed instruction, but also leaves plenty of room for play and experimentation, so you have the freedom to create a look that truly reflects your personality and sense of style. Why? Because being comfortable in your own skin is the most beautiful quality of all.

ALICIA SILVERSTONE

SKIN CARE

Skin is the blank canvas of beauty, so before you do anything else make sure it's as healthy and clear as possible. The right skin-care ingredients can coax your complexion from dull to luminous, rough to smooth, blemished to practically flawless. But the important step to take before selecting the best products for your individual needs is to determine your skin type.

SKIN BASICS

With more cleansers, creams, scrubs and serums crowding store shelves every day, putting together an effective skin-care routine can be, depending on your viewpoint, an indulgent adventure or an overwhelming task. With a little preparation, you can simplify the process. Begin by determining your skin type and targeting your needs. Are you concerned with moisturizing dry patches or preventing breakouts? Softening lines or making skin glow? Next, familiarize yourself with the most potent ingredients available today. Then, bone up on the myriad cosmetic procedures available in dermatologist offices, and the safest, smartest ways to get good results. This chapter covers it all, from easy, effective routines to at-home facials to the newest professional treatments—what they cost, how they feel and what they can realistically achieve.

YOUR SKIN TYPE

Ascertaining your skin type is easy, and is the first step you should take before you put anything on your face. To figure out whether it is normal, dry, oily or a combination of dry and oily, take this simple test:

FIVE BASIC SKIN TYPES

WASH AND DRY your face and leave it unmoisturized for three hours. Press a single piece of tissue or blotting paper to your face and remove it. Make your diagnosis:

NORMAL SKIN If no oil comes off on the paper and your face doesn't feel tight or flaky.

DRY SKIN If your skin feels dry, tight or flaky and no oil appears on the paper.

OILY SKIN If oil comes off of your nose, forehead and cheeks.

COMBINATION SKIN If there's oil on your nose and forehead (the areas of the face with the most oil glands) but not your cheeks.

SENSITIVE SKIN If your skin tends to be tight and blotchy and reacts to new skin-care products by becoming red, inflamed or itchy.

ADJUSTING FOR WEATHER

DON'T FORGET that your skin type can change depending on the climate, the season or your age. Which means you may need to switch to a lighter moisturizer or a gel cleanser in summer, or use richer, creamier products in winter, in an arid climate or even after a long flight. Many women experience adult acne in their 20s and early 30s and find themselves scanning labels for pore-scouring ingredients they haven't used since their early teens. As you get older, especially after menopause, the sebaceous (oil-producing) glands produce less, so typically dry skin becomes even drier. That's the time to add denser, more emollient creams, fortified with anti-aging ingredients, to your arsenal. By paying attention to any shifts and adjusting your regimen accordingly, you can make sure your skin consistently looks and feels its best.

SKIN-CARE REGIMENS

These simple skin-care routines – organized by skin type – will keep you cleansed, moisturized, treated and protected from morning to night.

	OBJECTIVE	CLEANSE	MOISTURIZE
NORMAL	To maintain a balanced, evenly textured complexion. To keep skin sufficiently hydrated.	Wash with a gentle, water-soluble cleanser each morning and night. Avoid soap, which contains surfactants, or lathering agents, that strip moisture from the skin; instead, opt for something with a milky or creamy consistency. *Clarins Gentle Foaming Cleanser ▶*	After cleansing, smooth moisturizing lotion all over your face. For maximum hydration, apply the lotion when your skin is damp. *Clinique Dramatically Different Moisturizing Lotion ▶*
DRY	To hydrate parched skin and keep it smooth and supple, rather than flaky and irritated.	Wash your face once a day, right before bed. Gently massage a milky cleanser into your skin to remove dirt, oil and makeup, and rinse with lukewarm water. In the morning, just splash your face with water. *Cetaphil Gentle Cleanser ▶*	Smooth a rich cream onto your still-damp skin once in the morning and at night. The thicker and creamier the moisturizer, the more hydrating it will be (ingredients to look for include glycerin, dimethicone and hyaluronic acid). *Crème de La Mer Moisturizing Cream ▶*
OILY	To cleanse thoroughly without stripping away natural oils. To squelch shine and prevent breakouts.	Wash your face twice a day with a non-soap cleanser designed for oily skin. If you tend to break out often, use a cleanser containing salicylic acid, which calms down inflamed skin and clears out the clogged pores that lead to acne. *Eucerin Pore Purifying Foaming Wash ▶*	If your face feels soft and supple after cleansing, you probably don't need a moisturizer. If it feels slightly tight or dry, try lotions that are oil-free and noncomedogenic (non-pore-clogging). *L'Oréal Pure Zone Oil-Free Moisturizer ▶*
COMBINATION	To address the needs of two different skin types on one face. To absorb oil in the T-zone (the nose and forehead) and hydrate dry areas.	Remove dirt and oil with a gentle, non-soap cleanser, which should do a thorough job without scrubbing. Anything that lathers will dry out already dry areas. *Purpose Gentle Cleansing Wash ▶*	Morning and night, apply a light-weight, oil-free moisturizer (look for gel formulations) and add a heavier lotion to dry areas. If your T-zone is really greasy, swipe it with a glycolic acid pad and don't moisturize it. *Aveeno Positively Smooth Facial Moisturizer ▶*
SENSITIVE	To cleanse, moisturize and treat without causing irritation.	To prevent irritation (itchy rashes like dermititis), wash with a gentle fragrance- and dye-free cleanser, and avoid ingredients such as acids, botanicals and irritating preservatives like ethanol and propylene glycol. *Cetaphil Gentle Skin Cleanser ▶*	Avoid anything scented or colored. The fewer ingredients a lotion contains, the better. Smooth it over your face after cleansing every morning and night. *B. Kamins Maple Treatment Night Cream ▶*

Your daytime moisturizer should contain an SPF of at least 15 and guard against both UVA and UVB rays. Wear it even on overcast days. (For more information on sun protection, see p. 154.)

Olay Total Effects UV Protection ▶

To keep skin looking fresh, slough off dead skin cells with a chemical exfoliant every night after cleansing. Look for a treatment cream or moisturizer containing alpha-hydroxy acids or glycolic acid. (For more information on these ingredients, see p. 22.)

Estée Lauder Diminish Anti-Wrinkle Retinol Treatment ▶

Use a moisturizer containing SPF 15 or higher. If you can't find one that feels rich enough, add sunscreen on top of your regular face cream.

*Chanel Précision Rectifiance Intense
Anti-Age Retexturizing Cream SPF 15* ▶

One night a week, use a lotion containing retinol or alpha-hydroxy acids. Retinol stimulates collagen production, which leads to plumper, smoother skin; acids exfoliate dead, scaly skin cells and expose fresher ones underneath.

Roc Retinol Actif Pur Night ▶

Apply mattifying gel or lotion after cleansing. These contain silica, clay, microsponges or polymers to soak up oil. Then, apply oil-free, noncomedogenic sunscreen with SPF 15 or higher.

Prescriptives All You Need Oil Absorbing Lotion SPF 15 ▶

At night, apply a topical retinoid (vitamin A-derived) lotion or serum to exfoliate (for more on retinoids, see p. 21), and skip moisturizer if your skin feels dewy without it.

Neutrogena Healthy Skin Anti-Wrinke Cream ▶

Apply oil-free sunscreen all over your face, either alone or over your moisturizer. A moisturizer with SPF is another option (just make sure it's SPF 15 or higher).

*Origins Have a Nice Day Super-
ChargedMoisture Lotion–SPF 15* ▶

Exfoliate with a cream containing alpha-hydroxy acids or retinols every night. Cut back to twice a week if your skin becomes red or irritated. Add extra moisturizer on extremely dry areas.

Clinique Total Turnaround Visible Skin Renewer ▶

Ward off harmful rays with an unscented, noncomedogenic sunscreen. Also, physical blocks (such as zinc oxide and titanium dioxide) sit on top of the skin and are therefore less irritating than chemical ones.

*Clarins fluide Désaltérant Moisture
Quenching Hydra-Balance Lotion SPF 15* ▶

Exfoliating aggressively with fruit acids or physical granules can irritate sensitive skin. Look for a cream with antioxidants (like vitamin C and Chair Hu) that feels hydrating and smooth on your skin.

Almay Kinetin Anti-Wrinkle Booster Serum ▶

SKIN CARE: EFFECTIVE EXTRAS

Once you've established a basic cleansing and moisturizing routine, supplement it with one or more of the following extras. These products aren't mandatory, but they (especially exfoliators) can leave your skin cleaner and smoother.

EXFOLIATION AND EXFOLIATORS

Exfoliation isn't as elemental as cleansing and moisturizing, but it should still be an integral part of any skin-care routine. Here's why: Every three to four weeks, new skin cells push their way from the lowest level of the epidermis (the top layer of skin) to the surface. Once there, they dry up and fall off, revealing plumper, fresher cells beneath them. Exfoliating speeds up the sloughing process by scrubbing off the top layer of skin. As a result, skin is smoother and more radiant—and skin-care ingredients penetrate more easily.

Exfoliants can be either physical or chemical. Physical ones are creams or gels containing rounded synthetic, polyethylene beads (avoid scrubs containing crushed nuts or apricot pits, which are abrasive and can cut your skin). Chemical ones include a variety of enzymes, fruit acids and retinoids (vitamin A derivatives). Dermatologists recommend exfoliating a few times a week; the more oily your skin, the more often you should do it.

TONER

Many of us grew up dutifully toning our skin every morning and night. (Remember all the cotton balls you went through?) But today, most dermatologists agree that toner isn't necessary. Its main purpose is to remove all traces of makeup and residual cleanser, but a high-quality cleanser, even a creamy one, should rinse off easily with water alone. Some women like the fact that toner leaves their face tight and smooth. But that taut, tingly sensation actually indicates dryness—

especially if your toner contains astringents such as alcohol or witch hazel. The ideal candidate for toner is someone with oily or acne-prone skin who enjoys that squeaky-clean feeling, and who can actually benefit from newer, more treatment-oriented formulations. Make sure to use an oil-free version that contains acne-fighting ingredients like salicylic acid, as well as hydrating ingredients like aloe and glycerin. If it leaves your skin uncomfortably tight, use it every other day.

CLEANSING CLOTHS AND PILLOWS

The newest category of facial cleansers are a boon for "germa-phobes" and frequent travelers. Cleansing cloths and pillows have built-in cleansers so they lather up when they get wet, and you toss them after one use so they never get contaminated with bacteria. Even better, some cloths are premoistened, so you don't even need water to wash your face (but bear in mind that premoistened cloths don't cleanse as thoroughly as the ones you wet, so to remove heavy-duty makeup, use the latter). They scrub skin like a washcloth, and some

(not the premoistened ones) have a rougher side for exfoliating. But the best part: Cleansing cloths and pillows are incredibly convenient. They eliminate the need to open a bottle or hunt for a wash cloth—tasks that sound effortless but actually feel like a chore after a late night out or in a cramped airplane bathroom. Keep a stash in your gym bag and toiletry kit; they'll keep your skin freshly scrubbed when you're short on time.

EYE CREAM

Eye creams have a richer, more slippery consistency than regular facial moisturizers and are pH formulated not to irritate your eyes. Look for eye creams—or gels, if you have oily skin—that are fragrance-free and contain no propylene glycol, which is an irritating preservative. Hyaluronic acid, a natural component of the dermis that binds water to your skin, will keep undereye skin from getting "crèpey." Silicone and dimethicone fill wrinkles temporarily, so the skin around your

eyes appears smoother. Vitamin K can inhibit dark circles caused by visible blood vessels under the eyes, and caffeine acts as an anti-inflammatory. Dab a watermelon seed-sized amount onto the skin around each eye every night after washing your face. Massage it gently into the bony areas under the eyes and on the outer corners, staying clear of the tear ducts.

ACNE: THREE COMMON TYPES

Adult acne is most commonly caused by hormonal changes related to PMS, pregnancy, menopause and taking birth control pills, such as Orthonovum, that contain estrogen and progestin hormones with higher levels of the male hormone androgen. Armed with some basic knowledge (wash your face with a mild cleanser, deep-clean with salicylic acid-based toner and moisturize with a noncomedogenic lotion) and the right treatment products laid out in the following chart, you can help keep breakouts at bay.

	COMEDONAL	PAPULAR	CYSTIC
CAUSES	Comedones are clogged pores caused by excess sebum (oil) mixing with dead skin cells to form a thick, sticky substance. An open comedone, or black-head, looks like a large, dark pore (the black color isn't dirt; it's the color the hardened sebum turns as it oxidizes in open air). A closed comedone, or whitehead, has skin growing over its opening and looks like a small, hard white bump. Black- and white-heads are often caused by using makeup and hair-care products containing oil, or by excessive sweating and humidity.	Papules are the pimples every woman knows and hates: Painful, inflamed pink or red bumps that develop when a clogged pore gets infected with bacteria. Stress, hormonal fluctuations and humidity all increase the chances of infection because they spur the body to produce more oil, which attracts bacteria. (Bacteria can also come from a finger, a facecloth, a makeup brush or even a phone.) And despite what your mother told you, chocolate and French fries don't cause acne—unless you smear them directly onto your face.	This is acne at its worst, both physically and emotionally. Rather than isolated pimples, cystic acne manifests itself as large, inflamed (and easily scarring) bumps arranged in clusters all over your face. Genetics are to blame: People with this condition have hyperactive sebaceous glands that pump too much oil into the pores, abnormal skin cells that don't turn over fast enough and a highly developed inflammatory response that causes such severe infections that pimples leave permanent pock marks.
PREVENTION	Exfoliate dead skin cells every morning and night with a salicylic acid wash. (In addition to exfoliating, salicylic acid can penetrate inside the pores to break up the clusters of cells that clog oil glands and cause pimples.) To keep blackheads from forming, deep-clean pores weekly with a clay mask. Keep blotting papers in your bag at all times to press onto shiny skin and soak up excess oil.	To kill acne-causing bacteria, wash twice a day with a benzoyl-peroxide cleanser. If over-the-counter acne treatments don't clear things up, your dermatologist can prescribe a topical vitamin A derivative such as Retin-A, which exfoliates skin. Keep in mind that birth control pills high in androgenic progesterone trigger oil production, so consider switching to a low-estrogen brand (such as Orthocept, Alesse, Yasmin or Ortho-tricyclen, the only birth control pill that is FDA-approved to treat acne).	See a dermatologist, who can prescribe an oral antibiotic such as tetracycline. If that doesn't help, you may be a candidate for Accutane, which is typically a last resort for acne patients. The drug, which decreases oil production in the skin, takes five months to work and has side effects ranging from the inconvenient (dry skin, nosebleeds) to the dangerous (severe depression and birth defects—so don't take it if you're breast-feeding, pregnant or planning to become pregnant in the next three months).
TREATMENT	Pull out blackheads with pore strips and eradicate whiteheads with an on-the-spot salicylic acid treatment product.	To reduce swelling and kill bacteria, use a spot treatment containing a high concentration (5 to 10 percent) of benzoyl peroxide. If that feels too harsh, try something that contains salicylic acid or sulfur. Hydrocortisone applied before bed can reduce redness and inflammation over-night (use the cream form if you have oily skin). For severe cases, try a topical pre-scription antibiotic such as Clindamycin.	For a single, festering pimple that won't go away, ask your dermatologist for a cortisone shot, which should work within 48 hours. If you're taking Accutane, you may need to treat the side effects. Acclovate, a prescription lip balm, helps heal severely chapped lips, and a mild cleanser can prevent skin from becoming too dry.

BEAUTIFUL SKIN AT ANY AGE

A tiny sliver of the female population is born with perfect skin, but most women have to work at it, at least a little bit. These celebrities are living, glowing proof that taking good care of your complexion—at any age—truly pays off in the form of healthy, radiant skin.

TWENTIES

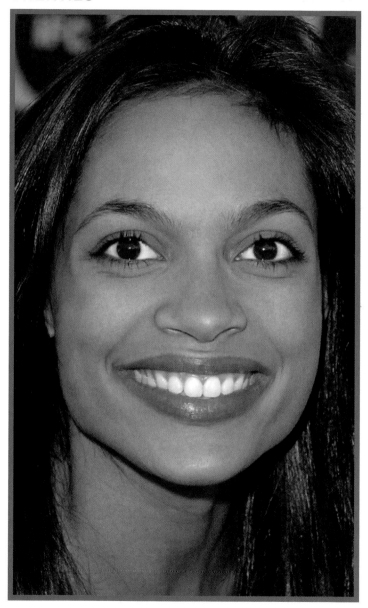

ROSARIO DAWSON

At the 2004 Independent Spirit Awards, Dawson shows off a complexion so smooth and poreless that makeup is almost an afterthought. The cardinal rule of skin care in your 20s? Establish good habits. Wear sunscreen every single day.

THIRTIES

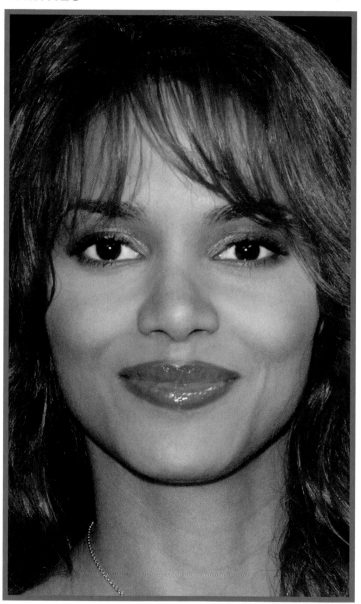

HALLE BERRY

Berry, shown here at the Los Angeles premiere of *Gothika* in November 2003, is the poster child for healthy, luminous skin. In your 30s, start using skin-care products containing anti-aging ingredients such as retinol and glycolic acid.

FORTIES

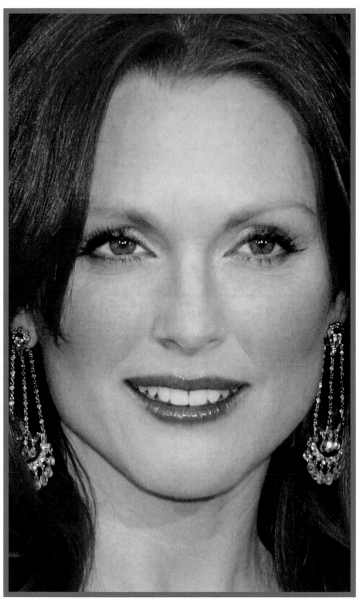

JULIANNE MOORE

Moore reveals her typically fresh, dewy complexion at the Academy Awards in February 2004. Now's the time to add extra moisture and, perhaps, try an in-office procedure to treat discoloration or soften lines.

FIFTIES

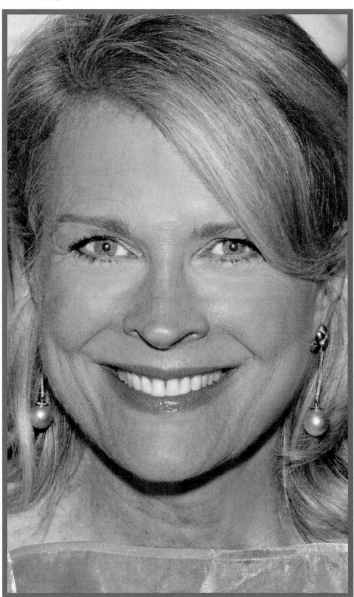

CANDICE BERGEN

Bergen lets her natural beauty shine through at a June 2004 fashion show in New York City. In your 50s, plump up sagging skin with Renova, a prescription-strength retinol product, or ask your dermatologist if you're a good candidate for injectible fillers.

The passage of time brings wisdom, but it also wreaks havoc on the skin. The culprit? Unstable oxygen molecules known as free radicals, which lack an electron in their outer shells and therefore snatch electrons from other, healthy molecules that cross their path. UV rays, cigarette smoke, alcohol and carbon monoxide (elements we're exposed to every day) all stimulate the production of free radicals, which in turn slow down cell turnover and spur the deterioration of collagen and elastin (fibrous proteins located in the dermis, or deeper layer of skin) that form the structure of the skin. The unfortunate results: Your complexion becomes dull and muddy, lines and creases appear and skin droops and sags.

Resigned to covering your head with a paper bag? Chin up. A growing number of antiaging ingredients, found in both store-bought creams and prescription topical treatments, are proven to help slow down the damage and restore firmness and radiance to skin of a certain age. If you seek more dramatic, long-lasting results, you can choose from dozens of professional treatments, performed by dermatologists, that target every inch of the body, from crow's feet to spider veins.

ROSALYN SANCHEZ

A GUIDE TO THE MOST EFFECTIVE INGREDIENTS

There are countless antiwrinkle creams on the market, each one promising firmer, smoother, dewier, younger-looking skin—and each one boasting some sort of breakthrough antiaging ingredient. Reading the back of a jar can be confusing and even intimidating, but the truth is there are only a handful of time-tested, truly effective ingredients out there—and you shouldn't need a chemistry degree to understand how they work. These are the major players—keep them in mind when putting together your ideal, personalized skin-care routine (see pp. 14–15), and you'll feel confident that you're doing everything you can to keep your skin smooth and healthy.

RETINOIDS

Considered by many dermatologists to be the most exciting skin-care breakthrough in the past decade, vitamin A derivatives (also known as retinoids and tretinoins, which are a type of retinoid) react with receptors on the outer-membrane skin cells. They not only exfoliate skin but also stimulate collagen production, which leads to plumper, firmer skin, reduced sun spots and the appearance of diminished wrinkles. Renova, a prescription cream, comes in two strengths: .05 percent and a less irritating (and less potent) .02 percent tretinoin, and has been clinically proven to increase the production of collagen. Retinol, the over-the-counter form of tretinoin, contains lower concentrations of vitamin A, which makes it less irritating, but also less effective, than its powerful prescription counterparts. Retinoids break down in sunlight, so make sure to choose a retinol-based product that is packaged in an aluminum tube. And look for formulations containing soothing ingredients such as panthenol (provitamin B5) and vitamin E, which reduce drying and irritation. Because retinoids thin the skin and make it sensitive to sunlight, it's best used as a nighttime treatment. In the morning, complement it with other antiaging ingredients (fruit acids, antioxidants) and sunblock. Because vitamin A can inhibit the skin's healing abilities, anyone using retinoids should also avoid waxing, microdermabrasion or laser resurfacing.

ALPHA-HYDROXY ACIDS (AHAs)

Exfoliants such as citric acid (derived from citrus fruits), glycolic acid (derived from sugar cane), malic acid (derived from apples), tartaric acid (derived from grapes and wine) and lactic acids (derived from tomatoes and sour milk) increase skin cell turnover by dissolving the protein bonds between the cells. As a result, dead skin cells fall off, revealing fresh, soft skin underneath. Acids only penetrate the epidermis, or outermost layer of the skin, so they don't prevent the formation of wrinkles (which takes place in the dermis, or second layer of skin). But they do even out skin tone, which makes them ideal for women with specific discolorations or generally blotchy skin. But be careful not to overdo it. These acids can be irritating. Make sure you use only one AHA product per day, and always wear a broad-spectrum sunscreen, since AHAs thin out the top layer of skin and make it more vulnerable to harmful exposure.

BETA-HYDROXY ACIDS (BHAs)

These fat-soluble acids, which include salicylic acid, are gentler than AHAs. In addition to exfoliating the top layer of skin, they brighten dull skin and clean out clogged pores by permeating the oil glands and breaking down accumulated skin cells. Their ability to target blackheads and pimples makes them perfect for women with oily skin and/or acne. Because they're slightly gentler than AHAs, BHAs can be applied twice a day.

ANTIOXIDANTS

These molecules scavenge the skin-damaging free radicals generated by sun exposure, cigarette smoke and pollution and inhibit them from damaging healthy cells. The most effective antioxidants on the market are:

CO-ENZYME Q-10 This molecule exists in all human cells and helps convert food into energy. It's more stable and less irritating than vitamin C. It's also less effective.

VITAMIN C Also known in skin-care circles as L-Ascorbic acid, vitamin C stimulates collagen production and decreases the damaging effects of sun exposure, helping to slow down the aging process. For maximum benefits, be sure to buy products with at least a 10 percent concentration of L-Ascorbic acid. Vitamin C is fairly unstable and degrades quickly when exposed to air and sunlight, so look for products that come in dark bottles or opaque tubes. You may feel mild stinging when you apply vitamin C to your skin.

IDEBENONE Dermatologists are raving about this newly discovered super-antioxidant, which was originally used to treat Alzheimer's disease and has been proven in numerous studies to be more effective than vitamin C, Co-enzyme Q10, kinetin (see below) and alpha-lipoic acid. It reduces dryness and improves the appearance of fine lines and skin texture, and is effective at preventing sun damage. Idebenone can be found in the nonprescription cream Prevage.

ALPHA-LIPOIC ACID This antioxidant and anti-inflammatory also occurs naturally in the body's cells. Because it is both water- and oil-soluble, alpha-lipoic acid can permeate every part of the cell (and even forage in between them) to fight free radicals.

SOY This antioxidant is specifically known for moisturizing, evening out skin tone, soothing sunburn and (according to initial research) inhibiting hair growth.

GRAPESEED EXTRACT, GREEN TEA AND WHITE TEA In addition to fighting free radicals, grapeseed extract has been shown to increase circulation and strengthen blood vessels, and is known for being extremely hydrating. Green and white teas have been touted for their anti-inflammatory and anticancer benefits; white tea also restores resiliency.

GROWTH FACTORS

Growth factors are extracted from plants, cultured epidermal cells, placental cells and human foreskin, and act as chemical messengers between cells, triggering a variety of cellular activities, including collagen synthesis. Topically applied growth factors have been shown to spur collagen production in wrinkled, sagging skin. These are the ones to watch (and try):

EPIDERMAL GROWTH FACTOR, OR EGF, is the protein molecule that helps heal cuts in the skin by stimulating the growth and division of new skin cells, thereby increasing circulation and building new collagen. Much research is being done on the effect of EGF on aging skin, and several creams on the market contain small sections of the molecule, which is too large to penetrate the skin as a whole. Some companies are overcoming that obstacle by producing oral or injectable forms of EGF to deliver higher concentrations of the molecule into the skin.

KINETIN AND KINERASE are plant growth factors that keep leaves plump, firm and green—and have a similar smoothing, firming, water-retaining effect on human skin. They're extremely gentle and won't irritate skin (or render it photosensitive) the way acids and retinoids will, so they're ideal for sensitive skin. But these non-irritating growth factors won't fight the signs of aging as aggressively as other ingredients either, so it may take longer to see results.

COPPER PEPTIDE COMPLEX is proven to boost collagen production and increase hydration and elasticity in wounded skin; the hope is that it can do the same for healthy skin. Based on existing evidence, copper, a micronutrient, firms skin by activating the enzymes that weave together and fortify collagen fibers.

PENTAPEPTIDES are another antiaging ingredient based on wound-healing research. Not only do pentapeptides cause a significant decrease in facial lines, but they also improve the appearance of dark spots and undereye circles.

Just a decade ago, smoothing wrinkles and tightening sagging skin was an all-or-nothing proposition. Beyond beauty creams, the main options were minor nips and tucks or a full-fledged facelift—and the attendant bandages, bed rest and shrouds of secrecy, not to mention the thousands of dollars needed to afford a top-notch surgeon. (Facial plastic surgery also comes with a long list of possible complications, including infection, excessive bleeding and permanent nerve damage.) Today, turning back the clock on your complexion has never been faster, easier or less invasive. The most effective nonsurgical cosmetic procedures—Botox, chemical peels, injectibles, laser treatments—require a regular visit to the dermatologist and are less traumatic and expensive than surgery (but certainly much pricier than a cream).

Keep in mind, however, that although these procedures will improve your skin's appearance considerably, they won't erase your problems completely. And if performed by

an unqualified aesthetician, they could do more harm than good. To be safe, schedule consultations with two or three board-certified dermatologists who have performed the procedure you're after hundreds of times. (Check the Web sites for the American Academy of Dermatology, aad.org, and the American Society for Dermatologic Surgery, asds-net.org, for referrals.) Spas are fine for relatively superficial treatments like microdermabrasion and light chemical peels using glycolic or salicylic acid, as long as the place is reputable and the aestheticians are licensed. But when needles, lasers and powerful peeling agents like trichloroatic acid (TCA) enter the picture, stick with doctors. The best scenario: A "medi-spa," where aestheticians are trained and supervised by dermatologists; usually, these spas are part of a high-end dermatologist's practice.

PROFESSIONAL COSMETIC PROCEDURES

	BOTOX	**COLLAGEN AND OTHER INJECTIBLES**
HOW IT WORKS	Tiny amounts of this purified toxin (also known as Botulism Toxin, a derivative of the poison that causes botulism when ingested) are injected into underlying facial muscles to temporarily paralyze them. Relaxed skin stretches out, causing wrinkles to soften and vanish.	After you've been tested for allergies, an anesthesia-laced collagen derived from cows is injected into wrinkles and/or lips for an instant plumping effect. Newer injectables like Restylane, Radiance and Cosmoplast are formulated in labs rather than taken from animals or cadavers, and therefore don't require allergy testing. Restylane, which won FDA approval in December 2003, is made with hyaluronic acid, a substance found in the skin that helps keep it plump, and eventually dissolves naturally into your body's tissues. Radiance is a creamy synthetic form of calcium hydroxyapatite, a substance found in bone and teeth. And Cosmoplast is made from purified, lab-grown skin cells.
WHERE IT GOES	Creases between brows, horizontal forehead lines and crow's-feet, which are caused by frowning, squinting and smiling. Generally, Botox is not recommended for the mouth area because it can inhibit your ability to smile, but some people use it to soften deep marionette lines, which extend from the corners of the mouth to the chin.	Thin lips, forehead furrows, deep creases from the corners of the nose to the corners of the mouth, lipstick bleed lines and smile lines around the corners of the mouth.
HOW LONG IT TAKES (AND LASTS)	Thirty minutes maximum. You'll see results within two days to two weeks, and they'll last three to six months; then you'll need to be re-injected.	Duration of the treatment depends on the number of wrinkles you are filling, but injections generally take less than an hour. Collagen is eventually absorbed into the body, so you need to repeat the procedure every three to six months. Restylane lasts six to nine months; Radiance lasts three to five years, and Cosmoplast lasts about as long as collagen.
WHAT IT FEELS LIKE	Botox is injected directly into the wrinkled or furrowed area and pinches like a bee sting; you only feel pain when the needle punctures the skin. You may see a red spot on the injection site immediately afterward, but it should fade within ten minutes. It's best not to exercise for four to five hours.	They're relatively painless (similar to a bee sting), but local anesthesia can be used.
HOW IT HEALS	Some people experience bruising or swelling for several days after injections.	There's virtually no downtime. You can have slight bruising from the needle, and the injected areas may look puffy and red for a few hours after the treatment.
COSTS	$400 to $500 per site. A pair of crow's-feet counts as one site; a furrowed brow counts as another.	$400 to $700 per site.
RISKS	Even an experienced dermatologist can inject you too close to the muscle, causing drooping eyelids, a downturned mouth (that drools involuntarily) or an overall stiff appearance.	Even if you've tested negative twice for collagen allergy, there's still a 3 percent chance that you'll have a reaction. If you go to an unskilled dermatologist for any kind of injection, you risk bruising and lumpiness.

LIGHT CHEMICAL PEEL	MICRODERMABRASION	NONABLATIVE LASER
A 30 to 50 percent solution of lactic or glycolic acid is applied evenly onto the face to exfoliate the top layer of dead skin cells. If you have acne, you'll need a 20 percent salicylic acid solution instead.	Minuscule aluminum-oxide crystals are swept across the face with a small, handheld vacuum, gently sloughing off dead skin cells to reveal the fresher, finer-pored skin underneath.	Unlike traditional lasers, which burn the entire top layer of the skin and its imperfections to spur collagen production (resulting in rawness and redness that can take several months to heal), nonablative, or nonsurgical, lasers cool the top layer of skin while penetrating directly to the second layer, where they use high heat and gentle light pulses to stimulate new collagen growth and remove unwanted hair and hyperpigmentation—without the burning sensation.
Hyperpigmentation (dark areas), active acne and generally blotchy, dull-looking skin.	Dull-looking skin, sunspots, acne scars.	Wrinkles, scars, unwanted hair, brown spots and broken blood vessels.
Glycolic and lactic acid peels stay on skin for two to 15 minutes, depending on the severity of the damage you're treating. Salicylic acid stays on for approximately one minute. For significant changes, you'll need at least four peels, spaced three weeks apart. The results should be permanent, as long as you use sunscreen daily.	A full face takes 20 to 30 minutes. For optimal results, schedule three to six treatments, spaced two to four weeks apart.	Fifteen minutes to an hour. You'll need two to six treatments, scheduled three to four weeks apart. The results for wrinkles, scars and blood vessels can last for up to four years if you use sunscreen daily.
Your skin will burn a bit during the treatment, but the pain is tolerable.	The crystals cause a mild scratching sensation that feels like a cat licking your face.	The laser feels like a rubber band snapping your skin or tiny pin pricks—it's painful but tolerable.
Depending on the strength of the acid, your skin may be slightly red and scaly for several days. Moisturizer will prevent flaking.	Your face will be flushed for five to 10 minutes. Sensitive skin may experience redness for a little longer if too much pressure is used.	Because the laser bypasses the top layer of skin, there's no visible wound or downtime. You may see a bit of redness, but it shouldn't last long.
About $200 per peel.	$100 to $200 per treatment.	$250 to $750 per session.
Your skin can get burned. Peels are also known to exacerbate cold sores around the mouth.	If it's done too aggressively, your face can get scratched. Microdermabrasion can also aggravate acne and spread existing warts.	Bruising and slight pigment irregularities, as well as scarring if performed by unskilled hands.

CONTINUED ON NEXT PAGE

PROFESSIONAL COSMETIC PROCEDURES

	LIGHT SOURCE	LED PHOTOMODULATION
HOW IT WORKS	While lasers use a single wavelength, light sources use multiple ones to injure the under-layer of skin, prompting it to create new collagen in order to heal. They can be adjusted to treat specific skin types and conditions but don't penetrate as deeply as nonablative lasers and are less precise. Commercial names for light sources, also known as IPL, include Aurora and Quantum.	You stare into a screen of 2,000 low-intensity, blinking lights that modulate the activity of your skin cells without using heat. The lights stimulate collagen growth and decrease collagen disintegration, smoothing fine lines, reducing the appearance of pores and decreasing redness. The commercial name for the machine is Gentlewaves.
WHERE IT GOES	Rosacea, sunspots, blotchiness, acne, dilated blood vessels and unwanted hair.	It tones and tightens the entire face.
HOW LONG IT TAKES (AND LASTS)	Thirty minutes or less. Dermatologists recommend a series of three to five sessions, four to six weeks apart. Results last six to 12 months. Light source treatments can be combined with microdermabrasion.	The procedure lasts a scant 30 to 90 seconds, but you need six to 10 treatments, spaced several weeks apart, to see results.
WHAT IT FEELS LIKE	Mildly uncomfortable, but less painful than nonablative lasers.	Nothing: You just stare at a screen.
HOW IT HEALS	Minor bruising can occur.	You don't need to heal. There's no recovery time at all.
COSTS	Around $500 for a full face.	$100 to $150 per treatment.
RISKS	Similar to laser treatments: scarring and irregular pigmentation.	None.

DERMAPLANING	RADIO FREQUENCY (RF)	VEIN THERAPY
Using short, precise movements, an aesthetician or dermatologist grazes a sharp scalpel across the face, skimming away dead cells and evening out the skin's surface. It can be done all over the face or in specific spots. As a bonus, it temporarily removes unwanted hair at the same time.	After a numbing cream is applied to skin, radio frequency waves emitted from a handheld device heat and penetrate the skin (even more than a laser does), causing underlying collagen to shrink and contract; the result is a subtle "mini-lift." This FDA-approved procedure is known as Thermage.	In vein therapy (also called sclerotherapy), a chemical solution is injected into your vein with an extremely fine needle. The solution irritates the lining of the vein, causing it to swell, collapse and turn into scar tissue, which the body then absorbs.
Blotchy, dull skin, mild acne and acne scars.	Sagging skin in the brow area, cheeks and neck.	The procedure targets the legs: spider veins, which typically form a sunburst pattern under the skin, and large blue varicose veins, which are raised. Though spider veins on the face are commonly treated with lasers, sclerotherapy may be a more precise method of removing fine veins in the eyelid and under the eyes.
Twenty minutes per treatment. Dermatologists recommend one treatment per month for three months in a row.	Twenty to 30 minutes. Doctors recommend one to three treatments, one or two months apart. The results last up to 18 months.	A treatment takes 15 to 30 minutes. After several treatments, you will see a 50 to 90 percent improvement, but full fading takes a few months. The results can be permanent, but new veins may appear.
Like having someone shave your face. As abrasive as the name sounds, dermaplaning is actually gentle and, most important, chemical-free, so it's a smart choice for people with sensitive skin. But make sure your aesthetician is experienced with the procedure because you don't want to risk getting nicked.	Extremely painful waves of intense heat. You may require topical anesthesia and an oral analgesic.	You will feel some stinging when the needle pierces your skin.
Immediately, and without a trace. Avoid applying cream right afterward because your skin is especially sensitive and might have an allergic reaction.	You may be slightly pink for a day or two.	Patients typically experience red, raised areas where the veins were injected, but they disappear in a day or two. Another side effect is dark brown spots, which are caused by blood escaping larger treated vessels. In most cases, they fade within a year.
About $200 per session.	$1,500 to $5,000 per session.	$200 to $800 per session, depending on how many veins are treated.
Dermaplaning can worsen severe acne infections or spread warts.	Severe temporary pain. If you have silicone implants in your face, they may react to the heat (there have even been anecdotal reports of silicone oozing out).	In extremely rare instances, people have an allergic reaction to the chemical solution that is injected into their veins.

Dermatologists are divided on facials: Some dismiss them as pure snake oil; others claim that they deep-clean pores and remove black- and white-heads, as well as soothe, hydrate or exfoliate, depending on your specific needs. (And plenty of facial junkies with standing monthly appointments would agree.) But what do all those elaborate treatments really do? Here's the lowdown: Masks can moisturize intensely, making wrinkles look less pronounced and pores look smaller. Masks containing a cooling ingredient like menthol increase blood flow to the skin, imparting a rosy glow. But don't expect masks to perform miracles such as increasing collagen production, preventing wrinkles, erasing undereye circles and shrinking pores (which is impossible). One thing you can count on: Facials are relaxing, thanks to added bonuses like neck and shoulder massages.

For best results, make sure you go to a dermatologist or reputable spa and prepare to discuss with the aesthetician your skin-care gripes, at-home routine and any allergies or medications you're taking, including birth control pills. The more honest you are, the more customized the treatment can be, so give specific product names and come clean about a smoking or sunbathing habit.

Keep in mind also that there's only so much a spa facial can do. To instantly deflate a big pimple or conquer cystic acne, you have to see a dermatologist, who can inject cortisone into the blemish and prescribe the proper acne medications for chronic breakouts. A dermatologist can also perform deep acid or laser resurfacing to remove wrinkles, spider veins (for more information, see pp. 24–27), and serious signs of sun damage, as well as diagnose and treat medical conditions such as rosacea, psoriasis and eczema.

BASIC FACIAL STEPS

Spas offer dozens of different facials, each with a more tantalizing name and ingredient list than the last. To avoid wasting money and time on an ineffective treatment, cut through the clever marketing: Electric wands waved over the face and blasts of oxygen gas aren't likely to erase the signs of aging. And while scented oils are intoxicating, they won't get the dirt out. Here's what every basic facial should include:

CLEANSING AND MASSAGE

An aesthetician should remove any makeup from your face, then apply a gentle scrub (for normal to oily skin) or lotion (for normal or dry skin) and massage it in for up to 15 minutes. The massage increases circulation and relaxes your facial muscles; the scrub exfoliates dead skin, allowing mask ingredients to penetrate more easily.

STEAM

A steam machine sprays your face with a fine mist of hot steam, which softens the skin and triggers the sweat glands to draw dirt to the surface, making extractions much easier. This takes five to 10 minutes, and should feel relaxing, not uncomfortably warm.

EXTRACTIONS

Using two gloved fingers or an extraction tool, the aesthetician applies firm, uniform pressure around black- and whiteheads to push them out of the pores. Extractions can be painful, but they should not leave red, swollen marks. (However, you may have temporary redness or a tiny scab precisely where an extraction took place.)

MASK

The ingredients of the mask depend on your skin condition. If you have oily or acne-prone skin, you may have a mud or clay mask to draw out any remaining impurities, or a benzoyl peroxide or sulfur mask to soak up oil. If it's a youthful glow you're after, a mask containing alpha-hydroxy acids (AHAs), enzymes or glycolic acid (a powerful chemical exfoliant) will scrub away dead, dull skin. A hydrating mask can contain anything from glycerin to sweet almond oil. A ginseng or green tea mask soothes skin after heavy extractions. A mask should stay on for 10 to 15 minutes and is followed by another cleansing and a thin layer of moisturizer.

AT-HOME FACIAL

To maintain healthy skin between professional treatments, give yourself a facial at home once a week. It's surprisingly easy and fast, and rest assured, Mom's egg-white and oatmeal masks are no longer on the menu.

STEP ONE

Wash your face to remove all dirt and makeup. If you have oily or combination skin, use a gentle foaming cleanser; for dry skin, use a cream or milk cleanser.

STEP TWO

Spread a scrub onto your face to exfoliate and buff skin. Scrubs containing small, round, synthetic beads in an emollient base are safest, since natural scrubs with larger crushed nuts can have jagged edges and may tear skin. (Scrubs should never hurt.) Rinse it off.

STEP THREE

Fill your bathroom sink with warm water, dip a facecloth in, and press it onto your face one or two times.

STEP FOUR

Spread a store-bought mask onto your face, avoiding the immediate eye area, and leave it on for 10 to 20 minutes. If you have oily skin, look for a clay or mud mask; if you have dry skin, apply a hydrating gel or cream mask. (Use both kinds of masks on combination skin.) Rinse.

STEP FIVE

Smooth on a soothing, basic moisturizer. Avoid antiaging products containing acids or retinols; you don't want to overexfoliate your skin.

THE QUICKIE

Skip the scrub and the warm compresses. Cleanse your face and slather on a mask (a clay or mud one if you have oily skin, and a cream or gel one if you have dry skin). Leave it on for five or 10 minutes, rinse and moisturize.

THE FULL TREATMENT

Once you apply the scrub, massage it into your face for three to five minutes in small, circular motions in an upward direction. Next, add some aromatherapy to the mix. Fill your sink with warm water and add a teaspoon of either lemon juice or rosemary or eucalyptus essential oil if you have oily skin; or lavender or sandalwood essential oil if you have dry skin. Lean over the sink, dip a clean washcloth into the water and press onto your face for ten seconds. Repeat five to eight times until your skin feels very moist, soft and supple. Use an appropriate mask, rinse and moisturize.

Q&A

Does smoking really have a harmful effect on skin?

Absolutely. Smoking is the second largest cause of skin damage (after sun exposure). Nicotine constricts the blood vessels in the face and decreases the flow of oxygen and nutrients to the epidermis. Smoking also causes wrinkles around the mouth and eyes from repeated pursing of the lips and squinting.

Will drinking eight glasses of water a day keep my skin moist?

Not necessarily. This beauty myth has been drummed into our heads for so long that it's hard to believe it isn't true. But here's the reality: Drinking plenty of water certainly keeps the body, including the skin, hydrated, but the outermost (oldest) layer of skin is made up of dead skin cells, which don't absorb water from within the body. Therefore, the moisture level of skin is affected mainly by external factors, such as cold, wind and dry heat, and also by the number of sebaceous, or oil-producing, glands you have.

What causes puffiness and dark circles, and how can I get rid of them?

Puffiness under the eyes occurs when you retain water and your under eye tissue swells. Dark circles indicate blood vessels or hereditary pigment. To reduce puffiness, look for an eye cream containing caffeine, which causes blood vessels to temporarily constrict, or shrink. You should also avoid salt and drink plenty of water. For a quick at-home fix, apply cool compresses (tea bags soaked in ice water or cucumber slices work well) and rest with your head elevated for as little as 15 minutes or as long as overnight. To lighten dark areas, use a cream containing hydroquinone or kojic acid; both brighten hyperpigmented skin. To cosmetically improve the appearance of dark circles, apply eye creams that contain mica or light-diffusing particles to make the skin seem lighter and brighter; if necessary, follow with concealer (for application tips, see p. 41).

Can I extract blackheads myself?

Only if you're extremely careful. One false move, and you could end up with an infected cyst. If you're desperate to take matters into your own hands, do so after a hot shower, when pores are soft and dilated. Apply gentle, even pressure around the pore using a comedone extractor (available at drugstores). To clean off any residual bacteria, wipe the surrounding area with a cotton ball soaked in alcohol. This method works best for women using prescription Retin-A or an over-the-counter retinol treatment every day since those products draw blackheads to the surface of the skin. To avoid reinfection, remember to sterilize a comedone extractor after each use by placing it in boiling water for 10 minutes and then rubbing it with alcohol.

Are there any inexpensive microdermabrasion kits that I can use at home?

Yes. Dermanew Personal Microdermabrasion System ($80, 666-443-3762) is a gentle, at-home option, but it doesn't exfoliate with the same intensity as a professional treatment. The kit contains an oscillating resurfacing tool that massages corundum crystals into the skin. The tool doesn't have a vacuum—making it gentler than professional versions and ideal for sensitive skin—but it still reduces fine lines and evens out skin tones. Other companies offer creams containing crystals, but they don't come with tools, so again, the results will be subtler than from a professional treatment. The Prescriptives Dermapolish System ($125, prescriptives.com) includes a treatment cream containing aluminum oxide crystals, a soothing antioxidant mist and a moisturizer. Philosophy's Resur-face Peel ($65, philosophy.com) consists of an exfoliating cream containing vitamin C (ascorbic acid) crystals and an activation gel that you apply on top. The Cellular Dermabrasion Cream from La Prairie ($225, 800-821-5718) polishes skin using crushed diamonds, freshwater pearls and quartz crystal.

MENA SUVARI

SKIN-ENHANCING MAKEUP

The right products can transform healthy skin into head-turning skin. Camouflage imperfections and create a radiant, seamless complexion with the help of foundation, concealer, powder and a swoosh of blush or bronzer.

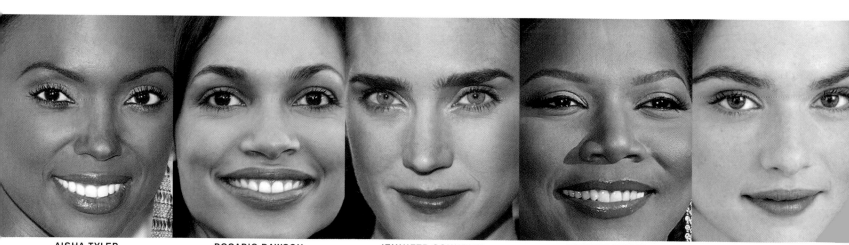

AISHA TYLER ROSARIO DAWSON JENNIFER CONNELLY QUEEN LATIFAH RACHEL WEISZ

FOUNDATION

Ever since Hollywood makeup guru Max Factor invented pancake makeup in the 1930s, foundation has gotten a bad rap for being thick, heavy and cakey. But today, those masklike formulations are as obsolete as a 25-cent movie ticket. Thanks to a variety of technological advances, modern foundation does far more than coat the skin. It blends in effortlessly and feels weightless and comfortable. It renders discolorations virtually invisible and allows skin to breathe while offering some protection from sunlight, pollution and other environmental hazards. It can also deliver antiaging ingredients and moisturizers. Whether you choose a dewy finish, a classic matte finish or something in between, it gives your skin a natural, smooth surface.

Best of all, foundation is totally optional. The days of women "putting on their faces" every morning (just thinking about it is daunting) are over. If you simply want to hide a smattering of freckles or a dark sunspot, skip the full application and smooth foundation only where you need it. Strategically placed concealer has the advantage of covering only undereye circles or the occasional pimple. And if all you require is a light, sheer wash to even out blotchiness and give your complexion a boost, tinted moisturizer should do the trick. If you're lucky and your skin looks great bare, forgo foundation entirely.

Whichever makeup you decide to use, be sure to choose the ideal shade and formulation for your skin. Then have some fun with it: Perhaps tinted moisturizer, the lightest, sheerest option, is just right for work, while foundation loaded with light-deflecting particles provides a sexy shimmer for an evening out. A cream-to-powder base, which leaves skin looking matte and even, is perfect for a formal business meeting or a glamorous black-tie event—any occasion for which a timeless look (that lasts under pressure) is required.

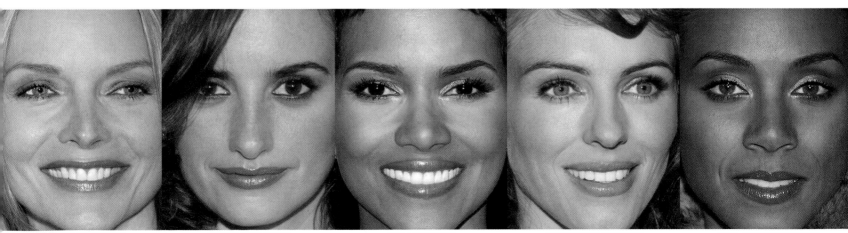

MICHELLE PFEIFFER PENELOPE CRUZ HALLE BERRY ELIZABETH HURLEY JADA PINKETT-SMITH

FINDING THE RIGHT SHADE

The perfect shade of foundation should vanish into your skin without a trace, so when shopping in a department store, don't ever buy base without trying it on. Here's how:

PICK A FEW COLORS: Show up with a clean, bare face and select a couple of shades that seem close to your natural skin tone. Many makeup artists believe that yellow-based foundations look warmest and most natural on all skin tones, but if you're extremely fair, try something a bit pinker and cooler.

PUT THEM ON: Apply small amounts along your jawline (not your hand or inner wrist, contrary to popular belief), so you can make sure

the base matches your face and your neck, hence avoiding the dreaded mask effect.

TAKE A GOOD LOOK: Stand near a doorway or step outside of the store (ask to borrow a hand mirror) and examine your skin in natural light. The right shade is the one you can't see because it blends in so perfectly. Remember also that your skin color changes from summer to winter, so switch foundation shades accordingly.

MAKEUP ARTISTS agree that foundation is worth spending some money on because it's so crucial that the tone and product be customized to your skin. However, there are plenty of high-quality, inexpensive foundations out there, too. So if you're shopping in a drugstore, test a shade by standing near a door or window and hold-

ing the bottle up to your neck while looking in a mirror. If you fear you can't make an accurate assessment, buy two different shades from a drugstore with a liberal return policy (like Rite Aid), hang on to your receipt and try them at home.

FIND A BASE DESIGNED SPECIFICALLY FOR YOUR SKIN TYPE

Once you've pinpointed the perfect shade, the next step is to nail down the proper formulation, which will cater to your skin type and provide the specific kind of coverage you need. Usually, choosing a formulation is a simple matter of reading the label. For instance, "oil-control" foundation contains oil-absorbing powders to prevent skin from becoming shiny or greasy, and "moisture-rich" foundation contains hydrating ingredients to keep dry skin feeling soft and supple. If a bottle boasts fancy-sounding antioxidants or sunscreen, think of them as bonus ingredients. Just to be safe, you should always wear sunscreen under your base.

OILY SKIN

Look for words like "oil-control" or "oil-free" on liquids, powders or sticks. For minimal coverage, smooth it on only where your skin tone is uneven and set it with powder. (For more information on applying powder, see pp. 42–43.) Oil-free liquids tend to produce the most natural effect. If your skin is extremely shiny, you may need one containing oil-absorbing powders to give your skin a matte finish. Some oil-free bases even contain salicylic acid to combat acne; others are silicone-based to help them slide effortlessly and evenly onto your skin.

COMBINATION SKIN

If your skin is mostly dry, try a moisturizing foundation. If it's mostly oily, go with oil-free. Cream-to-powder bases work particularly well on combination complexions with very oily areas because they cut shine and provide ample coverage. In a feat of cosmetic chemistry, newer "balancing" formulations designed specifically for combination skin actually integrate powders that absorb sebum and emollients that moisturize dry patches.

DRY SKIN

Look for a base with moisturizing properties; your best bets are bottles with the words "hydrating" or "moisture-rich" on their labels. Liquid foundations hide flaky skin best, as long as they're oil-and-water formulations designed to hydrate parched skin. (Purely water-based foundation can actually accentuate dry scales.) Hydrating foundations promising a "satin" finish give skin a subtle glow. For a matte appearance, look for bases containing skin-softening ingredients like vitamin E.

PRIMERS

It's easy to dismiss foundation primers as the cosmetic equivalent of the emperor's new clothes, but they do serve some purposes. These lightweight, transparent gels and lotions, which contain silicone, dimethicone and glycerin, glide onto skin and help manage a range of needs, such as: hydrating skin so lines are less obvious and making pores appear tighter, creating a smooth, uniform surface on which to apply makeup; anchoring foundation and preventing it from soaking into dry skin and disappearing too quickly; increasing the amount of time you have to blend in foundation before it dries, so you achieve a truly flawless finish; providing a barrier between the skin's oils and your makeup, so foundation lasts longer.

Few people require such high-performance makeup (nor do they want to deal with an extra application step) every day. But for special occasions, primer can make skin look extra polished.

FINDING THE PERFECT FORMULA

Foundation comes in so many different forms that anyone can find a base that caters specifically to her lifestyle and skill level. Here's the lowdown on every category.

	TINTED MOISTURIZERS	LIQUID FOUNDATIONS	STICK FOUNDATIONS
COVERAGE	Minimal. These sheer, lightweight lotions help even out skin tone and provide a moist, natural finish, but they won't cover dark spots, blemishes or red blotches.	Sheer to medium. A liquid can veil uneven pigment, but still leave freckles exposed. For more substantial coverage, smooth on an additional layer where you need it.	Medium to heavy. This user-friendly design quickly conceals blotchy areas while maintaining a dewy finish.
WHO SHOULD USE THEM	Women with clear complexions and normal-to-dry skin, or women who don't feel comfortable wearing, or carefully applying, a lot of makeup. Because they're lightweight and sheer, they're also great during the hot, humid summer months, when a thicker foundation can feel stifling.	Women with normal or combination skin, or anyone who likes the rich, lotion-like consistency. If you have oily skin, use an oil-free formula. If your skin is very dry, avoid water-based formulas, which can accentuate flaking. Applied in several layers, liquid hides blemishes well because it's less likely to accumulate around them the way a thick cream or powder might.	Women with little time for brushes and sponges. Stick foundations provide on-the-spot coverage in a flash.
TOOLS	Your clean fingertips.	Apply the foundation with clean fingertips and use a makeup sponge or synthetic foundation brush for extra blending.	Apply it straight from the stick and blend it into skin with your fingers or a dry sponge.
HOW TO PUT IT ON	Start in the center of your face and blend outward to the edges, as you would with a regular lotion. Blot any shiny spots with powder.	Shake the bottle and pour a small amount into one palm. Use your fingertips to dot the foundation onto your forehead, nose, cheeks and chin. Blend the base outward, gently pressing it into the skin around the eyes and using light strokes everywhere else. Go over it with a dry sponge.	The key is avoiding a streaky finish. Once you've applied the foundation straight from the stick, soften and blend in the edges using a sponge or your fingertips (the warmth of your fingers will encourage the base to soak into your face).
RECOMMENDED	*Laura Mercier Tinted Moisturizer SPF 20*	*For Light Skin: Giorgio Armani Luminous Silk Foundation* *For Dark Skin: Iman Second to None Oil Free Makeup SPF 8*	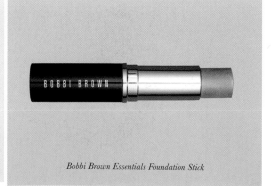 *Bobbi Brown Essentials Foundation Stick*

CREAM FOUNDATIONS	CREAM-TO-POWDER FOUNDATIONS	POWDER COMPACT FOUNDATIONS
Medium to heavy. Creams, which typically come in jars or compacts, offer the best of both worlds: rich moisturizers and total coverage. For a dewy, sultry look, you can dilute it with a few drops of regular moisturizer.	Medium. These bases deliver a matte, even finish and feel lighter than a cream.	Medium. Unlike their predecessors, which left you looking more floury than fetching, today's formulations, which come in a compact, give skin a soft, fresh appearance.
Women with dry, flaky skin.	People with normal to oily skin who want to inhibit shine while wearing a weightless base. Beware: This formula can accentuate dry skin and blemishes.	Women who want to "mattify" oily skin and minimize the appearance of large pores.
Your fingertips.	A sponge.	A big, fluffy brush or a sponge.
Blending it in by hand produces the smoothest, most realistic finish because you can control the quantity (always start with less and add on) and press it into your skin.	Press a highly absorbent, disposable, latex-free makeup sponge (either wet or dry) into the compact and smooth the makeup evenly onto your face, working from the center outward.	Use a brush to lightly dust on a sheer veil of foundation. A sponge can press the makeup more precisely into skin, resulting in a flawless face.

Cover Girl Aquasmooth

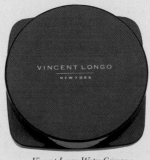

Vincent Longo Water Canvas

MAC Studio fix Powder

Considering the tiny amount of space it takes up, concealer packs a powerful punch. It instantly camouflages blemishes and sunspots and eliminates redness and undereye circles so you look well rest-ed and wide awake—even when you feel the opposite. But that's not all. Whether it's worn on bare skin or carefully applied on top of foundation, expertly applied concealer makes your skin look so refreshed and perfect that you may not need a lot of other makeup.

If concealer has always seemed too technical for you, take heart; you're not alone. finding the right shade and texture for your skin is really the main challenge. After that, it gets easier. Just keep in mind that a little bit goes a long way. A mere smidge of concealer is plenty. If you pile it on, it will only draw attention to the very problems you're trying to hide. The key to effective concealer: Match the texture and amount to the task at hand.

FACE Stockholm Corrective Concealer Kit

FINDING THE RIGHT SHADE

The proper shade of concealer varies depending on the area of your face you want to hide. But generally, yellow-based tones look most realistic on all kinds of complexions, and orange-based tones blend well into dark or black skin. (Avoid concealers with any hint of white in them: They'll act like spotlights on your blemishes and turn a dirty shade of pale gray as the day progresses.) To cover undereye circles, makeup artists recommend using a tone that is slightly (almost imperceptibly) lighter than your skin to offset the dark pigment. For blemishes and discolorations, look for a hue that matches your skin exactly. The closer the match, the less you'll have to use and the more natural and un-made-up you'll look. In the store, try on concealer specifically where you plan to wear it and study it in natural daylight. The perfect shade will be unobtrusive.

FOUR COMMON CONCEALER FIXES

Concealers come in three main forms: light creams in tubes, slightly drier sticks and opaque, potted versions. Each of these textures tackle specific problems.

	THE RIGHT FORMULA	THE APPLICATION	RECOMMENDED
UNDEREYE CIRCLES	Something dense enough to handle dark circles, but delicate enough for the thin skin around the eyes. The best choice is a light, creamy formulation designed specifically for the eye area; anything too thick or dry will look chalky. If your dark circles are mild, deflect them with a concealer containing light-diffusing pigments. For deep, dark circles, go for denser coverage. A cover-up with yellow undertones should effectively camouflage blue veins under the skin.	Prepare the skin under your eyes with a light, nongreasy eye gel. If the gel is too creamy, the concealer will slide out of place. When it's totally absorbed, use a small, firm-bristled nylon concealer brush with a tapered end to apply concealer as sparingly as possible directly onto the dark areas. If you don't feel comfortable using a brush, gently dab it on with the pad of your ring finger, which won't apply too much pressure. Blend it in using a patting, not rubbing, motion. Let it soak in for a minute or two. If you can still see darkness through it, apply another layer. *Yves Saint Laurent Touche Éclat* ▶	
BLEMISHES	Greasy concealers will clog pores and make existing acne even worse, so if you have oily skin, look for an oil-free one that contains salicylic acid, benzoyl peroxide or sulfur. A green neutralizer (see p. 51) can cut the red ness of an inflamed pimple. Use it as a primer for concealer.	Dot on concealer with a fine-tipped, nylon concealer brush. Your mission is to neutralize the redness of the pimple, not to cover it with a thick coat that will only attract light and draw even more attention. Wash your brush weekly to remove any bacteria that could re-infect skin and lead to new blemishes. Set with a light dusting of loose powder. *Proactiv Solution Concealer Plus* ▶	
DISCOLORATION	A densely pigmented concealer to thoroughly cover dark spots (liquids are too sheer). Stick formulations and concealer pencils that feel soft and malleable are ideal for small targets. They have a relatively dry consistency, so they adhere quickly and are easy to control. A cream concealer offers comparable coverage but is easier to spread onto larger areas.	If the hyperpigmented area is small, dot on concealer, blend it in lightly with a finger-tip and set it with translucent powder. If you have large dark areas on your face, camouflage them with a foundation that gives medium to full coverage, and use concealer only on the parts that show through. *Prescriptives Traceless Skin Responsive Corrector* ▶	
REDNESS	Yellow-tinted neutralizing makeup counter-balances redness in sensitive skin. Spot-treat redness that peeks through the neutralizer with an opaque, highly pigmented concealer with yellow undertones. If you have rosacea, a skin condition that causes eruptions of redness on the nose and cheeks, a blue-tinted cream can neutralize the color of inflamed skin.	Smooth a tinted neutralizer, either yellow or blue, onto clean skin with your fingers; follow with your regular foundation. Use a nylon concealer brush to apply yellow-based concealer onto red patches and blend it into skin with your fingers. Set it with translucent powder. *Lorac Oil Free Neutralizer* ▶	

Many women think powder is hopelessly old-fashioned. But it's excellent for holding foundation and concealer in place, creating a smooth canvas for blush and eye shadow, and giving skin a lustrous finish. And don't forget its classic role as an instant cosmetic touch-up: a quick dab on your nose is the fastest, most foolproof way to douse shine and tone down uneven color. The downside of powder is that the wrong color or consistency can also make you look . . . strange. Here's how to avoid such a fate.

BRONZING POWDER

WHAT IT DOES
Bronzing powder gives skin a healthy, tanned appearance—and you don't have to spend a second in the sun. Look for warm golden or brown tones a few shades darker than your skin. The sheerer the texture, the more natural it will look. Bronzing powder also helps neutralize red or ruddy complexions.

WHAT IT FEELS LIKE
Soft and fine, like any loose powder; or, if it comes in a compact, like pressed powder or blush.

HOW TO APPLY IT
With a big, fluffy brush. Use it over foundation or on bare skin. Rather than dusting a uniform layer onto the face, place it where sunlight would naturally hit: the center of your forehead, the bridge of your nose, the tops of your cheekbones, and your chin.

PRESSED POWDER

WHAT IT DOES
Because it comes in a compact, pressed powder is portable and perfect for touch-ups. It can be applied on bare skin, as a sheer base or on top of foundation to set it. Pressed powder provides a heavier, more matte finish than loose.

WHAT IT FEELS LIKE
It has a more opaque finish than loose powder, so it feels slightly denser and, as a result, stays on longer. If you have oily or acne-prone skin, look for an oil-free formula and press it into your T-zone throughout the day.

HOW TO APPLY IT
Smooth it on in fast, upward strokes with the velour powder puff or sponge that comes in the compact. Pressed powder lasts a long time, but sponges and powder puffs are bacteria magnets. Wash (with an antibacterial liquid soap) or replace them once a month.

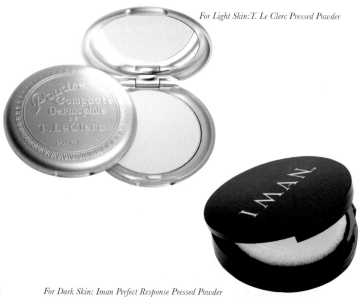

For Light Skin: T. Le Clerc Pressed Powder

For Dark Skin: Iman Perfect Response Pressed Powder

Guerlain Terracotta Bronzing Powder

LOOSE POWDER

WHAT IT DOES

Loose powder, which is either pigmented or "translucent," sets makeup, blots shine and leaves skin looking lightly buffed. If you choose to wear pigmented loose powder, look for one with pale yellow or golden undertones that matches your skin as closely as possible (if you're vacillating between two shades, choose the darker one). The yellow hue gives a warm glow and runs a lower risk of turning thick and chalky as the day goes on. If you want minimal coverage and opt for what's called translucent powder, make sure it's as sheer as possible. Those powders contain some light pigment and they, too, can look chalky.

WHAT IT FEELS LIKE

The ideal texture is extremely fine, fluffy and weightless—which is precisely the reason why loose powder is very messy and should probably be left at home and not carried around in a handbag.

HOW TO APPLY IT

Lightly dip a big, fluffy brush into the powder and get rid of any excess by blowing on it or tapping the brush handle on your forearm or the edge of the bathroom sink. Sweep it onto your face in soft, upward motions. Loose powder also works as a subtle highlighter if you dust it only below your eyes, down the bridge of your nose, and on the center of your chin. (Extra loose powder placed just under your eyes is also perfect for catching falling eye shadow particles, which you can brush off when you finish applying it.)

Shu Uemura Colored Brush 18R

IRIDESCENT POWDER

WHAT IT DOES

This powder contains light-reflecting ingredients such as pearl and mica to give skin a sexy shimmer.

WHAT IT FEELS LIKE

Loose powder.

HOW TO APPLY IT

Use a large brush to sweep it across your forehead, cheekbones and jawline. Use it over foundation or on bare skin. For extra sparkle, continue down to the shoulders and collarbones.

Shu Uemura Loose Powder

Revlon Skinlights Face Illuminator

HIGHLIGHTING MAKEUP

A perfectly matte face is a beauty standard and a classic, but sometimes you want to live in the moment. A healthy-looking glow—the kind you get from running three miles or racing down a ski slope—is an utterly modern evening look, especially on warm nights when you're showing off a tan and baring your neck and shoulders. Lucky for you, there's a huge selection of clever highlighting cosmetics that makes it easier than ever to illuminate your complexion without raising your heart rate. And unlike the brash, glittery makeup of old, this new generation of highlighters boasts refined opalescent particles that subtly play with the light that hits your face, imparting radiance exactly where you want it and diffusing any imperfections. But the best part about modern shimmer cosmetics? They're a breeze to apply because the iridescent ingredients are so tiny they rarely come on too strong. In addition, they free you from wearing a lot of other make-up so you feel as fresh and natural as you look.

JENNIFER GARNER

THREE DEGREES OF IRIDESCENT MAKEUP

	LUMINESCENCE	SHIMMER	SPARKLE
THE EFFECT	These lightweight lotions or sheer foundations produce an almost invisible sheen that gives skin instant radiance and dewiness.	Brighter than a luminescent lotion, shimmer, which usually comes in a creamy stick or pot, gives skin a conspicuous opalescent sheen.	Glamorous, high-wattage glimmer, best saved for after dark.
HOW IT WORKS	Micro-light particles and mica refract light (break it up and bounce it around, like a crystal), thus diffusing and minimizing the appearance of wrinkles and discolorations.	Pearl or mica particles catch light as you move.	Glitter products contain mica particles that are larger than those in shimmer makeup, so they reflect light more brightly.
BEST FOR	Dry or normal skin, which looks most natural when lotion is applied all over the face. If you have oily skin, avoid the T-zone and focus on the cheeks and temples.	Highlighting and defining cheekbones and browbones, enlarging eyes, making lips look fuller.	Eyelids, cheekbones, clavicles, shoulders—but not all at once.
APPLICATION TIPS	If you have clear skin, you can use luminescent lotion or sheer luminescent foundation in place of foundation. Otherwise, layer it under or over foundation for added coverage (the lotion works even when worn under foundation) or mix it with foundation before applying it to your skin. For an even softer effect, mix a few drops of lotion with your regular moisturizer and apply to bare skin.	Rub a small amount underneath your browbones and along the upper edge of your cheekbones, connecting the two lines at your temples. Dot a bit of shimmer in the bow of the upper lip and the center of the lower lip to create the illusion of fullness. To brighten eyes and make them look bigger, use a small makeup brush or cotton swab to rub a dot of shimmer to the inner corners. Avoid highly visible wrinkles anywhere on the face; shimmer can seep into cracks and accentuate them after a few hours.	Cream eye shadows containing glitter are easier to use than loose glitter products because they stay put. To apply loose glitter or powder, use a brush or sponge for smoother blending, and stick with one color so you don't end up looking like a Vegas showgirl. For a sparkly, sun-kissed finish, mix glitter dust with bronzing powder in the palm of one hand and brush it lightly across cheekbones, shoulders and décolletage.
RECOMMENDED	*Giorgio Armani fluid Sheer*	*Nars The Multiple*	*Kevyn Aucoin The White Liquid Shimmer Spot Highlighter*

BLUSH

Biologically speaking, flushed cheeks signify youth, health and sexual excitement. Today, blush doesn't send such a blatant message, but it is arguably the most effective cosmetic there is. Nothing brings a dull, drowsy face to life faster than a swipe of pretty color on the cheeks. If you only have time to apply one kind of makeup before dashing into a meeting or out to dinner, choose blush. (That said, if you have naturally rosy cheeks, you might reach for concealer or lipstick instead.) You'll look vibrant and awake without appearing to be trying too hard.

Figuring out the most flattering blush color for you is simple—use nature as your guide. What do your cheeks look like after a snowball fight? An afternoon on the beach? Those are the tones to replicate—in a lighter, more toned-down version. Try rose or apricot shades, which look the warmest and most realistic. The darker your skin, the deeper (and more pigmented) the blush can be.

CHOOSING CHEEK COLOR

Although choosing cheek color is, of course, subjective, don't forget to consider your basic skin tone. Subtle is almost always more flattering, but who's to say you won't look (and feel) smashing in fuchsia sometimes? There are quick guidelines, however, that can save you some time and trouble.

DETERMINE WHETHER YOUR SKIN TONE IS WARM OR COOL	TRY ON MAKEUP SHADES IN THE SAME CATEGORY	TAKE A GOOD LOOK
Here are three surefire tests: Check the veins on your inner wrists. If they appear greenish, you have warm skin. If they look blue, you have cool skin. Consider how your skin reacts to sun. Warm skin tends to tan; cool skin tends to burn. Slip on a silver bracelet, then a gold one. Silver looks better on cool skin; gold complements warm skin.	If you have warm undertones, you probably look best in yellow-based blush colors such as peach and terracotta; if you have cool undertones, blue-based pinks and berries will work.	Rules or no rules, remember that choosing makeup colors is very subjective, and the smartest approach is trial and error. It's pretty basic: An unflattering tone will make you look tired and sickly, and a flattering one will make your face come alive. Next, all you have to do is select the formulation best suited to your needs and learn how to apply it like a pro.

PICK A BLUSH TEXTURE

	POWDER	CREAM	LIQUID AND GEL
WHO'S IT FOR	All skin types, but best for oily skin and anyone who wants long-lasting color.	Anyone can wear cream blush, but it's particularly suited to dry or older skin because of its rich, moisturizing properties. It doesn't blend as easily onto oily skin.	Normal to oily smooth skin. Fast-drying gels and liquids are hard to spread onto dry skin. They're waterproof and long-wearing, which makes them ideal for women who go all day without touch-ups; but, by the same token, gels and liquids are dense and can go on too strong. Go easy at first, and add on if you need to.
WHAT IT LOOKS LIKE	A soft bloom of color with a matte finish.	Fresh and luminous, like a natural flush emanating from within your skin.	A sheer wash of healthy color.
HOW TO APPLY	Use a big, fluffy, natural-bristle brush; the small brushes that come with most powder blushes are too stiff and small and will leave narrow, hard-to-blend stripes on your cheeks. Smile exaggeratedly into the mirror to reveal the apples of your cheeks. Dip the brush into the blush powder, tap off any excess to avoid an avalanche of color where the brush first touches the skin, and swoosh it on in circular motions moving from the cheeks toward the temples.	Dab several small dots onto the apple of each cheek and use your fingers to blend them in using circular motions. The warmth of your fingers will help the makeup melt into the skin.	Use fingers to rub the blush into the apples of the cheeks. Work fast, because gels and liquids dry quickly on your skin (and stain skin, much like watercolor paint), so once it's set, it won't budge until you wash your face.
EXTRA ADVICE	If you have oily skin, apply loose powder before blush. It will soak up any oil and prevent blotchiness.	For an extra burst of color (or added intensity for evening), dust a layer of powder blush on top of cream blush.	These blushes blend smoothly onto bare skin. Don't apply them on top of powder; they'll get streaky. To facilitate smooth application, apply moisturizer or primer right before. Wash your hands immediately after blending into cheeks to prevent stains on your fingers.
RECOMMENDED	*For fair skin: Nars Orgasm* *For dark skin: Nars Sin*	*For fair skin: Stila Convertible Color in Poppy* *For dark skin: MAC Sheertone Blush in XX*	*Liquid: Benefit Benetint Rose-Tinted Lip and Cheek Stain* *Gel: Tarte Cheek Stain*

BLUSHING BEAUTIES

Rosy cheeks never fail to make a woman look fresh, feminine and pretty. As demonstrated by these diverse celebrities, blush is one of the most versatile cosmetics: Whether you're pale- or dark-skinned—or dressed up or down—a healthy flush brings your face to life.

JENNIFER ANISTON

Ideally, blush complements both your complexion and your hair color. At the January 2004 première of *Along Came Polly,* Aniston plays up her tawny skin and gold-streaked hair with a peachy bronze shade.

LUCY LIU

When applied on outer edges of the cheeks and straight back toward the ears, blush can widen a narrow face. Liu demonstrates this beautifully at the 2004 Vanity Fair Oscar Party at Morton's in Beverly Hills.

KATE HUDSON

At the première of her movie *Le Divorce* at the 2003 Venice Film Festival, Hudson radiates romantic charm with upswept hair, sparkling drop earrings and just a hint of soft, pale pink blush.

THANDIE NEWTON

A warm, mocha complexion calls for richly pigmented blush. Newton, shown here at the British Academy of Film and Television Awards in London in February 2003, pumps up her cheekbones with a dusting of glowing copper.

APPLICATION TIPS FOR DIFFERENT FACE SHAPES

Blush can achieve far more than giving your cheeks a burst of color. Using three different shades (a bright one for color, a slightly darker, neutral, flesh-colored hue for shaping, and an iridescent powder for highlighting), you can showcase your great bone structure in a few quick strokes, whether you were born with it or not. It's called contouring, and for those of you who just shuddered at the thought, don't fret; with these subtle methods, it actually looks natural.

It's also simple to do. first, figure out what shape your face is—round, square, heart, long or oval (see the famous faces below)—because that will determine the technique you use. (If you're stumped, here's a trick: Look in a mirror and trace the outline of your face with lipstick or eyeliner pencil.) Next, locate the underside of your cheekbones by touch. Now follow the steps below, and don't forget to keep the shades soft.

CHARLIZE THERON

OVAL

Lucky you! No need to contour. For a natural, daytime look, brush blush onto the apples for a pretty, flushed look. At night, add more blush to the tip of the nose and across the bridge of the nose for an extra glow.

REESE WHITHERSPOON

HEART

To soften and broaden your pointed chin, apply the brush to the lower part of the apple. Instead of contouring, blend a highlighter around the chin and along the jawbones to balance out your face.

CHRISTINA RICCI

ROUND

To thin the face, apply the brighter blush to the apples of your cheeks, making sure not to go closer to the nose than under your irises (or you'll look like Raggedy Ann). Dust the contour shade below the cheekbone down to the jawline and blend well.

SARAH JESSICA PARKER

LONG

To widen a long, narrow face, brush the brighter blush onto the apples of the cheeks and extend the color straight out toward the ears (not up toward the temples) to create the illusion of width. Dust the contour shade in a wide band across the middle of the forehead (about a quarter of the way down from your hairline) and along your chin to further create the appearance of width. (Skip the highlighter.)

JULIANNE MOORE

SQUARE

To soften the angles of a square face, concentrate the brighter color on the apples of your cheeks, then brush it up and out toward the temples to give your face a lift. To round the corners of your jaws, dust the contour shade from your chin to the middle of your ears along the undersides of the cheekbones.

Q&A

How can I customize my foundation shade?

Two major lines have offered this service for quite some time. Prescriptives Custom Blend foundations are available in sheer to full coverage and accommodate specific skin types with extras such as oil-controlling beads and moisturizing extracts. To find a Prescriptives counter that custom mixes foundations, go to prescriptives.com. Another company providing this service is Only Yourx Skin Care (800-877-4849), whose PhotoCover Custom-blend foundations can be supplemented (by the company) with sun protection, moisturizing ingredients and pearlized highlighting pigment. The company also makes an oil-free formulation, and all of its foundations are noncomedogenic.

What should I do if I've put on too much foundation?

Sweep both palms in smooth motions over your face to soak up excess makeup. Don't rub or pull at your skin; you'll wipe off sections of base and be forced to start over from scratch. If that doesn't do the trick, press (but don't rub) a single piece of tissue over your face. Soften abrupt lines of demarcation between your face and neck with a damp makeup sponge.

How can I tone down too much blush?

If you've overdone it with cream blush, blot the color off with a tissue. If powder blush is the cause of the problem, diffuse it with translucent powder. Dust it on with a brush or powder puff and smooth it across your cheeks until the color is subdued. Since gel and liquid blush "stain" the cheeks, the only way to lighten them is to wash your face, moisturize, and reapply your makeup more sparingly.

Can I use foundation as concealer?

If you don't have a lot to cover and you really want the convenience of using just one product, a dense, full-bodied foundation might do the job. But most foundations are thinner in texture and tend to move around a bit, so they don't give the precise coverage you'd get from a thicker, more deeply pigmented concealer. In a pinch, you can use the dried-up, gooier foundation accumulated in the opening of the bottle to cover up imperfections. But if you have relatively clear skin, you're better off skipping the foundation all together and just tackling trouble spots with the right concealer.

What kind of concealer works best on the body? I want to cover some scars and veins on my legs.

Use the same kind of concealer you'd use on facial discolorations—a densely pigmented product that looks opaque on skin, or, for larger areas, try a product made for the body (Dermablend Leg and Body Cover Creme is an excellent one; for more information, go to dermablend.com). A waterproof formulation won't smudge or rub off on your clothes.

What do pastel-colored concealers do?

Green, yellow and lavender concealers aren't supposed to look green, yellow and lavender on your skin—at least in theory. Rather, they should temper extreme skin tones by neutralizing the hues opposite them on the color wheel. Green formulas counteract mild redness, so try them on blotchy areas and visible blood vessels. Blue-tinted creams cover large rosacea-affected areas more effectively. Yellow foundation is meant to hide undereye circles. Lavender primers can make sallow skin look rosier. A disclaimer: Tinted primers and concealers are time-consuming, and sometimes they look strange. A concealer that matches your skin tone is often a better choice.

KATE BOSWORTH

EYES

"The eye is the jewel of the body," said Henry David Thoreau. And it's an apt image. More than any other feature, your eyes are capable of expressing a multitude of emotions. Eye makeup— whether natural, shimmery, deep or dramatic—only enhances that ability. Once you know how to apply it, you can make almost any statement you want, however subtle or strong.

If your eyes are your most eloquent feature, then your eyebrows are the most animated. By rising or dipping slightly, they completely alter the expression of your face, from stern to surprised to perfectly serene. So integral are the eyebrows to conveying emotions that hundreds of psychological studies have been devoted to them. On a purely aesthetic level, picture the faces of Brooke Shields, Jean Harlow, Frida Kahlo and even Star Trek's Mr. Spock. All of them owe at least some of their fame to their famous brows.

In addition to telegraphing feelings, eyebrows frame the face and create clear boundaries for eye makeup, which is why keeping them well groomed is so important. The cleaner and more artfully shaped they are, the more open, uplifted and symmetrical your face looks. In fact, many makeup artists assert that if your brows are in great shape, you need almost no other makeup to look polished and pulled together. (Some enthusiastic pros even venture to say that a good brow-grooming is almost as effective as a facelift!)

If you prefer to leave your brows in the hands of a professional, you'll need to decide which method of hair removal (described on p. 56) you'd like to try, and be sure to ask around for an aesthetician with a good eye before you make your final choice. If you choose the D.I.Y. approach, the step-by-step lesson on page 57 will provide all the arch support you need.

SALMA HAYEK

PROFESSIONAL BROW-SHAPING METHODS

Whether you want your brows to be thin and delicate or full and more natural-looking (in recent years, the trend has been toward the latter), one of these shaping techniques—all alternatives to tweezing—will work for you. Keep in mind: The thinner the brow, the more maintenance it requires.

	WAXING	THREADING	ELECTROLYSIS
HOW IT'S DONE	Hot or cold wax is spread over stray hairs above and below the brow line and pulled off in one quick, ripping motion (in the opposite direction of hair growth). High-end salons and spas typically use a blue or green wax that contains an anti-inflammatory ingredient such as azulene, which makes the wax gentler than traditional golden honey wax.	Widely practiced in various parts of Asia, this ancient form of hair removal requires one tool: a strand of 100 percent cotton thread, which is twisted and pulled along a row of unwanted hair (as opposed to a single hair), removing multiple hairs from the roots at once. Like tweezing, threading lifts hair directly from the follicle. It requires three to five swipes per brow.	An aesthetician inserts a needle with an electric current running through it into one follicle at a time to zap it and prevent further growth. Because hair grows in stages, and because a follicle can only be destroyed during the active growth, or anagen, stage, multiple sessions are required for permanent removal.
PAIN FACTOR	Imagine ripping a Band-Aid off of a hairy part of your skin. The top (dead) layer of skin is removed along with the hair, so skin may be left red and irritated for up to an hour afterward. To alleviate redness or swelling, press a clean washcloth dipped in ice water or a cotton ball soaked in witch hazel onto your skin. If you're heading out or back to the office, bring concealer with you to cover up the redness.	Similar to tweezing, but with more of a vibrating sensation.	High. It feels like prolonged pinpricks. To alleviate pain, talk to your doctor about using the prescription cream Emla two hours before the treatment. Taking two or three aspirin two hours before a treatment also helps.
HOW LONG IT LASTS	Two to eight weeks (about as long as a tweezing).	Two to eight weeks (the same as tweezing and waxing).	Forever.
PRICE	$10 to $50	$35 to $60	A 15-minute session costs $15 to $100. Most women require eight to 12 sessions, spaced one or two weeks apart.
THE BOTTOM LINE	Waxing is faster than tweezing, but less precise and more painful. Many aestheticians wax the larger areas above and below the brows and then fine-tune the shape with tweezers. Waxing is ideal for women who have bushy, unruly brows or who have never been to a professional because it quickly de-fuzzes the area between your brows and near your temples, so you start with a clean slate.	The procedure is speedy, more precise than waxing, and relatively painless. As threading gains popularity, more and more salons in the U.S. are offering the service.	Electrolysis is a major investment of time and money—and it's painful. But if you have thick, dark brows that require constant upkeep, it may be worth it.

TWEEZING YOUR OWN BROWS

Plucking is a precise art that requires a bit of geometry, a sense of proportion, and the right tools (to say nothing of patience), which is why so many women are afraid to tweeze. Believe it or not, practice does make perfect. Here's how to go from fuzzy to sleek in six user-friendly steps.

STEP ONE

Trim random, extra-long hairs. Use a round brow brush to brush brow hairs straight up. With brow scissors (regular scissors aren't sharp or small enough) trim any hairs that extend above the natural brow shape. Brush brows straight down and trim hairs that extend below it.

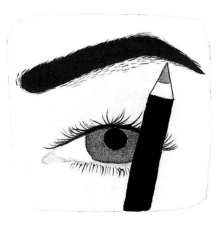

STEP TWO

Determine the inner edge of the brow. Place a brow pencil vertically along the right side of your nose, flush against your face. Where it hits your brow is where the inside starting point of your brow should be. Mark this spot with the pencil and repeat on your left side.

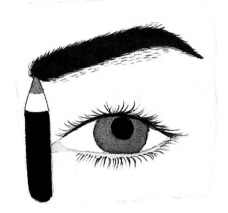

STEP THREE

Locate the outer edge of your brow. Hold the bottom of the pencil at the center of your bottom lip, aligning the top of the pencil with the outer corner of your right eye. Where the inside edge of the pencil hits your brow is where it should end. Mark the spot with the pencil and repeat this step on your left side.

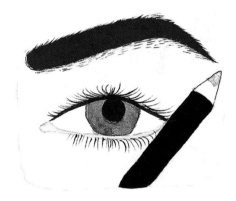

STEP FOUR

Find your arch. Hold the base of the pencil at the center of your lips and angle it until the inside edge aligns with the outer edge of your iris (the colored part of your eye). The highest point of the arch should be where the inside edge of the pencil meets your brow.

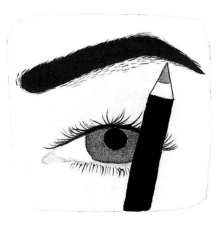

STEP FIVE

Sketch in the shape. Using a brow pencil or brow powder on a soft round brush, lightly sketch in your ideal eyebrow silhouette based on the points you determined in the previous steps. Use a white pencil or a concealer stick to mark any stray brow hairs that fall outside of the determined parameters.

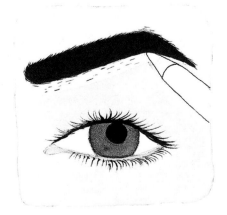

STEP SIX

Tweeze the stray hairs that you've covered with white pencil or concealer. Pull skin taut and tweeze hairs in the direction of hair growth. Don't rush: Move back and forth between brows every few hairs and step back often to look at your whole face. Tweeze newly sprung stray hairs every few days.

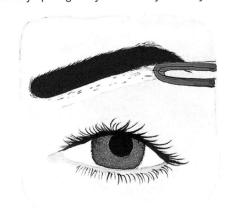

CUSTOMIZE YOUR BROWS TO FLATTER YOUR FACE

You can't go wrong with the classic brow shape: medium full with a tapered end and soft arch. But if you want truly customized arches, factor in the shape of your face. Think about proportion as well: If you have prominent features, you'll look best with fuller brows; if you have small, delicate features, try a thinner silhouette. And most important, if you've overplucked, force yourself to put away your tweezers for three or four weeks and let your brows grow out. During that period, cover any unsightly stubble with creamy, neutral eye shadow applied all the way up to your brows.

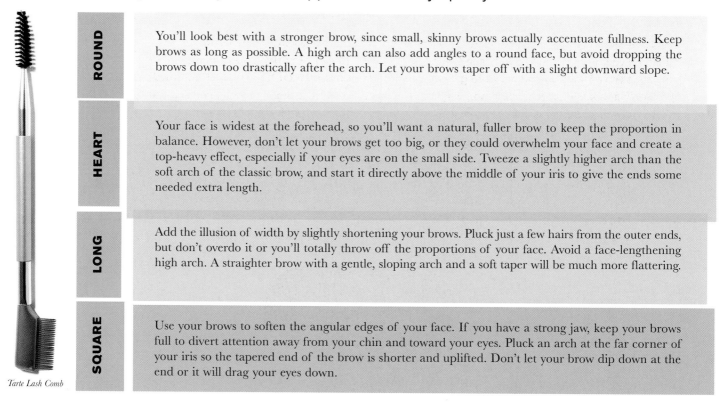

ROUND — You'll look best with a stronger brow, since small, skinny brows actually accentuate fullness. Keep brows as long as possible. A high arch can also add angles to a round face, but avoid dropping the brows down too drastically after the arch. Let your brows taper off with a slight downward slope.

HEART — Your face is widest at the forehead, so you'll want a natural, fuller brow to keep the proportion in balance. However, don't let your brows get too big, or they could overwhelm your face and create a top-heavy effect, especially if your eyes are on the small side. Tweeze a slightly higher arch than the soft arch of the classic brow, and start it directly above the middle of your iris to give the ends some needed extra length.

LONG — Add the illusion of width by slightly shortening your brows. Pluck just a few hairs from the outer ends, but don't overdo it or you'll totally throw off the proportions of your face. Avoid a face-lengthening high arch. A straighter brow with a gentle, sloping arch and a soft taper will be much more flattering.

SQUARE — Use your brows to soften the angular edges of your face. If you have a strong jaw, keep your brows full to divert attention away from your chin and toward your eyes. Pluck an arch at the far corner of your iris so the tapered end of the brow is shorter and uplifted. Don't let your brow dip down at the end or it will drag your eyes down.

Tarte Lash Comb

THE BEST TWEEZERS

Trying to shape your brows with a pair of weak or unaligned tweezers is maddening. To snatch hairs from the follicles every time (inferior tweezers can leave roots behind, leading to ugly ingrowns), eyebrow experts recommend using flat tweezers with a slanted or mitered edge, which grab hair strands more easily and reliably. For added pulling power, look for tweezers that close tightly from both sides and have plenty of tension and spring.

Tweezerman Tweezers

FILLING IN BROWS

If your brows are light and sparse, or you want some extra oomph for evening, add depth and structure by filling them in. Make sure your brows are a shade or two deeper than your hair color, but beware of going too far. For instance, blondes look best with dark blond or taupe brows, brunettes and redheads look best in light browns or cocoas. Asians can wear dark grays or browns. Pencil, powder and gel are the main brow-filler formulations. Each has its own advantages and application tips, described below.

PENCIL

Brow pencils define brows and add color. To prevent the pencil from tugging on your skin, roll the tip between two fingertips; the warmth of your skin will soften it and help it to glide smoothly onto skin. If you apply it in a light, feathery manner, very sharp strokes can simulate individual strands of hair. But since pencil can look harsh, go with a shade that is a bit softer and lighter than your brows. And don't use it to extend a short brow: Pencil looks waxy and fake on bare skin. (Use powder instead.) For long-lasting coverage, lightly brush matching shadow over the pencil, and set the look with clear brow gel.

Eliza Brow Definer

POWDER

You have two choices: powder designed specifically for filling in brows or regular powder eye shadow. Applied with a firm, flat, angled brush, it adds subtle, natural color to your brows. Tap off any excess powder into the sink and brush it onto brows in quick, short strokes. For a polished finish, set it with clear brow gel.

Paula Dorf Duet Brow Duet

GEL

Tinted brow gels, which come in tubes and are applied with mascaralike wands, tame straggly hairs and add definition with the least amount of effort. For a totally natural but groomed effect, use clear brow gel. Brush it up toward the arch and outward to the ends. In a pinch, clear mascara or a bit of hairspray on a brow brush works too.

Senna Brow Fix

DYEING EYEBROWS

Tinting your brows makes a huge difference in a matter of minutes. If your brows are very close to your eyes, bleaching them two shades lighter can enlarge your eyes and open up your whole face. If they're faint, darkening them a shade or two adds definition. Dye your brows a few shades darker than your base hair color without changing tones completely (if you have brown hair, tint your brows a dark cocoa, not black).

GREAT BROWS

As these stars demonstrate, the best brows are natural-looking and shaped to complement an individual's eyes and face shape.

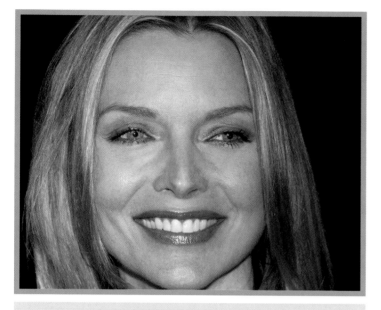

MICHELLE PFEIFFER

Pfeiffer wears her brows a few shades darker than her blond-streaked hair at the 20th Anniversary re-release of *Scarface*.

QUEEN LATIFAH

At the 2003 Screen Actors Guild Awards in Los Angeles, Queen Latifah opens up her face with delicately shaped brows.

RACHEL WEISZ

Weisz keeps her strong facial features balanced with long, full brows at the 2003 Sundance Film Festival in Park City, Utah.

MING-NA

Brows don't have to have dramatic peaks. Ming-Na's brows have gentle, low arches but still frame her face and showcase her eyes.

ANGELINA JOLIE

Sometimes thinner is better. Jolie reveals classic, tapered arches at the world première of *Beyond Borders* in October 2003.

KATE HUDSON

Blond brows can wash out any skin tone. Hudson prevents that by offsetting her sunny hair with light brown brows.

MADONNA

At the launch party for her *Music* album, Madonna demonstrates that brows can be full and still be immaculately shaped and clean-looking.

SANAA LATHAN

At the 2003 BET Awards in Los Angeles, Lathan shows off sculpted brows that arch near the ends and lift her eyes upward.

MASCARA

Even the most minimalist, makeup-shy women tend to wear mascara—and for good reason. Lush, darkened lashes not only exude femininity, but also brighten and enlarge your eyes. Once you've found the right formulation for your lashes, applying mascara is practically foolproof. What's not to love? Whether worn as an accent on a bare face or as the crowning touch on sultry evening eyes, this low-effort makeup has high, high impact.

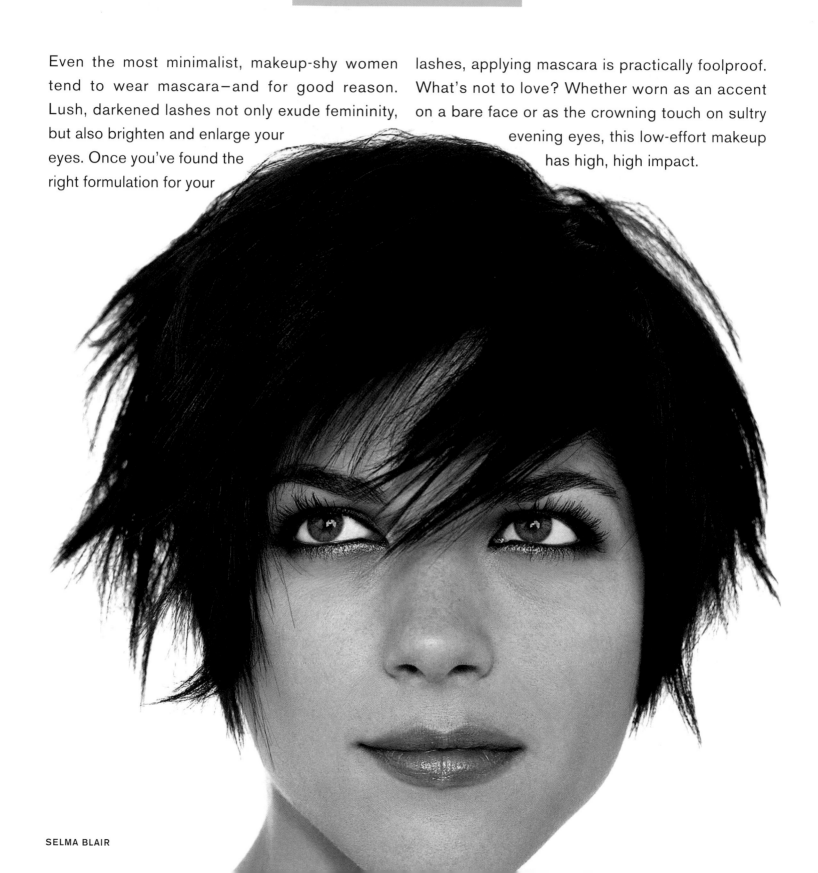

SELMA BLAIR

FIVE FORMULATIONS

These days, mascara does everything but take out the trash. Choose one specifically designed to improve upon what nature gave you.

LENGTHENING

The wands that come with lengthening mascaras have short, densely packed bristles that allow you to get more mascara onto each lash with every swipe. The design also makes it easier to touch up tips—the most important area to coat if you're trying to achieve the appearance of longer lashes. Lengthening mascara contains plastic polymers that cling to lashes and extend beyond the tips of your lashes to add precious millimeters.

Lancôme Définicils ▶

THICKENING

Mascaras that add volume have a thicker formula of waxes and silicone polymers that coat the lashes and bulk them up. They also contain darker, more intense pigment, which gives the illusion of denseness with just one or two layers.

Yves Saint Laurent Luxurious (Faux Cils) ▶

CURLING

These contain polymers that cause the mascara to contract once it's been applied, causing lashes to shrink and lift. "Fixing" polymers hold the curves in place. Curling formulas work particularly well on short lashes.

Maybelline Sky High Curves ▶

NON-SMUDGING

Waterproof and water-resistant mascaras have special formulas that repel water and minimize smudging and running. The best ones are formulated to dissolve easily with oil-based makeup remover so they don't have to be scrubbed off. Waterproof mascara is best for swimmers and at the beach; water-resistant is easier to remove and therefore more appropriate for weddings and watching movies like *Terms of Endearment*. Use both types sparingly because they tend to dry out lashes.

L'Oréal Voluminous Waterproof ▶

NON-CLUMPING

Clump-free mascara keeps lashes from looking gloppy—thanks to moisture-rich ingredients like silk extract and glycerin, which allow the product to glide on smoothly. Applicators with long bristles pull it evenly through your lashes. They contain fewer waxes and fibers than regular mascaras, so you won't get a lot of volume and length. The effect is more natural than va-va-voom.

Maybelline Lash Discovery Waterproof ▶

APPLYING MASCARA

STEP ONE

Curl your lashes. Open the curler and position it around lashes and as close to your upper lid as possible without pinching the skin. Keep your eyes open and gently squeeze the curler closed. Pump the curler once, bending your wrist upward to curl lashes, and release.

STEP TWO

Pull the wand from the tube (don't pump it, which forces air into the tube, drying out the mascara). Wipe off excess mascara from the wand. Hold the wand horizontally at the base of your lashes and wiggle it back and forth from underneath them to create thickness before drawing it up and out to the tips.

STEP THREE

Wait a minute and repeat for a uniform finish. If you have naturally thick, long lashes, one coat is probably enough coverage for daytime. If your lashes are quite light, put a touch of mascara on the bottom lashes as well, so the upper lashes will not seem artificially colored.

> **THE QUICKIE**
> Don't bother curling your lashes. Apply mascara from roots to ends, wiggling the wand back and forth as you draw it through your lashes for a thorough, even application. Repeat, but only if necessary. One layer will provide plenty of definition.

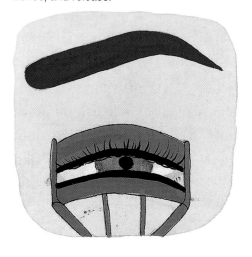

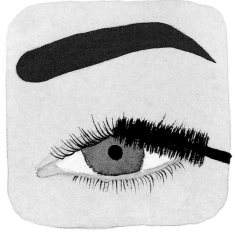

MASCARA FOR SPECIAL OCCASIONS

STEP ONE

To create a soft curve to your lashes (rather than a harsh L-shaped bend), walk the curler up the lashes, pumping one or two more times until you reach the tips. After applying one or two coats of mascara, use a metal lash comb or baby toothbrush to separate lashes and remove any clumps.

STEP TWO

If you have very short lower lashes or are prone to running eye makeup, skip this step. Otherwise, to coat bottom lashes, hold the wand horizontally and run it back and forth on top of your lower lash line.

STEP THREE

To avoid a spidery effect, use clean fingers to pinch excess mascara from tips; this adds definition without emphasizing length.

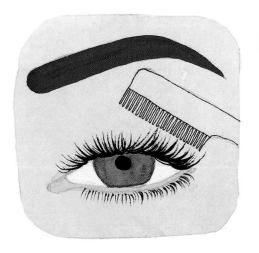

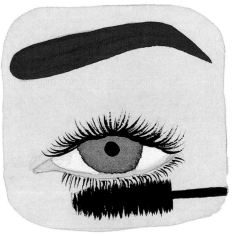

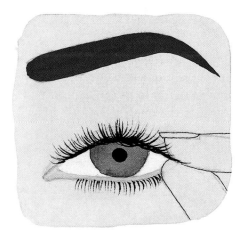

REMOVING MASCARA

Unless you use a gentle non-soap cleanser, your regular facial cleanser is probably too irritating to use on the delicate eye area. To clean off regular mascara, try a creamy or water-based makeup remover, which should dissolve it without scrubbing. To take off waterproof formulas, you'll need an oil-based remover. Massage it into your lashes and then press them with a damp cotton pad or (dark-colored) washcloth. Refrain from rubbing or using tissue, which can be abrasive and leave residue.

APPLYING FAKE LASHES

In this age of extreme artificial enhancement, false eyelashes seem almost quaint. But they allow your eyes to flutter and flirt like nothing else. These are your options: whole rows of false lashes, individual lashes, or tiny clusters of two or three lashes. Full falsies thicken and intensify your entire fringe; individual pieces fill out sparse areas and look more delicate and natural, especially if you use different lengths and place most of the long ones in the center of your lash line. (For a more seductive vibe, attach a few long ones at the outer corners.) If you prefer a strip, trim the lash tips unevenly to make them look more realistic. And toss the conspicuous white glue that comes with most kits. Instead, buy a dark eyelash adhesive (sold individually at drugstores for about $5).

STEP ONE

Use tweezers to dip the base of the lash into lash glue. If you're applying a full strip, use the tip of a fine makeup brush to apply a thin line of glue along its base. Wait a few seconds for the glue to get a bit gummy.

STEP FOUR

When lashes are dry (about 30 seconds), gently separate them with a lash comb. Curl your lashes and brush on a coat or two of mascara. To camouflage the base of false lashes, smudge dark eye shadow over it.

STEP TWO

Place the lash near the outer top corner of your lash line, as close to the roots as possible. If you're using a strip, hold it by the lashes above your own lashes and apply the entire row as close to your upper lash line as possible, starting at the outer corner. Then press gently with your fingertip or a cotton swab along the base to secure the entire strip to your existing lash.

STEP FIVE

To remove fake lashes, use your fingers to massage them gently with an oil-based eye makeup remover. They should slip right off.

STEP THREE

Repeat the process, placing two or three false lashes in the center or near the outer corners, spaced between your natural lashes.

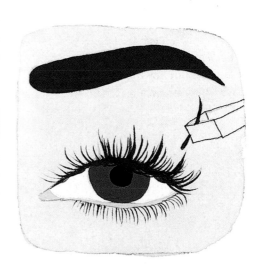

EYE LINER

Behold the power of eyeliner. It transformed Elizabeth Taylor into Cleopatra and Audrey Hepburn into Holly Golightly. Liner not only enlarges and draws attention to your eyes, but it also adds drama, feline sex appeal or punk-rock chic, depending on your mood. On the flip side, liner is one of the trickier cosmetics to apply, which explains why women wear it less frequently than beauty no-brainers such as lipstick and mascara.

Which comes first, eyeliner or eyeshadow? It depends on the look you want. For example, for a smoky eye, dark shadow goes on top of liner to "set" it, but for a cat eye you'd draw a dark line over pale shadow. Learn the proper application techniques and get comfortable (and steady) with sharp pencils and stiff-edged brushes, and you'll realize liner can be as versatile and expressive as the most accomplished actress.

EYELINER FORMULATIONS

Eyeliner comes in three forms, each with a unique look and level of difficulty. One rule applies across the board: Liner should be pliable, so that it never tugs at the thin skin around the eyes.

PENCIL

Pencils go on relatively quickly and blend easily, so they're an easy everyday option. Automatic, mechanical and felt-tip pencils are always sharp, but be careful: Precise lines can look severe on eyes of a certain age. Kohl pencils tend to be fatter and softer and have an almost powdery consistency, which makes them ideal for creating soft daytime looks and smudgy, smoky evening eyes.

Chanel Precision Eye Definer

POWDER

This is the most natural-looking kind of eyeliner, and it's easy to apply with almost any type of fine, short-bristle brush. Some cake (pressed powder) liners require a moist brush, but most can be used wet or dry. Many makeup artists use powder eye shadow as eyeliner: As long as it's densely pigmented, it works just as well. (To keep dry shadow liner from fading, smooth a bit of oil-free foundation across your lids first.)

Trish McEvoy Powder Liner

GEL

Of the three formulations, liquid liner is the most precise and long-lasting and has the sharpest, most defined look. On the flip side, it can also look dated. And as anyone who has applied it with a shaky hand knows, it's the hardest type of liner to use. Liquid liners that come with small, pointed brushes create a very fine line, so they're ideal for beginners. For a less intense effect, gently dot liner just between lashes with the tip of a brush. Felt or sponge tips are wider and therefore provide less control. Liquid liner shouldn't budge once it dries—but use a waterproof formula in humid conditions, just in case.

Make-up Forever Liquid Liner

APPLYING PENCIL LINER

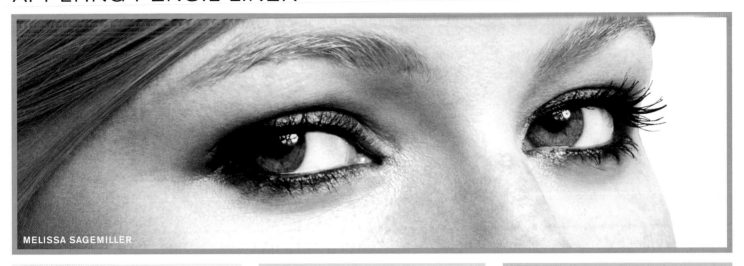

MELISSA SAGEMILLER

STEP ONE

Grind your wooden pencil to a rounded point for a barely there effect, or use a kohl pencil with a wide, smooth tip for a lush, less delicate line. Blow or wipe away shaving crumbs from the tip of the pencil.

STEP TWO

Start at the inner corner of your upper eyelid and follow your lash line to the outer corner in one continuous stroke, staying as close to the lashes as possible. Control the width of the line by varying the amount of pressure you apply. (For specific looks, see pp. 76-79.)

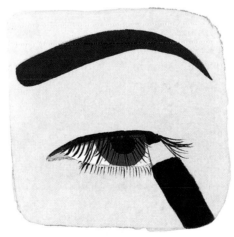

STEP THREE

Repeat underneath your eye, starting at the midpoint and working outward.

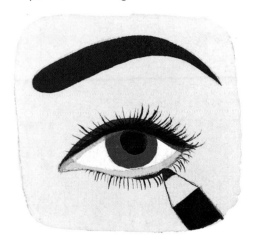

THE FULL TREATMENT

Cover veins and smooth the skin's surface with a fine layer of concealer, creamy foundation or translucent powder. Tilt your chin upward so you can see your lids fully in the mirror. Roll the tip of a sharpened pencil between two clean fingertips to soften and warm it up, and hold the pencil close to the tip for maximum control. Draw a line along your lashes as described in steps one and two above. For a more stylized look, try one of these variations:

For a sultry effect, line the lower rims as well, staying as close to the lash lines as possible. To get an edgier look, draw a line from the lower inner corner straight out rather than curving it upward along the bottom curve of the eye.

To create a smoky eye, apply neutral shadow over your entire lid, then smudge darker shadow on top of liner and use the sponge tip that comes on some pencils or a cotton swab to blend it out and up. Prep skin with translucent powder if you plan to extend liner past the outside corner of your eyes (it will keep the line from running), and draw a tail that curves upward. A downward stroke will drag your entire face in the same, sad-looking direction.

APPLYING POWDER LINER

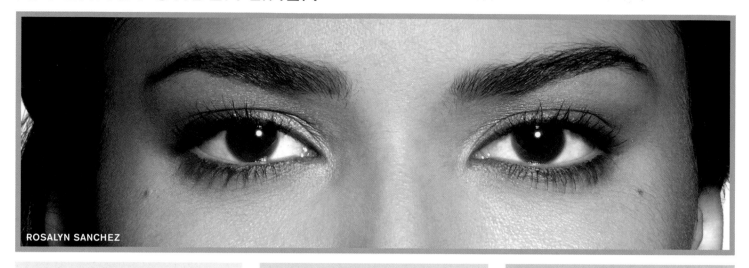

ROSALYN SANCHEZ

STEP ONE

Start with a clean lip brush or small, flat-edged liner brush. For a soft, natural line, go directly to step two. Otherwise, place a dot of water or eye cream onto the back of your nondominant hand and dab the brush into it to moisten it.

STEP TWO

Dip the dry or moistened brush into cake or powder liner—or try a densely colored eye shadow. Use the brush to dab powder in a series of connected dashes along your lash lines, leaving a line of color.

STEP THREE

For added intensity, repeat along the bottom lash lines, but start at the center, not the inner corners, and work outward to make your eyes appear wider. Gently dab a cotton swab along the top line of color to soften the effect of the powder.

THE QUICKIE

When applied more freely, powder liner saves you a step by doubling as eye shadow. Dip a flat-edged brush into powder liner or eye shadow and run it along your top lash lines. For a smoky effect, apply it to the bottom lashes, working from the middle outward.

THE FULL TREATMENT

Cover veins and even out the skin's surface with a fine layer of concealer or translucent powder. Dip a small, flat-edged eyeliner brush into powder liner or eye shadow and tap off any excess. To add intensity and make the liner last longer, dip the brush into a drop of water on the back of your other hand. Press the brush along your lash lines, laying down several layers of color for a strong, defined look. If you prefer a smudged effect, go over the liner with a cotton swab and blend the color upward.

APPLYING LIQUID LINER

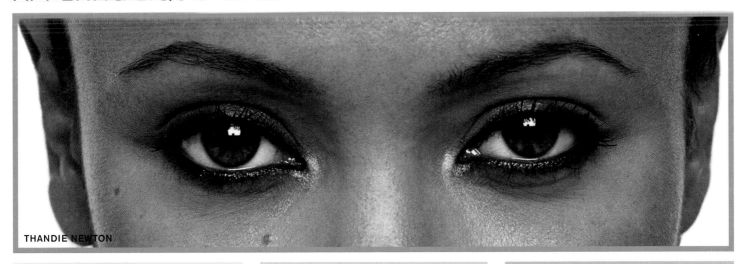

THANDIE NEWTON

STEP ONE

With your free hand, pull your lid taut at the outer corner. From the inner corner out, draw a line along the upper lash line (skip the bottom; liquid liner looks too heavy on lower lashes). Make it as thin as possible; you can always trace over it for a bolder look.

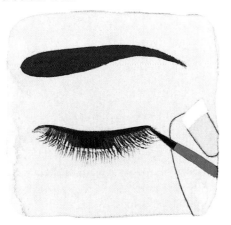

STEP TWO

If you prefer a smoky effect to the more graphic look of strongly lined eyes, wait for liner to dry and use a small flat brush to blend eye shadow on top of the liner.

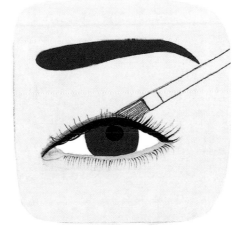

STEP THREE

To extend the liner past the outer corners of the lids for a classic Audrey Hepburn cat eye, continue to apply shadow just beyond the edges of the eyes, angling it slightly upward.

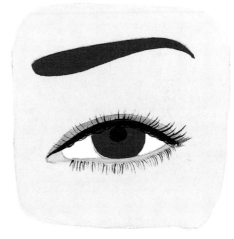

THE QUICKIE

The thinner the line, the easier the application, so go for a spare but defined look. Draw a fine line from the inner to the outer corners of your top lash lines. Eye shadow will overpower the delicate lines, so add one layer of mascara and nothing else.

THE FULL TREATMENT

Cover veins and even out the skin's surface with a fine layer of concealer or translucent powder. Pull your eyelid taut and slightly downward so you can clearly see your upper lid. Rest your elbow on the counter for steadiness as you paint on the liner. If you want a thicker line, repeat. Set the liner by tracing the line with a powder shadow in the same color. For a smoky finish, add more powder shadow and blend it in with a cotton swab.

LINER NOTES

A few millimeters of eye makeup can make your whole face more symmetrical and balanced. Optimize your individual eye shape with these specific pointers.

SMALL

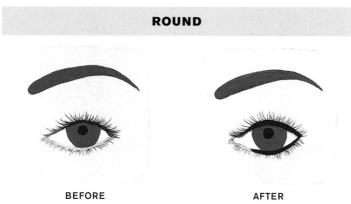

BEFORE AFTER

Line the inner rims of the lower lids with white, nude or light blue liner to make the whites of your eyes appear brighter and bigger. (See p. 81.) Leave the top lash lines bare.

WIDE-SET

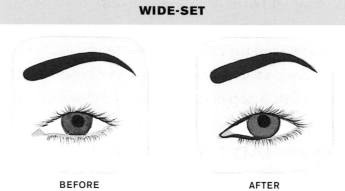

BEFORE AFTER

Minimize the space between them by applying a darker liner on the inner corners and a slightly lighter shade on the rest of the lash lines.

ROUND

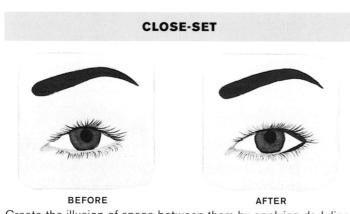

BEFORE AFTER

Make eyes more oval by lining the outer two thirds of the upper and lower lash lines and joining them at the outer corner. Concentrate mascara on the outer corners of the upper lashes.

ASIAN

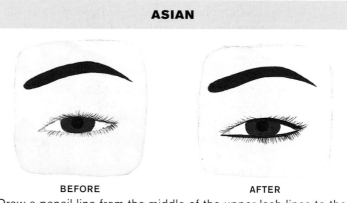

BEFORE AFTER

Draw a pencil line from the middle of the upper lash lines to the outer corners and all along the bottom lids. Smudge lines. Apply a light shadow on the center of the upper lid and blend it in.

CLOSE-SET

BEFORE AFTER

Create the illusion of space between them by applying dark liner on the outer quarter of the top and bottom lash lines.

ALMOND-SHAPED

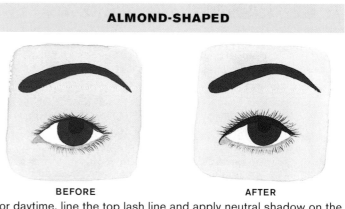

BEFORE AFTER

For daytime, line the top lash line and apply neutral shadow on the lid. For night, trace top and bottom lines and gently smudge them.

It's easy to fall into an eye-makeup rut, brushing on the same neutral shades day after day. But branching out isn't as big a deal as you think. With a few swipes of a brush, you can conjure a soft, clean finish, a pop of color, a romantic haze or a pair of sexy, smoldering rings. Forget about contouring, contrasting and all those other confusing terms. Arm yourself with some basic skills and a broad palette of colors—and have some fun.

EYE SHADOW FORMULATIONS

Before you pick up a brush, familiarize yourself with the different eye shadow textures and choose one that will achieve the effect you're after.

	PROS	CONS	RECOMMENDED
POWDER	Because it can be used both wet and dry, powder is the most versatile, long-lasting eye shadow and works for all skin types. It's also easiest to control because it stays put, once you apply it. Powders are either matte or iridescent. Matte powders absorb light and therefore create depth; metallic or shimmery powders deflect light and bring out the eyelids, so they work best as highlighters. Use a brush with soft, domed bristles to blend powder into creases and corners, and a stiff, flat one to press color into the lash line.	Powders sit on top of the skin, so they can make lids look dry and cakey and exaggerate fine lines. Minimize that risk by using only ones that feel smooth and almost creamy (not dusty) to the touch.	*Dior Powder 5-colour Eye Shadow* ▶
CREAM	Creams, which can be smoothed on with the fingers, look most natural because they accentuate your skin's texture and "melt" into skin rather than sitting on top of it. They're subtler than powders and easy to blend into dry complexions.	They're harder to control (and less durable) than powder because they tend to slide around and gather in creases, particularly on oily skin.	*MAC Paints* ▶
PENCIL	These chubby pencils, most of which contain shimmery shadow, are the most user-friendly, fuss-free shadow formulations. They're portable, easy to maneuver and double as eyeliner.	Sticks wear down and lose their shape, so you have to keep an oversize sharpener handy.	*Cover Girl Eye Slicks* ▶
LOOSE POWDER	Loose powder can be matte or shimmery. Depending on what kind you use, it can brighten eyes with dramatic, glittery flecks, subtly illuminate them with a veil of shimmer, or (if it's matte) create a soft cloud of color.	Loose powder can get messy. It's tricky to control the amount that goes on—be prepared for some of it to end up on your clothes and the bathroom counter.	*MAC Pigment Shadow* ▶

CHOOSING COLORS

For most eye-shadow looks, you'll need three shades: a medium tone for your lids, a darker one for the lash lines, and a light version for high-lighting the brow bones. If that sounds like too much work, a simple wash of neutral shadow across the lids does wonders for waking up sleepy eyes and polishing the face. When choosing neutrals, for either a quick swipe or a three-shade application, let your skin tone be your guide. Women with dark or olive skin look best in warm colors (peachy or golden taupes), while icier shades (pale beiges, neutrals with cool pink undertones) flatter fairer skin.

When choosing more vivid shades, study the color wheel: The hue opposite your eye color is usually the most complimentary. For blue eyes, it's orange; for green, it's red. Of course, no one would paint her eyes bright orange and red. Instead, look for shades that have hints of those colors in them. Warm aubergine or violet both have red bases, and therefore will intensify green eyes. A rich copper or gold (both of which have orange undertones) will brighten blue eyes. Brown eyes can wear a wide spectrum of colors, so experiment until you find shades that work for you.

A note on trendy, rainbow-colored eye makeup: Electric blue shadow and brows coated in gold glitter make a bold, beautiful statement on the runway or in a magazine, but in reality, they can look strange even for a gala evening. That doesn't mean you can't add a spark of high fashion to your everyday (or nighttime) look. Just tone down a high-fashion look until it blends easily into your lifestyle. A sheer wash of pale, iridescent blue across the lids and a hint of metallic brow powder, for instance, will liven up your skin and make you look sun-kissed. If wearing a bright shade on your eyes feels too risqué, hold off on colorful shadows and liners and ease into the mood with a tinted mascara. If you choose to go all out, don't match your makeup exactly to your clothes (a major no-no) and try to stay within your comfort zone.

CLASSIC EYE SHADOW TECHNIQUE FOR THREE EYE SHAPES

ALMOND-SHAPED

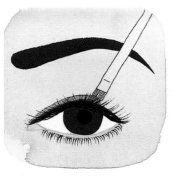

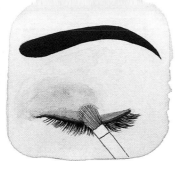

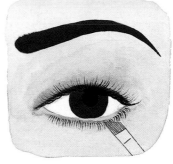

Use a straight-edged brush to work the darkest shade into the top lash line. Draw it out diagonally at the outer corners to create a slight upturn.

With an eye shadow brush, swoosh the medium-toned shadow over the darkened lash lines and blend it up toward your creases.

Dip the flat brush into the dark shadow and press it into the lower lash lines. The powder will create soft definition rather than a harsh line.

THE RESULT A subtle gradation of color focused on the outer corner accentuates the almond shape.

FLAT CREASE

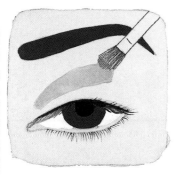

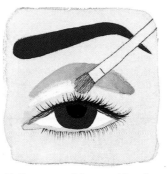

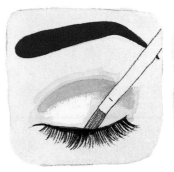

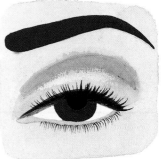

Use a shadow brush to locate the indentation above the upper edge of your eyeball. Brush a medium shadow back and forth across that area to "create" a subtle crease.

Pull your eyelid taut with a finger. Apply the lightest shadow onto the lid beneath the medium-toned shadow. Fill in the lid all the way down to the lash line.

Use a flat brush to apply the darkest shade to the top lash line, starting at the inner corner and working outward. Blend it in well so there are no harsh lines.

THE RESULT Light shading around the socket creates depth in the crease, and a clean lower lash line makes the eye look more open.

ROUND

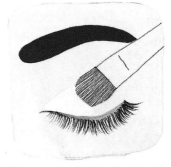

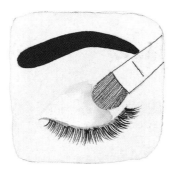

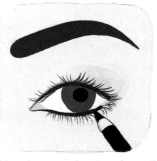

Use a round-tip shadow brush to apply the lightest shadow color onto the inner half of the eyelid, from the lash line all the way to the crease.

Dust the mid-tone shadow onto the outer half of the lid to draw attention away from the center.

Line inner and outer rims of the top and bottom lids with a soft eye pencil. Eliminating the lightness on the inner lower lid helps define the eye.

THE RESULT The play of light and dark shadows helps elongate round eyes, especially ones that seem to protrude.

EYE CANDY

Whether soft and neutral or graphic and colorful, eye shadow highlights and enhances the face's most dynamic features. These looks—some classic, others edgy—are both striking and sexy.

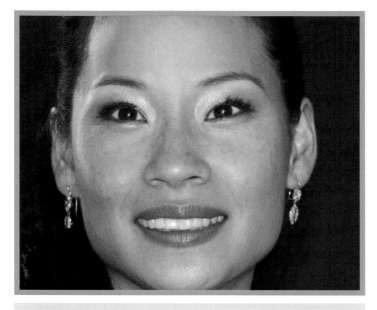

LUCY LIU

Liu illuminates her entire face with cool pastel shadow at a *Charlie's Angels 2: Full Throttle* press conference in June 2003.

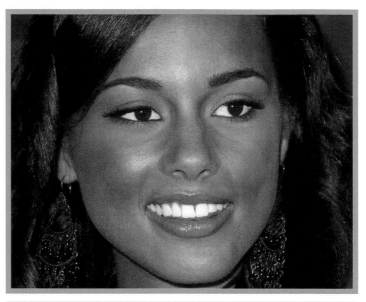

ALICIA KEYS

Keys chooses a crisp, timeless look—focusing more on her defined eyeliner than her shadow—at a press conference in February 2004.

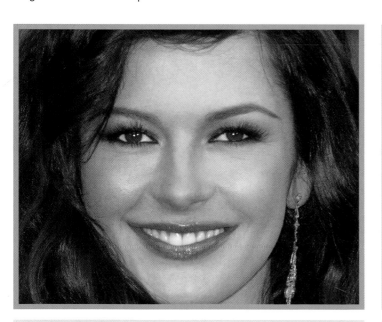

CATHERINE ZETA-JONES

At the 2004 Academy Awards, Zeta-Jones pairs dark, smoky eyes with loose, sexy hair. The effect: brunette bombshell.

CHARLIZE THERON

Theron makes a statement with a solid wash of coppery brown shadow at the 2004 Costume Institute Gala in New York City.

SCARLETT JOHANSSON

At the 2003 première of *Girl with a Pearl Earring,* Johansson glows in soft, contouring layers of brown and beige shadow.

JENNIFER CONNELLY

In keeping with her unstudied hair, Connelly stays neutral at the première of *House of Sand and Fog* in December 2003.

GWYNETH PALTROW

Ringed in flattering brown, Paltrow's eyes smolder at the National Film Theater's 50th Anniversary in 2002.

GARCELLE BEAUVAIS-NILLON

Beauvais-Nillon enlivens her dark complexion with bronze eye shadow at a 2003 Oscar party in Los Angeles.

FOUR KEY LOOKS

Timeless or trendy, realistic or fantastical, these iconic looks are surprisingly easy to execute. Add a clean, sexy shimmery eye or attention-grabbing graphic cat eye to your repertoire.

SMOKY EYES

JENNIFER LOPEZ

STEP ONE

Use a black, cocoa or charcoal pencil or shadow to draw a line all along the upper lash lines. Brush a line of dark shadow on top of the liner. Smudge the lines with a cotton swab or sponge-tip applicator.

STEP TWO

Use a shadow brush to sweep gray, brown or silver shadow (or a lighter shade of blue or violet, if you used a colored liner) from the lashes up to the creases and blend in just above the crease.

STEP THREE

Brush on a quarter-inch-thick line of dark shadow along the lower lash lines and diffuse it with a cotton swab. The color should look like a soft ring around your eyes. Curl lashes and brush on two coats of mascara.

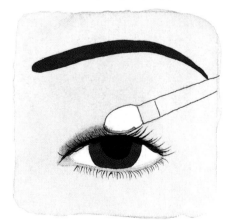
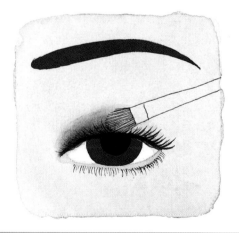
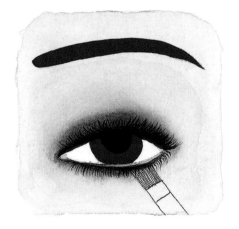

THE QUICKIE

Use a dark pencil to line your top and bottom lash lines. Smudge the lines, drawing the color out into a soft haze. Finish with mascara.

THE FULL TREATMENT

To keep shadow in place, create a dry, smooth canvas for it by applying foundation and translucent powder to your eyelids. Before applying shadow, blow on the brush to get rid of excess, so the color fades as you blend it outward. Soften the borders by brushing translucent powder around the boundaries. For extra sultriness, dab shimmery eye shadow on the center of each lid.

SHIMMERY EYES

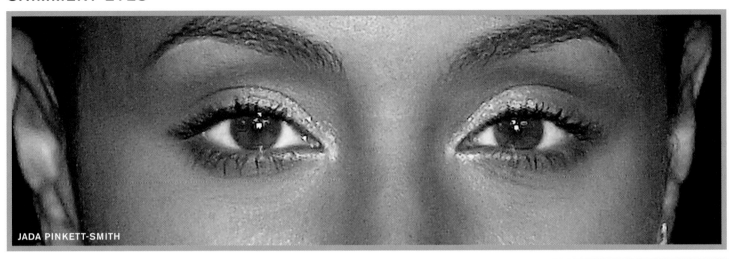

JADA PINKETT-SMITH

STEP ONE

Stroke brown pencil or shadow into the top lash lines and smudge with a cotton swab or sponge applicator.

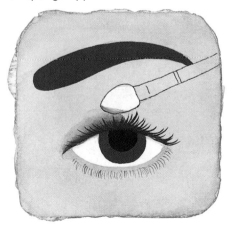

STEP TWO

Apply a pale iridescent cream or powder shadow onto the lids from the lash lines to the brows to lighten the entire area. Add a soft line along your lower lashes too.

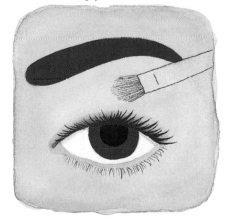

STEP THREE

If you want to deepen the crease, brush brown shadow just above it. Finish with mascara.

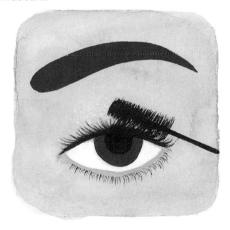

THE QUICKIE

Apply pale, shimmery shadow over your lids and along your lower lashes to create a ring of light around your eyes. Finish with mascara.

THE FULL TREATMENT

For extra staying power, prepare your eyelids with foundation and powder. After applying eyeliner and the wash of pale shimmery powder or cream shadow from the top lashes to the brows, dab a shimmery pink or peach shadow on each lid, including the inner corner of the eye (hold the brush perpendicular to your face and move it back and forth like a windshield wiper to ensure an even deposit of color). Blend it in at the crease. Brush on some shimmery shadow beneath your eyes. Curl your lashes and apply mascara.

CAT EYES

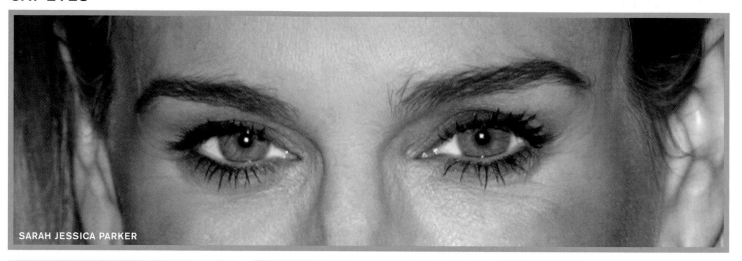

SARAH JESSICA PARKER

STEP ONE

Brush a pale, neutral shadow from the lash lines all the way up to the brows.

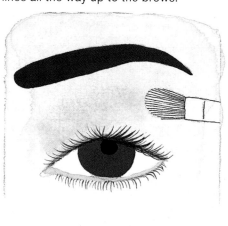

STEP TWO

Paint black liquid liner along the top lash lines from the inner corners toward the outer corners. (For more tips on liquid liner, see p. 69.) Extend the liner beyond the corners at an upward angle.

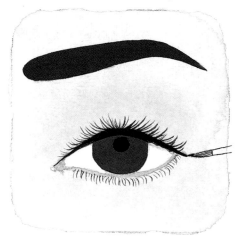

STEP THREE

Brush on two even coats of black lengthening mascara.

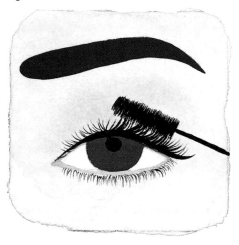

THE QUICKIE

No time to fuss with liquid liner? Reach for a pencil instead—any shade will work. Draw a line along the upper lash lines and extend it slightly beyond each outer corner, extending the line upward, not down. Add mascara.

THE FULL TREATMENT

Prep eyes with foundation and powder. Brush a pale, neutral shadow from the lash lines all the way up to the brows. Paint liquid liner in a very fine line along the top lash lines from the inner corners to just beyond the outer corners, angling the line upward at the end. Go over the line one or two more times, slowly building up to the thickness you want. Apply two coats of mascara.

PASTEL EYES

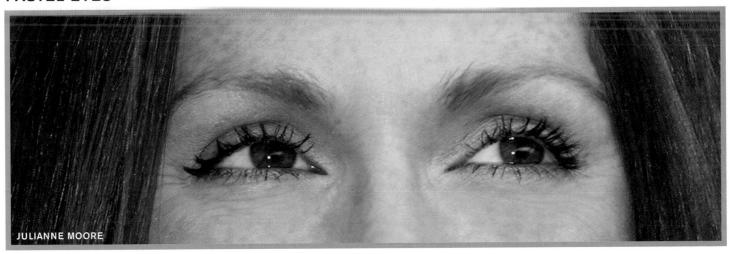

JULIANNE MOORE

STEP ONE

Choose a sheer pastel shadow and brush it on the lid from the inner corners outward, stopping at mid-eye.

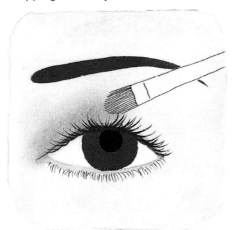

STEP TWO

Brush a slightly paler shadow on the outer half of the lids and blend the two colors together where they meet.

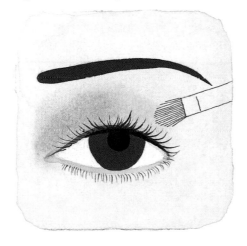

STEP THREE

Apply two coats of mascara.

THE QUICKIE

Choose one sheer pastel shadow and smooth it across your lids, starting at the upper lash lines and blending it upwards to the brows, using a brush or your fingertips. To keep your eyes from looking too pale, brush on one coat of mascara.

THE FULL TREATMENT

Prep lids with foundation and translucent powder to ensure a clean, non-oily canvas. Proceed as directed in the basic steps. For a truly monochromatic effect, tint the lashes with a mascara in the same color family as the shadow. For example, if you applied lilac shadow, go with violet mascara; if you used celadon, try forest green.

Is it okay to wax my brows at home?

There are plenty of home waxing kits on the market that are perfectly safe and easy to use. But they're best for cleaning up a few stray hairs above and below the brow line between professional waxings, rather than for full shapings (which require more precision than most people can manage on their own). If you have sensitive skin, look for a wax that contains azulene, a natural anti-inflammatory. You can use either hot strip wax, which is removed with a muslin strip, or a self-peeling one. Most pros use the strips because they tend to remove hair more thoroughly, but waxing novices should stick with self-peeling wax because it's easier to use. Hot waxes are always more effective than cold waxes.

What kind of mascara won't irritate sensitive eyes?

Large particles (like hard waxes and fibers), fragrance and harsh preservatives (Thimerosal is a common one) are the major eye irritants. To avoid a reaction, read the label before you buy or head straight for mascaras whose labels say they are 100 percent fragrance-free and dermatologist-, ophthalmologist- and/or allergy-tested. Two to consider: Almay One Coat Mascara, which is hypoallergenic, and Neutrogena Weightless Volume Wax-Free Mascara.

My hands always shake when I apply eyeliner, which leads to crooked lines. What can I do to stay steady?

Holding still is especially crucial when applying liquid liner, but these tips work for all types. Place an elbow on a table in front of a mirror, and with your free hand, pull your lid taut at the outside corner of the eye to create a smooth, flat canvas. For added security, lay a mirror flat on a table in front of you so you are forced to look down. You'll have a clearer view of your entire lid and be able to get the makeup closer to (or right into) the lash line. Clean up a crooked line with a moistened cotton swab.

How can I make my eye shadow last all day?

If you use powder shadow, prepare your eyelids with a thin layer of foundation first—this gives the shadow something to which to adhere. Then lock the shadow in place with a light dusting of translucent powder. If you use cream, it's more lasting when you carefully apply it with a brush and set it with a light dusting of loose powder. Then apply a second layer of shadow.

Help! I overplucked! What can I do?

You're out of luck for the moment. All you can do is let your brows grow back in, which typically takes about a month. In the meantime, fill in sparse spots with brow powder or pencil (use light, feathery strokes for a realistic finish), and set the color with brow gel to avoid smudging.

I have close-set eyes. What's the most flattering way to shape my brows?

Keep them thin to help create a wider-eyed look. Open up the space around your eyes by removing hair from underneath your brows. If you're unsure how to do this, hire a professional. It's worth it.

My eyeliner always runs. How can I prevent this?

Before applying any kind of liner, prep your upper and lower lids with a minuscule amount of foundation and set it with translucent powder. This creates a dry, grease-free surface area. After you've applied liner, another dusting of translucent powder will hold it in place. If you prefer not to layer on the foundation and powder, set liner by tracing powder shadow (in the same shade) directly on top of it. For super-long-lasting liner, try this triple threat: Stroke on pencil liner first, apply powder liner (or shadow) over that, and top it all off with liquid liner.

Is it safe to wear white, light blue or beige pencil on the inner rims of my eyes? It seems to make my eyes look bigger.

The experts are divided on this issue. Ophthalmologists and certain makeup artists are against it, claiming that liner can break off and flake into the eyes, causing irritation and (if your pencil isn't clean) infection. Other makeup artists, however, love the look of white or light liner on the inner rims (see "Liner Notes" on p. 70 for its power to whiten and brighten). If you decide to use liner on your inner rims, sharpen your pencil to ensure that the tip is clean, and soften the point by drawing a few lines on the back of your hand first so you don't poke yourself.

I wear contacts. How can I avoid irritating my eyes and damaging my lenses when applying liner?

To keep contacts in the clear, avoid lining the inner rims of your eyes and make sure your pencil point is free of all shavings by wiping it, blowing on it or tapping it on the back of your hand. If irritation does occur, remove your lenses and flush out your eyes with warm water or saline solution.

What's the best way to clean up smudged mascara?

Moisten a cotton swab with water and wipe off smudges before they dry. For tough spots, use makeup remover instead of water.

What is the point of clear mascara?

Clear mascara is like lip gloss for your eyes. It makes them look darker and more visible without being obvious. It's also great for people with oily skin, since it won't smudge. Clear mascara can also be used as brow gel to hold unruly brows in place.

My nose is thick and wide. How can I shape my brows to make it look narrower?

Go with a thicker brow because fullness balances larger features. As a visual trick, keep the distance between brows small to make your nose appear thinner. Again, if this makes you nervous, leave it to a professional.

When I apply shadow only up to my crease, I can't see it. Any tips?

If your eyes are deep set and your upper lids disappear when your eyes are open, try giving eyes more dimension by using a light, neutral shade over the entire lid to open up the eye. Then apply a medium-toned shadow both into and slightly above the crease, brushing it back and forth like a windshield wiper. To keep the look natural, use a light hand and blend well with a soft brush. And don't apply color too high on the lid—it can look fake and overdone.

I've heard that liner worn on the lower lid can make your eyes look smaller. Is the same true of eye shadow?

If you apply a very dark shadow underneath your lower lid it can have the same eye-shrinking effect as liner. But a light color can do just the opposite. Use a small brush to smudge a pale, shimmery shadow into the outer half of the lower lash lines. The light-deflecting particles, as well as the placement of the shadow, create the illusion of a wider, more open eye.

How can I take my daytime shadow look into the evening?

It's easy. Just intensify everything and add a little shimmer. Smooth a dark shadow into the crease and along the upper and lower lash lines, then dust a glittery highlighting shade onto the brow bones and inner corners of the eyes. You'll instantly look ready for a night out.

LIV TYLER

LIPS

Lipstick doesn't really need an introduction. Chances are you've been wearing it since childhood, when you first pillaged your mom's makeup case. Still, a little lip service never hurt anybody. Here's how to keep your pucker healthy and apply color in a way that flatters your individual mouth shape, whether you intend to downplay a prominent pout or maximize a thin grin.

Dry, chapped lips are uncomfortable, unattractive and make a poor canvas for makeup, so try to keep your lips as moist and smooth as possible. For starters, wear lip balm every day—if possible, use one with SPF to deflect sun damage. Lip balm comes in a wide spectrum of textures ranging from watery to waxy, and everyone seems to swear by one brand or consistency. But generally, the lighter and thinner the balm, the smoother a base it creates for lip color (as long as it isn't too slick, in which case color won't adhere well). Thicker, gummier ones are best for wearing alone, especially if you're going to be exposed to the elements. Ultimately, use whatever feels comfortable and sufficiently

hydrating on your mouth. And if you want your lips to smell like roses or taste like strawberries à la the Lip Smackers of seventh grade, look for a fragranced or flavored balm.

To combat particularly dry lips, use a treatment product containing salicylic acid once a week to slough off dead skin cells. If flaking persists, resort to physical exfoliation. Mix a pinch of brown sugar with a dab of lip balm to buff away any dead skin, or apply balm, let it soak in for 15 minutes, then gently brush your lips with a cotton swab or soft-bristled baby toothbrush. A few minutes before applying color, smooth on an even layer of lip balm, allow it to dry, then blot any excess so lipstick goes on evenly.

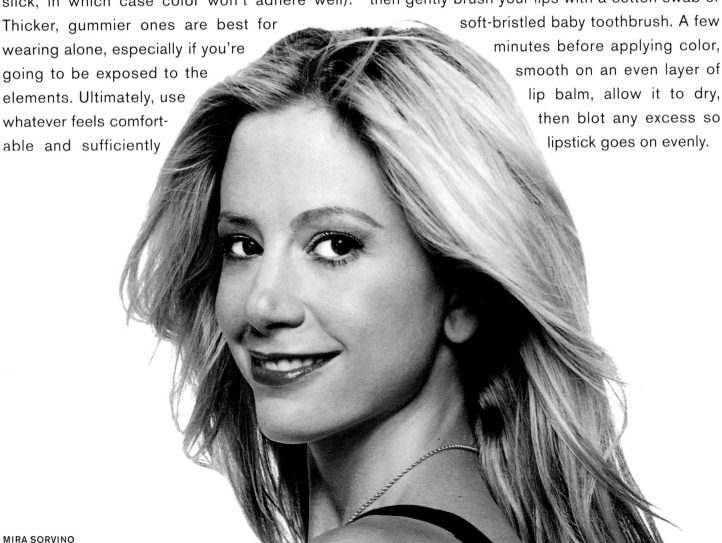

MIRA SORVINO

LIP COLOR

Lip color is a cinch to apply (open tube, swipe across mouth, smack lips) and an effortless way to change your look from sexy to sophisticated, mod to melodramatic, or innocent to edgy in seconds. No wonder women rotate dozens of tubes at a time. When picking a shade, the sky's the limit. Depending on the statement you feel like making, you can leave your lips neutral, freshen up with a pink or berry shade, or cover them in crimson and let them scream for attention: The choice is yours. (But if you opt for the latter, don't use strong colors on the rest of your face.)

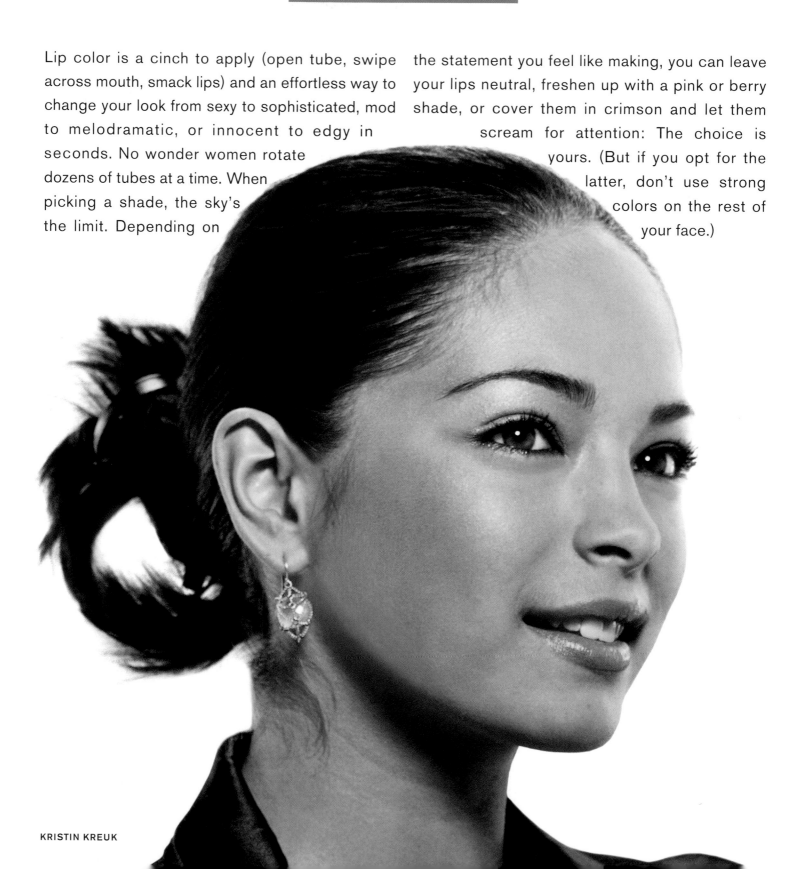

KRISTIN KREUK

CHOOSE A LIP COLOR FORMULA

Use this comprehensive guide to achieve the perfect pucker, from transparent to totally opaque.

LIP GLOSS

Whether sheer or tinted, glosses, which are made of a mix of emollients and liquid waxes, are the most hydrating but least enduring of lip formulas. As a rule, the denser and gooier the gloss, the longer it will stay on. But beware, glosses can leave you in the hair-stuck-on-mouth predicament. Wear gloss if you want a sexy, extremely shiny finish and don't mind reapplying frequently. And if they contain hydrating ingredients such as lanolin, beeswax, jojoba oil and coconut oil, they can do double duty as lip balm.

Lancôme Juicy Tubes ▶

SHEER LIPSTICK

Sheer lipsticks contain very little pigment, which is why the color looks lighter on your lips than it does in the tube. Because the coverage is less dramatic, sheer lipsticks are decidedly casual—and a wonderful way for women who normally wear neutrals to try intense, trendy colors. These formulas often have a smooth, lush finish, which makes them pleasantly hydrating, but they don't last long.

Clinique Almost Lipstick in Black Honey ▶

SHIMMERY LIPSTICK

These lightweight formulations look metallic, opalescent or pearly in the tube, but appear soft and subtle on your lips. Light-reflecting mica particles provide the shimmery finish.

Maybelline Wet Shine in Pink Diamonds ▶

CREAM LIPSTICK

Cream formulations are loaded with emollients such as vitamin E, shea butter and dimethicone (also known as silicone), which help seal in moisture while depositing full, lustrous color on your mouth. They're great if you like strong color and prefer less shine than you'd get from gloss.

Nars Lipstick ▶

LIP STAIN

Commonly found in liquid or gel forms, stains are delivered to your lips by way of a dry solvent like alcohol, which helps the pigment grip without adding shine, texture, or body. The effect: Natural lips loaded with pigment, as if you've just eaten a cherry Popsicle. The absence of emollients adds to their long-lasting effect. However, they can leave lips dry, so keep lip balm handy.

Benefit Benetint ▶

MATTE LIPSTICK

Matte lipsticks are saturated with pigment but have few emollients, so they last longer than creams but tend to be more drying. The look? Intense color, zero shine. Prepping your lips with balm is mandatory, but blot it before applying color so it doesn't interfere with the matte texture of the lipstick.

MAC Matte Lipstick ▶

LONG-WEARING LIPSTICK

Formulas that are designed to last at least eight hours owe their staying power to special ingredients that evaporate when deposited onto your lips, leaving behind only pigment. The absence of emollients can make these formulas very drying, though newer formulations come with a moisturizing top coat to help keep your lips moist.

Max Factor Lipfinity ▶

GOING TO EXTREMES

The quickest way to completely alter your look? Switch from very pale to very bright lipstick (and vice versa). It can mean the difference between innocent and sophisticated, casual and black tie.

GWYNETH PALTROW

When the objective is a simultaneously casual and polished look, berry-colored lipstick, like the one Paltrow wears here, is the perfect call.

Burgundy lips are practically mandatory when donning fur and enormous, sparkly earrings, as Paltrow does in December 2003.

JULIANNE MOORE

At a Gilda's Club Worldwide benefit in May 2004, Moore's soft peach lips suit her auburn hair.

At the 55th Annual Writer's Guild of America West Awards in March 2003, Moore looks romantic in deep, wine-colored lipstick.

PENELOPE CRUZ

Cruz was a vision in pale pink at the 2004 Rome première of *The Last Samurai.* Her soft lips took a backseat to her strong, smoky eyes.

Cruz's cherry red lips are the focal point of her classic evening makeup look at the 2004 U.K. première of *The Last Samurai.*

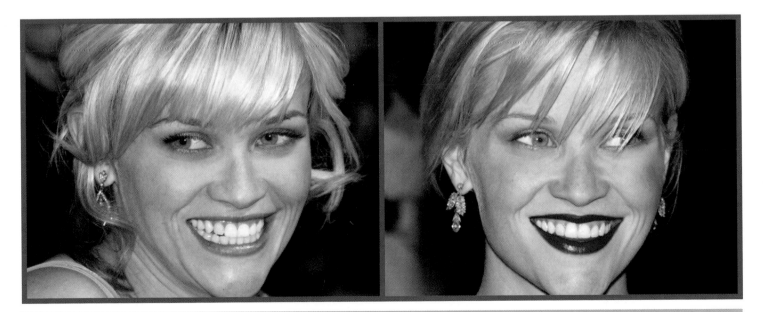

REESE WITHERSPOON

Witherspoon radiates sweetness and light at the *Sweet Home Alabama* première with pale cheeks and glossy pink lipstick.

At the *Legally Blonde 2* première, the actress pumps life into a plain black ensemble with classic crimson lips.

A RICH, FLAWLESS MOUTH IN TWO SWIFT STEPS

Luscious, long-lasting color requires more effort than applying lipstick straight from the tube, but it's well worth the effort. A lip brush and tissue are all the extra ammunition you need.

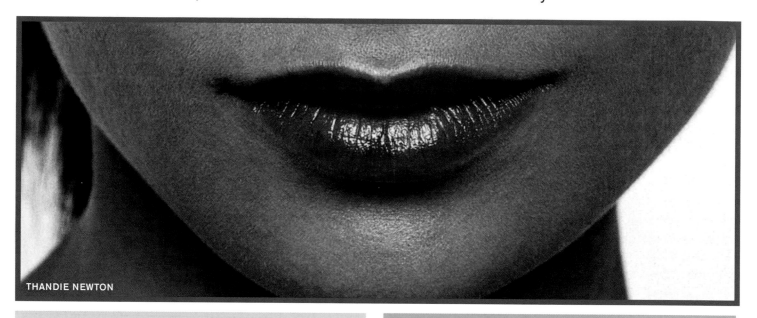

THANDIE NEWTON

STEP ONE

Use a lip brush to apply a thin layer of lipstick, starting at the center of your mouth and blending outward. Several thin layers of color will last a lot longer than a single thick coating. Avoid the corners so you don't end up with a clown mouth.

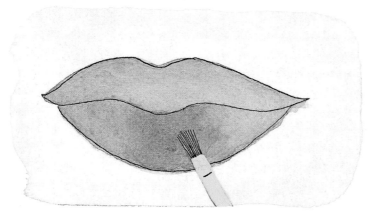

STEP TWO

Press your lips together to soften the overall effect and blot your mouth with a piece of tissue.

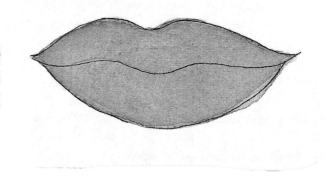

THE QUICKIE

Apply lipstick straight from the tube, dabbing (not rubbing) it on. If you have a tissue, blot your mouth; if not, get on with your day.

THE FULL TREATMENT

Start with lip pencil. Choose one that matches your lipstick color (never use a darker one) and hold it at an angle for softer application. Apply it from the outer corner of your upper lip to its center. Repeat this on the other side and on your bottom lip. Fill them in with light, feathery strokes using the side of the pencil's point rather than the actual tip; brush lipstick on top. Blot with tissue.

SEEING RED

For cool elegance and all-out glamour, nothing beats the impact of strong red lipstick. These stars demonstrate that the classic look is adaptable to all skin tones—and all occasions.

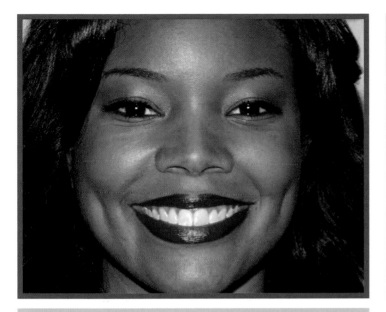

GABRIELLE UNION

Union, shown here at a party in L.A. in 2004, achieves lasting color by lining her mouth with red pencil, then filling it in with lipstick.

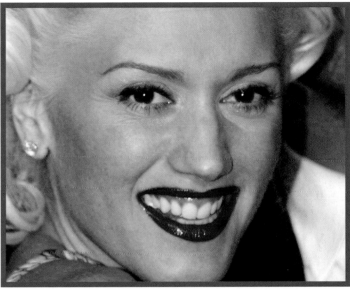

GWEN STEFANI

Fire-engine red lips help Stefani channel Marilyn Monroe at the 2004 *Vanity Fair* Oscar Party in Los Angeles.

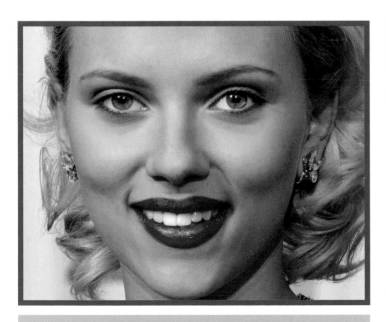

SCARLETT JOHANSSON

With her vivid lips, softly curled coif and small, sparkly earrings, Johansson exuded 1950s glamour at the 2004 Academy Awards.

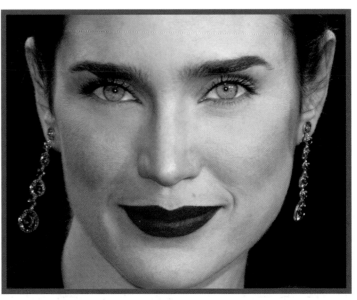

JENNIFER CONNELLY

Connelly's perfectly painted lips stand out against her porcelain skin and simply styled black hair at the 2003 Academy Awards.

MAKING THE MOST OF YOUR LIP SHAPE

There's no such thing as a perfect lip shape, but if you want to make your mouth appear a little fuller or thinner, it's easy to create an illusion with well-placed liner or lip gloss. Try these tricks:

FULL LIPS

To play them down, use a neutral, soft matte lipstick and skip the liner. Apply color to the center of your lips with your finger and blend outward, leaving the edges soft and undefined. To play them up, trace pencil just inside the lip line and blend with a brush, then apply lipstick.

THIN ON TOP AND FULL ON BOTTOM

Create balance by following the thin lip advice on your top lip and the full lip on your bottom one. Apply lipstick and add nude gloss to highlight the top lip only.

THIN LIPS

Trace just the outer edge of your lips with a neutral liner. Blend. Apply sheer lipstick in a medium or light shade (very dark color can make thin lips look smaller) and dot iridescent gloss on the middle of the bottom lip to make it appear fuller and more pouty.

BOW-SHAPED LIPS

Go for the vintage 1930s look. Tuck your upper lip under your teeth so you can easily see the V-shape in the center of your top lip. Line the bow first, then the bottom lip at the center (just below the bow) to balance the lip. Draw light lines to the outer corners on top and bottom. Finish with your favorite lipstick.

LIP SHAPES

These four actresses make the most of their distinct lip shapes, using clever makeup strategies and optimal lipstick colors to achieve flattering effects.

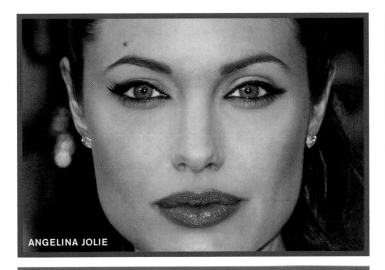

FULL LIPS

Jolie is the poster girl for full, pouty lips. At the 2004 Academy Awards, she wears soft, rosy lipstick.

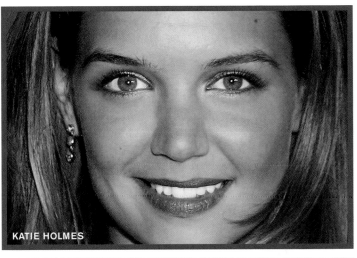

THIN ON TOP AND FULL ON BOTTOM

Holmes balances out her slightly uneven lips by defining her thinner top lip and leaving the edges soft on the lower, fuller one.

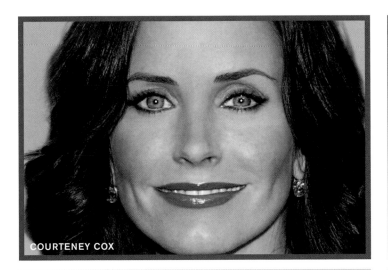

THIN LIPS

At the 2003 Golden Globe Awards, Courteney Cox adds dimension to her thin lips with glossy, berry-colored lipstick.

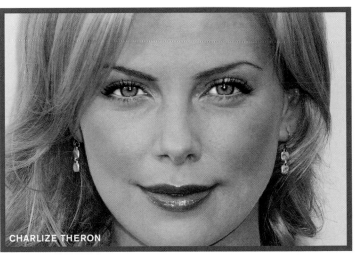

BOW-SHAPED LIPS

Theron plays up her bow-shaped lips by accentuating the curves of her upper lip and wearing a sweetly glamorous color.

FAIL-SAFE SHADES FOR EVERYONE

If any single facial feature invites endless experimentation, it's the lips. Sure, you've heard all the old clichés: Only blondes can wear pink; redheads must never wear red; coral lipstick should only be legal in Palm Beach. In truth, thousands of colors will look amazing on you, so go to a store that encourages sampling, start twisting tubes open and trying them on until you find a shade (or 20) that you love—and remember to mix it up: neutrals for day, darker, bolder shades for night, sparkly glosses for summertime, and so on. (Of course, if you're happy with your three tried-and-true plums or berries, by all means stick with them.)

If you need some very broad guidelines to rein you in, remember that, as with all makeup, your skin tone is the major indicator of what will look good on you. Many makeup artists advise women with pink complexions to wear cooler colors such as blue-reds and blue-pinks, while those with yellow, olive or black skin to wear warmer, more orange hues. (Another way to think about it? Avoid colors that you know will handicap your complexion. If you have pink, ruddy skin, pink lipstick will bring those blotches right out. If you have olive undertones, fuchsia will turn you even greener.)

As for all that mumbo-jumbo about universal colors, there are really only a few for the lips: Berry or red shades, which can have blue (cool) or orange (warm) undertones, and can be sheer or opaque, light or dark. Whichever one you choose, you'll end up with a customized version of classic red lips—and that's a universal symbol of beauty.

Q&A

Is lip balm addictive?

We've all heard the popular myth that certain lip treatments are spiked with addictive ingredients, which cause our lips to be incessantly chapped and in need of balm. But there's no scientific evidence to support this rumor. What feels like an addiction is actually a psychological effect that happens when you get used to your lips feeling soft and supple immediately after applying balm. After a while without balm, your lips lose their softness so you probably start licking them to hydrate them, which in turn dries them out even more. It's no wonder we all reach for the lip balm.

Do "treatment" lipsticks do anything?

To some extent, treatment lipsticks can help. The amount of antiaging ingredients found in lip treatments is minimal, so you may see a slight difference but nothing significant. Ingredients such as vitamin C and kinetin are exfoliants, so they can help prevent chapping and peeling. But be careful: The skin on the lips is extremely sensitive, so there's a possibility that those kinds of ingredients will cause irritation. If something stings, wipe it off immediately.

Is it true that certain lipsticks make teeth look whiter?

Absolutely. But before you decide which shade is best for you, determine the color of your teeth. There are two basic hues: yellow-ivory-browns and blue-grays. To find out which category is yours, hold a piece of white paper next to your mouth, smile and compare your teeth to the paper. If your teeth appear more yellow, wear red and orange shades to make your teeth appear lighter. Purple and pink hues will only accentuate the discoloration. If you fall into the blue-gray range, avoid reds and oranges, which cast warm undertones and make the cool color of your teeth more conspicuous. Instead, try bright pink, berry and purple shades. Another trick, which works regardless of tooth color, is to sweep your cheeks with bronzer and apply a sparkly, pale pink lipstick. There's nothing like a tan with light pink lips to make teeth pop and appear whiter. (For more on making your teeth look as white as possible, see pp. 180–181.)

How can I wear nude lipstick without looking washed out?

Modern nude lips are sheer and shiny, not pasty and caked on. And as confusing as this may sound, they're pale pink, not beige. Outline your lips with a pencil one shade darker than their natural color, but avoid muddy brown hues, which are unflattering. Choose a rosy taupe color if you have fair skin, a pale brick hue if you have an olive complexion, and coppery shades if you have dark skin. Then fill in lips with the pencil and top them with a pale, gold-flecked sheer pink gloss. Don't glop it on: The gold flecks will catch light and sparkle even if you have very little on. To counteract pale lips, wear peachy or pink blush. Bronzer will make you look monochromatic—just the effect you want to avoid.

How do I keep lipstick off my teeth?

To avoid staining your teeth with lipstick (a classic cosmetic faux pas), try this old-school (but still effective) trick: Insert the tip of your index finger into your mouth, close your lips around it, and pull it back out. The color on your inner lips will come off on your finger, not your teeth.

Do lip plumpers really work?

Yes, to a certain degree. By irritating the surface of the lip with ingredients such as alpha-hydroxy acids, lactic acid or even cinnamon, many plumpers can make lips appear temporarily swollen. However, the effect typically lasts only four or five hours. Newer plumpers contain ingredients such as hyaluronic acid and alpha-lipoic acid, which help your lips retain moisture and therefore look plumper. But again, the effect is temporary.

What happens when lipstick wears off?

The scary truth is: You eat it. As bizarre as it sounds, the average American woman consumes six pounds of lipstick over the course of her lifetime. But don't worry—a little lipstick along with your morning bagel won't hurt you. The waxes and polymers are nontoxic and are easily broken down by stomach acids.

JULIA STYLES

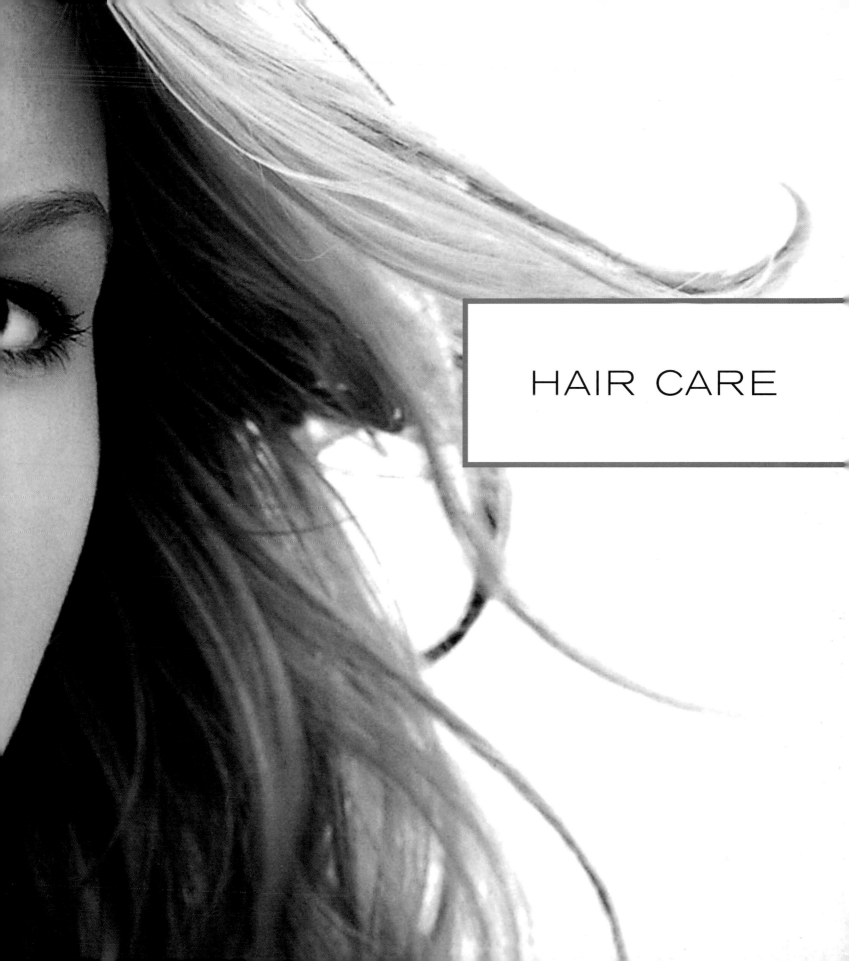

HAIR CARE

Samson was really onto something. As superficial as it sounds, there's no denying the fact: Hair is a tremendous source of strength, self-esteem and sex appeal. And because hair is usually the very first feature other people notice, it's the ultimate beauty barometer, clearly broadcasting a woman's personality, sense of style, even her age and social status.

HAIR BASICS

In decades past, stiff, structured coiffures ranging from beehives to bouffants to perms to power bangs reigned supreme. Today, healthy, lustrous, touchable hair is the gold standard—the softer, shinier and more moveable the better.

The possibilities are infinite. This chapter will explain how to get a flattering cut, choose the best products for your hair type, and style your tresses with skill and ease. It will demystify dozens of methods for altering your texture, color and cut, whether you crave a change that lasts a few months or just a few hours. And with any luck, it will inspire you to try looks you've never dreamed of—a true indication of inner strength.

MANDY MOORE

SHAMPOO AND CONDITIONER

Shampoo is, of course, soap for your hair. When mixed with water and massaged in with your fingertips, it removes sebum (oil), debris and product build-up from your scalp and hair. And despite what the labels say, you don't need to lather twice unless your hair is extremely oily or loaded with products. Rub shampoo between your palms before spreading it onto your hair, then massage it into your hair and scalp for about 30 seconds.

Conditioner helps repair hair damage caused by heat (both indoor and outdoor), hair dryers, UV rays, wind, salt water, chlorine and physical manipulation—as well as chemical treatments like perms and hair color. When your hair is damaged, the cuticle (the outer structure that overlaps like shingles or scales) becomes ruffled, resulting in frizzy, dull strands. Conditioners can be fortified with moisturizing agents (such as fatty acids and panthenol, a vitamin B complex) and cuticle-coating ingredients (including silicones and proteins) that render hair sleek and tangle-free. After rinsing, keep cuticles smooth by blotting your hair dry (don't rub) and detangling it with a wide-tooth comb, from the ends up to the roots.

You may be half-asleep when you wash your hair in the morning, but stay alert when shopping for shampoo and conditioner. The right ingredients make all the difference. Does a shampoo include a mild cleanser like sodium laureth sulfate or a stronger one like ammonium lauryl sulfate? Does it contain conditioning agents such as shea butter or propylene glycol, or astringents like tea-tree oil to soak up excess oil? (Along those lines, keep in mind that clear shampoos are more lightweight than creamy ones, which makes them better for oily hair. Creamy shampoos can weigh down fine hair, but are excellent for dry or damaged hair.) If you have strong, shiny, consistently manageable hair, use any product designed for "normal" hair.

SHAMPOOS AND CONDITIONERS FOR DIFFERENT HAIR TYPES

The names of many ingredients on shampoo and conditioner labels can be confusing. Of the hundreds you might see, those mentioned here are common and should lead you to the best products for your hair.

	SHAMPOO	**CONDITIONER**
COARSE, TIGHTLY COILED	This is the driest hair texture (the reason: oil produced in the scalp doesn't flow as easily down the hairshaft as it does on straight hair), so use a moisturizing, creamy shampoo. Shea butter and coconut and macadamia nut oil coat the hair shaft, trapping water inside. *Redken All Soft Shampoo ▶*	For extreme hydration, use deep conditioners containing moisturizing fatty alcohols like cetyl or stearyl alcohol (they should be the second or third ingredient on the label) as well as panthenol and methicones (silicone or dimethicone). Essential oils and botanicals (avocado or jojoba oil) also work. *Redken All Soft Conditioner ▶*
THICK, WAVY OR CURLY	This hair type tends to be dry, so use a rich, creamy shampoo containing gentle detergents such as sodium laureth sulfate, TEA lauryl sulfate and TEA laureth sulfate and water-binding ingredients like propylene glycol. Shampoo every second or third day so your scalp's natural oils condition your hair. *Garnier Fructis Fortifying Shampoo ▶*	Apply a conditioner containing a smoothing ingredient such as soy protein or wheat protein both before and after shampooing. Look for conditioners containing silicone and proteins to coat the cuticles and reduce frizz without being too heavy. If your hair is still frizzy, try a lightweight leave-in conditioner. *Garnier Fructis Fortifying Cream Conditioner ▶*
FINE, LIMP OR OILY	To volumize hair, use a clear shampoo that doesn't contain conditioning agents, which can weigh hair down. Look for bodybuilding ingredients like panthenol and proteins, which coat the hair shaft, thereby increasing its circumference. *Bumble and Bumble Thickening Shampoo ▶*	Use a lightweight conditioner from mid-shaft down to the ends, and rinse thoroughly, or spritz a leave-in conditioner onto the ends only. If your hair is extremely greasy, look for a conditioner containing oil-absorbing tea-tree oil. *Bumble and Bumble Tonic Lotion ▶*
DRY, DAMAGED	Use a creamy shampoo formulated with a mild detergent, such as sodium laureth sulfate, and rich conditioning agents like shea butter or lanolin, which smooth the hair shaft, detangle it and diffuse static electricity. Avoid clear shampoos. *Kérastase Bain Satin 3 ▶*	Apply a sizable dollop (the longer your hair, the more you need) of an ultra-moisturizing conditioner from the roots to the ends. Ingredients to look for include shea butter, natural oils and proteins. If hair is super damaged, don't rinse out conditioner completely. *Kérastase Masqueintense ▶*
COLOR-TREATED	Use color-protecting shampoo or color-depositing shampoo. Color-protecting shampoos contain fewer harsh cleansers than regular shampoos, so they're less likely to strip color. Extra moisturizers help hydrate hair and restore shine. Color-depositing shampoos contain actual pigment that remains on the hair. *L'Oréal Vive Color Care Shampoo ▶*	Use one formulated for color-treated hair. If your hair is highlighted or dyed blonde, deep condition it once a week; if it's dyed dark, do so every two to four weeks. A regular deep conditioner is fine, but avoid ones that contain silicone, which can strip color. *L'Oréal Vive Color Care Conditioner ▶*

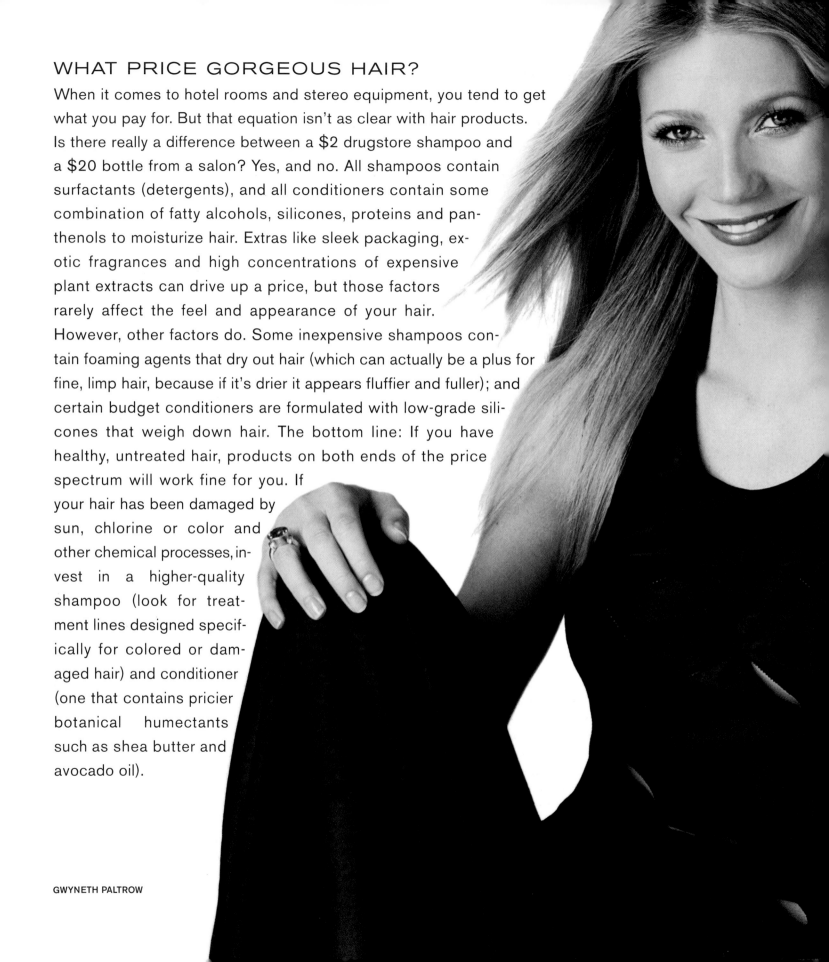

WHAT PRICE GORGEOUS HAIR?

When it comes to hotel rooms and stereo equipment, you tend to get what you pay for. But that equation isn't as clear with hair products. Is there really a difference between a $2 drugstore shampoo and a $20 bottle from a salon? Yes, and no. All shampoos contain surfactants (detergents), and all conditioners contain some combination of fatty alcohols, silicones, proteins and pan-thenols to moisturize hair. Extras like sleek packaging, ex-otic fragrances and high concentrations of expensive plant extracts can drive up a price, but those factors rarely affect the feel and appearance of your hair. However, other factors do. Some inexpensive shampoos con-tain foaming agents that dry out hair (which can actually be a plus for fine, limp hair, because if it's drier it appears fluffier and fuller); and certain budget conditioners are formulated with low-grade sili-cones that weigh down hair. The bottom line: If you have healthy, untreated hair, products on both ends of the price spectrum will work fine for you. If your hair has been damaged by sun, chlorine or color and other chemical processes, in-vest in a higher-quality shampoo (look for treat-ment lines designed specif-ically for colored or dam-aged hair) and conditioner (one that contains pricier botanical humectants such as shea butter and avocado oil).

GWYNETH PALTROW

DAMAGE AND DANDRUFF

The only way to cure damaged hair is to cut it off: Hair is dead, so trauma is not reversible. But there are ways to improve the way it looks and feels. If your hair resembles straw, apply a rich hydrating mask or deep conditioner and wrap your hair in a warm towel (straight from the dryer) for 20 minutes. The heat opens the cuticles and helps ingredients to penetrate into the hair shaft. A hot-oil treatment can also add shine and luster to ravaged hair. Administer these treatments once a week, and for extreme damage, try two or three times weekly. To protect weakened tresses from further wear and tear, take these precautions.

HOW TO PREVENT HAIR DAMAGE

CONDITION every single time you wash your hair to gradually add back moisture that's been sucked out over time by sunlight, chlorine and chemical processes. If your hair is extremely dry and brittle, apply leave-in conditioner in addition to regular conditioner.

DON'T TOWEL-DRY your hair. It roughs up the cuticles, making hair harder to comb. Instead, gently squeeze out water, wrap your hair in a towel, turban-style, until it is mildly damp, then use a wide-tooth comb to detangle it before blow-drying. (And whenever possible, don't blow-dry.) **IF YOU MUST BLOW-DRY,** protect your hair before blasting it with hot air. Products containing "thermal protection" (look for those words on the label) or silicone create a barrier between the heat and your hair, making the hair shaft less vulnerable to damage. Always hold your blow-dryer at least two inches away from your hair. Better yet, abbreviate the blow-drying process. Let it air dry for 30 to 45 minutes—until it's almost dry. Then dry your hair on low heat, fluffing it with your hands, until it's 80 percent dry, then style.

USE THE WARM SETTING ON STYLING TOOLS like curling irons and flat irons. Choosing warm over hot will decrease the chances of damage. Also, never let an iron sit still on your hair.

SLEEP ON SATIN PILLOWCASES, especially if you have dry, curly hair. Regular cotton fabrics create friction, which ruffles the cuticle and makes hair frizzy.

DANDRUFF

Flakiness is never attractive, but in hair (if not in personality) it's very treatable. Dandruff is caused by excess sebum, or oil, on the scalp. Your scalp is constantly shedding dead skin cells, which normally get washed away. The scalp also hosts a fungus called pityrosporum ovale, which lives in the skin. Normally, the levels of this fungus are too low to do anything. But when the scalp produces excess sebum, these yeast-like organisms proliferate, inflaming hair follicles and accelerating the shedding of dead skin cells, which fall off in large, oily flakes.

The best remedy is to rotate three over-the-counter dandruff shampoos—one containing salicylic acid (to exfoliate), one containing selenium sulfide (to soothe) and a third containing pyrithione zinc (an anti-inflammatory)—interspersing them with a regular shampoo every other day. A trio of treatments is most effective because if you use only one active ingredient, the fungus can adapt and become immune to it. Make sure to use a matching conditioner with the same active ingredient as the shampoo.

When shampooing, massage your scalp vigorously (using the pads of your fingertips, not your nails) to loosen flakes so they can be rinsed away, and leave the lather in your hair for three to five minutes. Rinse thoroughly, since residual shampoo can lead to more flaking. If that regimen doesn't fix the problem, see a dermatologist. (Bear in mind that flakes don't always indicate dandruff. They can also be caused by product build-up on your scalp or an extremely dry scalp.)

An impeccable haircut is a powerful anti-depressant. No matter how frumpy or grumpy you feel, it can pull your entire look together, bringing out your features and bone structure beautifully, reflecting your personality and sense of style, and working in proportion with your body to create a polished silhouette from head to toe.

No wonder a talented hairstylist is such a precious commodity. Since you'll be seeing (and paying) this person every six to eight weeks, don't settle. The best way to find a star is to ask around—and don't be shy about it. The most successful approach by far? If you see a stranger with your hair texture (that's key) who has a gorgeous cut, ask her who did it. If you read about a rising star in a magazine, call to schedule a consultation. And if you come across pictures of a fashionable hairstyle you covet, tear them out and take them to the salon—pros swear they welcome the effort and input.

A true hair master should be able to quickly assess the best styles for you based on your face shape and hair texture. But it doesn't hurt to be proactive about it, so do some homework before your appointment. If you are unsure of your face shape, look in a mirror and trace its outline on the mirror with lipstick. Then consult the following charts on face shape and hair texture for a selection of super cuts for you.

MAKE THE MOST OF YOUR NATURAL HAIR TEXTURE

There's something refreshing (and healthy) about embracing the locks you were born with. If you choose to go au naturel, consider these tips in addition to your face shape and hair length when picking a cut (refer to the face-shape chart on the opposite page as often as you need, since knowledge is power, particularly when you're about to get chopped).

STRAIGHT	CURLY	WAVY	FINE
A blunt cut can look dramatic— or too severe. Softly angled layers add texture and create movement by removing weight.	Have long layers cut into your hair underneath the surface to remove bulk.	For short hair, cut long layers at soft angles; ask for vertical angles on longer styles.	Cut layers into dry hair according to how your hair falls around your face, or choose a blunt cut; it will make hair appear thicker.

FLATTERING CUTS FOR DIFFERENT FACE SHAPES

The following rules are hardly set in stone, so feel free to ignore them completely. But if you're starting from scratch, they can help you narrow down your options.

OVAL

This is the most versatile face. A number of different styles will work, but whatever length you choose (unless you're going for a blunt cut), ask for layers near your cheekbones, lips or chin—whichever features you want to highlight. On shorter cuts, have your face framed with layers that skim (and therefore accentuate) the cheekbones; for longer looks, have the layers start at your cheekbones (which can help if your face is narrow as well as oval). Avoid short layers that add volume on top because they'll make your face look long. If your hair is thick or curly, don't get a blunt cut; you'll look like a pyramid.

JESSICA ALBA

SQUARE

The most flattering cuts soften the jawline with face-framing layers, but short, spiky looks and long, sleek styles with layers that start at the jawline and continue downward also look good. Avoid one-length bobs, especially chin length, and blunt-cut bangs; both will make your face look even more square. If you have curly hair, use layers to minimize side volume.

GWYNETH PALTROW

LONG

Chin-length cuts and bobs are ideal for women with long faces because they create the illusion of width. Curls and waves can also add breadth to your face and help it appear more oval, but avoid short layers that add volume on top. If you have straight hair, create width with bangs. Extremely long or short cuts will elongate your face, so take the middle ground.

HILLARY SWANK

HEART

The eyes and cheekbones are the focal points of this face. If you have short hair, draw attention to those features by keeping your top layers soft and long. (Side-swept bangs can have the same effect.) If you have long hair, downplay a pointed chin with long, wavy layers that graze your cheekbones and fall around your neck. Avoid blunt-cut bangs and harsh, choppy layers; subtle layers are more flattering.

BRITTANY MURPHY

ROUND

Styles that fall below the chin often look best, and layers from the lips down remove bulk and weight from the sides. Wispy and tapered ends de-emphasize roundness by allowing hair to fall close to your head, while one-length cuts tend to widen your face. If you have shorter hair, avoid blunt cuts. Instead, have layers snipped around your face to add some dimension and ask for more volume on the crown to lengthen your face.

JULIA STILES

TRIMMING YOUR OWN BANGS

Plenty of salons offer free bang trims to regular clients; just call ahead and tip the amount you would for a shampoo ($3 to $5). Otherwise, do it yourself. The ideal scissors are sharp, pointed and no more than five inches long. (Your best bet: Buy them at a beauty supply store.)

STEP ONE

If you usually blow-dry your bangs, apply styling gel and blow them dry using a round brush. If wash-and-wear is more your speed, let them air dry. Either way, never cut bangs when they're wet; they'll shrink when they dry and look too short.

STEP TWO

Use a comb to precisely section off the hair you do not want to cut. Tuck it behind your ears or pull it back into a ponytail. Only your bangs should be left loose.

STEP THREE

Using a styling comb (which is long and straight, with baby-fine, inch-long teeth), divide your bangs in half. Starting with one half, comb down bangs (comb teeth facing out) and rest the comb on your brow bone as a safeguard: Don't cut your bangs any shorter than the point where the comb hits your face.

STEP FOUR

Start "point-cutting," or snipping into the bang section at a 45-degree angle. Do a bit at a time, moving slowly. Repeat on the other half. Never cut bangs straight across; it's nearly impossible to keep a straight line.

STEP FIVE

Check the results. If they're too dense, cut layers by sandwiching a section of bangs between two fingers and pulling it vertically above your head, sliding your hand up toward ends and letting some strands fall. Then, lower your fingers an inch down the hair section and point-cut (a half-inch, at most) above your fingers.

FRINGE BENEFITS

There's something sexy about bangs. No matter what your age or ethnicity, a fringe is simultaneously feminine and fun-loving, girlish and come-hither. Some celebrities experiment with blunt bangs cut straight across; others opt for a soft, side-swept look reminiscent of Brigitte Bardot.

SUSAN SARANDON

Sarandon's bangs blend naturally into her hair at the 2004 Golden Globe Awards.

LUCY LIU

Liu's blunt, eye-skimming bangs give her hair instant body and texture.

AISHA TYLER

Tyler pays homage to Audrey Hepburn with full bangs styled to the side.

CATHERINE ZETA-JONES

A sheet of gently swinging bangs adds to Zeta-Jones's sex appeal.

EVE

Eve's short, choppy bangs give her charming gamine appeal.

HEIDI KLUM

Klum transforms her face with a delicate wispy blond fringe.

SHORT CUTS

Sweet or spiky, short hairstyles closely frame the face, making your features the center of attention. They're also incredibly low-maintenance, which is why many stars prefer a pixie to a long, flowing mane.

SHARON STONE

Stone's blond pixie looks both youthful and elegant at the 2004 Golden Globe Awards.

KIRSTEN DUNST

Dunst's casual cap of hair is both mod and totally modern.

NATALIE PORTMAN

Portman does a perfect impression of Louise Brooks at the *Cold Mountain* premiere.

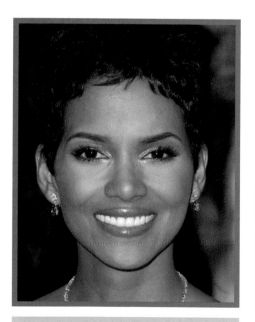

HALLE BERRY

It takes confidence to cut bangs very short, as Berry does for one of her signature looks.

MANDY MOORE

Moore sports long bangs, which also have the flexibility of being pinned back.

BRITTANY MURPHY

Murphy artfully camouflages a high forehead with well-placed strands.

HAPPY MEDIUMS

Hair that hovers around the shoulders wins for versatility. It can be worn up or down, wavy or sleek, and it's a bit easier to manage than extremely long tresses. Here, a range of possibilities.

NAOMI WATTS

Watts radiates 20s glam with loose, marcel curls at the 2004 SAG Awards.

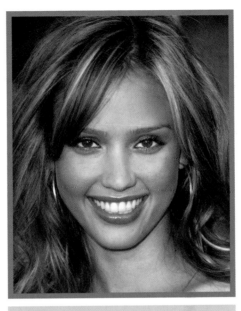

JESSICA ALBA

Alba's fluffy, slightly unkempt hair strikes the right tone at the 2003 Teen Choice Awards.

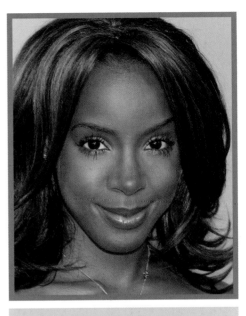

KELLY ROWLAND

Rowland's blown-out locks look groomed yet sexy at the 2003 *Freddy vs. Jason* première.

CATE BLANCHETT

Blanchett's tousled, shiny hair gives her a feminine look at the 2004 Berlin Film Festival.

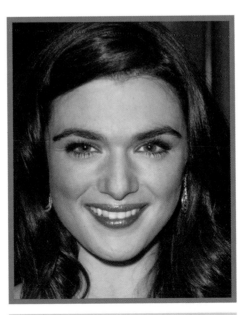

RACHEL WEISZ

A low side part adds style to Weisz's hair at the 2003 BAFTA/LA Britannia Awards.

CHARLIZE THERON

At the 2004 Berlin Film Festival, simple lines from Theron's straight locks frame her face.

GREAT LENGTHS

There's a simple reason little girls beg to grow their hair long: It's incredibly pretty and romantic. It's also a centuries-old emblem of femininity and healthiness. These celebrities are carrying on that tradition.

DEBRA MESSING

Messing's ringlets go well with a plunging neckline at the 2003 SAG Awards.

JANET JACKSON

Extensions give Jackson an extra jolt of glamour at her album launch party in March 2004.

KATE BECKINSALE

Beckinsale beautifully updates a classic 70s style at the 2004 première of *Van Helsing*.

LIV TYLER

Tyler wears her tresses loose and natural at an MTV appearance in 2003.

JESSICA SIMPSON

Simpson displays her classic full-bodied hair at a book signing in 2003.

JENNIFER LOPEZ

Lopez's gravity-defying style uplifts her face at a party in New York City in 2003.

Hair color is the key to reinvention and the true crux of any makeover. Celebrities as diverse as Julia Roberts and Gwyneth Paltrow, Jennifer Lopez and Halle Berry, have experimented with a rainbow of tones (and even created movie characters with the help of a simple single process).

Outside of Hollywood, of course, subtler shifts are the norm—and they, too, can have a profound impact. But a fresh new look comes at a price when it's done professionally. An initial dye job costs between $50 and $300, depending on the salon. Add highlights, and you'll pay anywhere from $75 to $400. The farther you stray from your natural color, the higher the cost and more frequent the maintenance. That's why it's crucial to schedule a free consultation with your colorist to discuss how much time and money you're willing to spend—before he or she even touches your head.

If you want a change but don't have the cash, consider dyeing your hair at home. Today's formulations are not only gentler and more hydrating than ever before, but they're also more foolproof; follow the directions, and what you see on the box should be what you get. But keep it simple. If you plan to venture more than two shades from your existing color, or do a base color and highlights (versus highlights on virgin hair or existing color, which can be done at home), or have permed, relaxed or very damaged hair, pay a pro.

JULIA ROBERTS

Plenty of actresses color their hair for roles, or shift a shade or two for fun in real life. Julia Roberts goes farther, bouncing around the spectrum as the mood strikes—and dazzling in each incarnation. In the last few years, Roberts has gone brunette, platinum blonde and red.

DIFFERENT COLORING PROCESSES

The pros recommend that you live with a permanent color for at least three months, since changing your hue more frequently can lead to severe hair damage. But thanks to a range of different formulas—available both at home and in the salon—even commitment-phobes can safely channel their inner chameleons.

	WHAT IT DOES	HOW LONG IT LASTS	THE IDEAL CANDIDATE
SEMIPERMANENT	This kind of hair color only deposits pigment. Because it doesn't contain ammonia or peroxide (i.e., bleach), it can't lighten hair—just darken it.	Six to 12 shampoos.	First-time users who want to subtly enrich their natural shade.
DEMIPERMANENT	This hair-color treatment contains low levels of hydrogen peroxide but is ammonia-free, so it deepens and intensifies your existing color but doesn't lighten it.	24 to 26 shampoos.	Someone who wants to give her natural color a boost for a few weeks with minimal damage to her hair.
SOFT PERMANENT	A newcomer to the home-coloring category, this formula has small amounts of ammonia and peroxide. It can lighten hair as much as one-and-a-half shades, and you can go longer between touch-ups than with permanent color because the results aren't dramatic.	Forever, but roots show in anywhere from two to four weeks, depending on your hair color.	Women with blond, red or brown hair who want to brighten up a little bit without doing anything drastic.
PERMANENT	This formula contains a blend of peroxide and ammonia (or an ammonia substitute), and it removes pigment from hair and deposits a new color. These products can lighten or darken hair up to three shades.	Forever, but roots start to show in anywhere from two to four weeks depending on hair color.	Because the change in color can be significant, only women with extensive at-home experience should use permanent color kits; newbies should go to the salon.
HIGHLIGHTS	Highlights lighten a few locks without changing your base color. The lighter strands don't necessarily need to be blond. If you have dark hair, for instance, you can add light brown, red or caramel highlights. An added bonus: Roots are less obvious when your hair is more than one color.	Forever, but you need touch-ups every four to 16 weeks, depending on how strongly your highlights contrast with your base color. The subtler the difference between shades, the longer you can wait.	A woman who wants to brighten her base color (and her complexion) by adding sunny-looking streaks around her face and the crown of her head.

CHOOSE THE BEST COLOR

Now that you've familiarized yourself with every hair-coloring procedure available, it's time to choose a color that will make your complexion glow from within. At the salon, your colorist should be able to offer several suggestions as soon as he or she sees your skin tone. But give it some thought beforehand. As with makeup, it's best to let your skin tone be your guide. To determine whether you have warm or cool undertones, hold a white piece of paper against your cheek. If your skin looks pink against the paper, you're cool. If your skin appears yellow or olive, you're warm. (For more advice on figuring out your skin tone, see p. 46.)

A cool skin tone means you should avoid hair colors in warm tones such as gold, auburn or copper, which will bring out the pink in your skin. Instead, try icy or ashy (green-based) shades like beige or champagne. Women with warm skin can get away with many more hues (witness Jennifer Lopez, Jennifer Aniston and Beyoncé). But in general, use warmer shades to offset the yellow undertones of your skin, and avoid ashy tones; they'll make you look sallow. More specifically, beware of bright blond shades, which can bring out the green in olive skin; try caramel or butterscotch instead. (If you're making a marked color change, don't forget to have your brows dyed as well—a shade or two darker than your hair color. For details, see p. 59.)

PROFESSIONAL HIGHLIGHTS

Some highlighting hints: Because uniform stripes are a dead giveaway, the most realistic-looking highlights are slightly irregular in width and spaced at different intervals. And plenty of your base color should show through to create contrast; too many lightened strands will wash out, rather than wake up, your complexion. If these tips sound far too technical, go to a professional, who will use one of the following methods.

BASIC HIGHLIGHTS

In the most common highlighting method, a small section of hair is gathered with the point of a rat-tail comb and laid on a square piece of foil. Bleach is painted onto the hair until it's saturated, then the foil is folded over the section.

BALIAGE

Sometimes referred to as "hair painting," this is a European coloring technique where highlights are painted on your hair without foils. (Cotton batting or plastic wrap may be used to separate bleached sections from the rest of your hair.) Baliage is the most artistic form of highlighting because the colorist can clearly see where he or she is putting the color. It's also the least artificial-looking when your hair grows out, because the roots are less obvious (no foil means no strict lines of demarcation).

CHUNKING

Popularized in the nineties, chunking is a technique in which big sections are lightened with one color. "Piecing" is a more evolved form of chunking. Colorists still work with sizable sections, but they use a number of light shades within each for a more three-dimensional, less bleached-out effect.

LOWLIGHTING

Darker strands are woven into lighter hair to create depth. This is also a common strategy for downplaying gray hair without subjecting yourself to a full dye job (for more information on covering grays, see p. 116).

HIGHLIGHTING HELPERS

Highlights are an expensive habit. Instead of getting a full head of highlights every time you go to the salon, alternate between full-head ($75 to $400) and partial-head ($50 to $150) highlights. To hide roots, give yourself a crooked part; the lines of demarcation will be blurrier.

DOING IT YOURSELF

If you've ever experimented with your hair color, you might have a horror story about dyeing your own tresses at home and ending up with disastrous results—usually of the green, purple or orange variety. To avoid this nightmare (and the expensive trip to the salon to correct your embarrassing mistake), remember to take your time and carefully follow the directions on the box. Today's kits are very sophisticated and hard to mess up, but that's no reason to throw caution to the wind. Supplement the printed directions with these expert tips, and you'll be sure to end up with luscious, long-lasting color.

HOME-DYEING TIPS

Bleaching or darkening hair in the privacy of your own bathroom? For beautiful results, follow these guidelines:

DON'T GO MORE than two shades lighter or darker than your natural color. On home kits, you'll find a chart that indicates how the shade on the box will work with your hair color. If you don't see your natural hair color on the chart, move on to another kit.

WAIT TWO WEEKS before coloring if you've had your hair chemically straightened or permed—particularly if you want to go lighter. All of those procedures are hard on the hair, so give your tresses a break in between.

DON'T WASH YOUR HAIR the day before you color. Your hair's natural oils will help protect your scalp from irritation.

IF YOUR HAIR IS VERY DRY, deep condition it (without washing it) the day before you dye it. Dry hair grabs pigment quickly, so color can develop unevenly.

DO A STRAND TEST on a bit of hair that you don't normally see (a good spot is behind your ear). This will help you gauge how long you'll need to leave on the solution to get the color you want.

WAIT A FULL DAY after coloring to wash your hair. The pigment needs 24 hours to settle into the hair shaft.

MAKING IT LAST

Considering all the effort (and expense) involved in coloring your hair, it pays to follow these tips for keeping it bright and shiny.

USE ONLY shampoo and conditioning products made for color-treated hair because they contain ingredients that condition and coat your strands, preserving the freshness of your color. Many regular shampoos contain strong detergents that strip hair of dye.

USE A COLOR-DEPOSITING SHAMPOO that contains pigments that stay in your hair once a week to boost luster (see Shampoos and Conditioners chart on p. 101).

CHECK LABELS on styling products to avoid ingredients that will have adverse effects on color-treated hair. Most contain alcohol, which can suck the shine right out of your hair.

HIDE GRAY ROOTS with a touch-up stick or even a dab of eye shadow (for more on covering gray, see p. 116).

Q&A

I want to save time in the morning. How effective are two-in-one shampoos and conditioners?

If your hair is healthy and hasn't undergone a lot of chemical processing, a two-in-one will probably work for you. Most shampoos contain conditioning agents anyway, but a two-in-one has added moisturizing agents to make hair glossy. However, if you have oily hair, you don't need the extra moisture. A two-in-one could coat your locks and leave them feeling heavier and greasier than before. Frequent shampooers should also steer clear: The detergents in shampoo strip hair of its natural oils, so you need a separate conditioner to replenish them. Two-in-ones aren't sufficiently hydrating for dry, damaged hair either because they don't contain enough conditioners.

I know AHAs exfoliate skin, but what do they do in shampoos and conditioners?

Alpha-hydroxy acid-based hair products have a higher pH than skin-sloughing products containing AHAs, so instead of exfoliating the way a facial cream does, they act as humectants, helping bind water to the hair shaft and sealing down cuticles, which results in heavy-duty moisture plus shine.

How can I prevent hair static?

When air is dry, especially in winter, static electricity is almost inevitable. To keep your hair from standing on end, try not to rub your head with hats and scarves, and keep blow-drying and other heat styling to a minimum. Avoid volumizing and clarifying shampoos, which can strip hair of natural lubricants. Also, a boar-bristle brush can help transport oils from your scalp to the ends of your hair. And most important, condition religiously to lock moisture into your hair strands. To get rid of fly-aways on the spot, try these foolproof (and resourceful) tricks from the pros: Spritz a hairbrush with Static Guard and run it through your hair; run newly moisturized hands through hair; or rub a dryer sheet across the surface of your hair.

Can I trim split ends myself?

Certainly. A split end occurs when the outer cuticle at the end of a hair strand dries out and splinters from excess brushing, blow-drying or chemical processing. Simply cut each strand one at a time, right above where it splits. For best results, use small, sharp scissors and trim every three months for long hair and every six weeks for short hair. (If you have a geometric blunt cut, snip your split ends less frequently, or you risk ending up with a jagged haircut.) To help prevent split ends, deep condition once a week.

What's the best way to hide my gray hair?

Permanent processes are the only way to completely cover gray, but because gray hairs have no pigment and are more resistant to color, they may turn lighter than the rest of your hair, making them look like highlights (which could be a good thing, depending on your preference). Semipermanent color and highlights work, but only if you have 15 percent gray hair or less, because they don't cover gray; they just help it blend. Vegetable dyes formulated for blondes won't provide coverage, but they'll render grays more translucent; those designed for brunettes can temporarily stain small amounts of gray. To camouflage grays between color jobs, use mascara, eye shadow or a temporary touch-up stick, but remember that rain, humidity or perspiration can make all of those cover-ups run.

What causes brassiness, and how can I get rid of it?

If your natural hair color is brown or darker, reddish tones are bound to surface when you go lighter. You can turn down the volume by choosing a cooler tone. But beware: As hair color oxidizes, even cool hues can turn brassy. To minimize damage, always wear a hat in the sun and wash with mild shampoos for color-treated hair. If your hair color goes off, use a blue or violet shampoo every third time you wash it; the blue tones will help cancel out any yellow or orange.

Help! I hate my new hair color! What can I do?

First of all, don't panic and attempt an emergency at-home color session; chances are, you'll only make matters worse. Second, sit tight for as long as possible. If you re-color your hair right away, you'll traumatize the already-processed strands. Wait at least a few days; a few weeks is ideal. Then, if you trust your colorist, ask him or her to correct it by dyeing it lighter or darker (and if you don't trust your colorist, go to someone new). In the meantime, buy a strong, detergent-based shampoo: Check the label for ammonium laurel sulfate—not sodium laureth sulfate, a gentle cleanser (see chart on p. 101)—to help fade the color. Never use bleach, which will result in muddy, uneven tones. Once you're back at the salon, your colorist can apply a product that will "erase" a hue that's too dark and restore hair to its previous shade rather than tone it down. Two effective (and commonly used) "erasers" are Rusk Elimin8 Color Corrector and Schwartzkopf Igora Color Cleanse. Your colorist will choose the optimal approach for your particular texture and hair-coloring history.

Is it safe to color my hair when I'm pregnant?

Doctors have different opinions on this issue (in regard to both the dye contacting the scalp and to the strong fumes), and several studies have provided no conclusive evidence either way. Since the amount of chemical absorbed through the scalp during hair coloring is minute, many experts don't believe it does any real harm to a baby. Still, many doctors prefer to play it safe by recommending that their patients wait until after the first trimester (the period in which the fetus's major organs are developing) to use semi-permanent and permanent dyes. If patients are still concerned after the first three months, they can use chemical-free vegetable dyes, or skip the single process and get highlights only. Even though there are chemicals involved, there's less chance of their being absorbed into the bloodstream because highlights are applied to individual strands, a few millimeters away from the scalp.

I'm growing out my bangs and they're in that awkward middle phase. How can I keep them out of my eyes?

Make overgrown bangs look lighter and less severe by putting a little styling gel on your fingers and scrunching your bangs up a bit, or by blow-drying them with a large round brush to give them more curve and shape. If your bangs are too long for these tricks or you prefer them to look sleeker and tidier, blow-dry them off to the side and secure them with a bobby pin.

My hair keeps breaking and won't grow past my shoulders. What can I do?

With the right routine, you should be able to grow your hair long. To make hair pliable, deep condition it twice a week with a conditioner containing proteins (try J.F. Lazartigue Salmon Protein Hair Restorer, $28; 800-359-9345). Apply it to damp hair and leave it on for 30 minutes before shampooing. After shampooing, use a vitamin-enriched conditioner like Pantene Pro-V Repair & Protect Intensive Restorative treatment (available at drugstores for about $4), which further fortifies your strands. Last, work some Redken Extreme Anti-Snap ($14; 800-733-5368), which protects against breakage, into towel-blotted hair, and let hair air-dry or blow it dry using low heat. To further prevent tearing your hair, use a brush with widely spaced plastic bristles. If this aproach doesn't help, see your doctor. Fluctuating hormone levels or vitamin or mineral deficiencies can retard hair growth.

I've been dyeing my hair blond for years and I want to return to my natural hair color. What's the best way?

You have two options: You can have your hair colorist gradually weave in lowlights until your hair gets back to its original color, or you can apply semipermanent color all over your hair.

THANDIE NEWTON

HAIR STYLING

Sift through old photographs, and you'll realize there's one surefire way to determine when they were taken: Examine the hairstyles. Yes, leisure suits and prom dresses are also dead giveaways. But hair, whether curled into a flip or feathered like Farrah Fawcett's, is an unerring sign of the times. It's also a resounding expression of your inner beauty, so style—and wear—it well.

Back in the day, women had their hair professionally done once a week—and then spent lots of time and energy keeping the style fresh until the next appointment. Now there's no need to heap on the hairspray, tease the roots, sleep with scarves on, or avoid swimming at all costs. Today's vast selection of styling products and tools gives you carte blanche to style your own hair like an expert any time you'd like. However, before you begin transforming your tresses, be realistic about where you're starting from and map out what you want to achieve. Then learn the lingo and get the details right: Small nuances like the density of styling wax or the width of a curling iron can mean the difference between looking like a ripply-haired Greek goddess and an unsuspecting perm victim.

DEBRA MESSING

STYLING PRODUCTS

If the hairstyling section of the drugstore makes your head spin, refer to the following glossary, and all those sprays and serums will be guaranteed to be less confusing. To make sure a product will work with your hair texture, just read the label—most of them target specific hair types. Once you're home, be careful not to overload your hair with product; it'll get greasy and heavy. Use a light hand and add more product as necessary.

HEAT-PROTECTANT SPRAY

BEST FOR: Protecting hair from the ill effects of blow-dryers, irons and hot rollers; setting a style so it has staying power.

TO USE: Apply to wet hair and blow-dry. For a lasting hold, spray dry hair section by section and set with an iron or hot rollers.

ANTI-FRIZZ SERUM

BEST FOR: Smoothing frizz, adding shine and conditioning. Most contain silicone, which sits on top of your hair shafts and also protects hair from heat.

TO USE: Smooth a dime-size amount through wet hair (if you apply more than that, your hair may feel greasy). Air-dry or use a diffuser on your hair dryer for curls, or blow-dry for straight hair using an additional styling cream or straightening balm. (For blow-drying advice, see pp. 124–131.)

MOUSSE

BEST FOR: Soft hold and volume for fine or limp hair, and definition for curly hair.

TO USE: Rub a table-spoon-size dollop in your hands and apply it to wet or damp hair, starting two inches from your roots. (Apply it from roots to ends on curly hair.) Blow-dry with your head upside down for maximum volume.

HAIRSPRAY

BEST FOR: Holding a hairstyle in place and protecting against humidity.

TO USE: To avoid helmet head, look for a flexible, soft-hold formula. Position the container eight to 12 inches away from your head and spray it over styled hair. For extra body, lift sections and spray close to the roots. A light mist is the safest bet; you can always add more.

STYLING GEL

BEST FOR: Providing volume and strong hold for short hairstyles. Gels do the job with water-soluble resins and silicones. Opt for alcohol-free formulas, which won't dry out hair—or leave suspicious-looking flakes. (When scanning the label, remember that cetyl alcohol is actually moisturizing.)

TO USE: Coat your palms with a thin layer of gel and work it through damp hair from roots to ends. Style hair and allow it to dry naturally for a wet look, or blow-dry with a diffuser. Excessive brushing and blow-drying can minimize gel's effect.

Redken Hot Sets Thermal Setting Mist

Kérastase Serum Oleo-Relax

Tresemmé Volumizing Mousse

Sebastian Shaper Hair Spray

L'Oréal Studio Line Mega Gel

VOLUMIZING SPRAY

BEST FOR: Boosting body in fine or oily hair. The most common effective ingredient is flexible resins, but sprays containing sea salt also add texture and volume.

TO USE: While your hair is still damp, spray the roots and first two inches of the hair shaft. Blow-dry with your head upside down. Avoid applying volumizers to the ends of hair—they don't contain as many conditioning agents as mousse, and may cause brittleness.

WAX/POMADE

BEST FOR: Smoothing flyaways and adding texture to straight, layered hairstyles. Waxes, which feel light and slippery, and pomades, which come in denser paste or cream form, are both petroleum jelly-based products so be wary of over application.

TO USE: For a strong hold, choose a hard, dry wax; for a lighter hold, select a soft wax or pomade. If you have fine hair, use a light, water-based wax.

STRAIGHTENING BALM/GEL

BEST FOR: Conditioning, smoothing and straightening dry, wavy hair by temporarily smoothing down the cuticles. Unlike anti-frizz serums, many balms offer holding power, which is crucial for straightening.

TO USE: While hair is wet, rub a quarter-size amount between your palms and smooth it onto hair from roots to ends. Blow-dry hair in sections. (For detailed blow-drying instructions, see p. 136.)

SHINE SPRAY

BEST FOR: Enhancing shine in dull, dry or damaged hair. Don't use it on fine or oily hair because it can add weight and make your hair look greasy.

TO USE: Hold 12 to 14 inches away and mist it lightly over dry, styled hair. If your hair is thick, add an extra spritz under the top layer.

STYLING CREAM AND LOTION

BEST FOR: Smoothing and straightening coarse, curly hair. Heavier than balms (which feel waxy), some styling creams and lotions primarily moisturize; others contain the same holding ingredients as balms.

TO USE: Apply a dime-size amount to wet hair, then blow-dry. You can also work a dab of styling cream through dry hair to make frizzies lie flat.

Phytovolume Actif

Murray's Superior Hair Dressing Pomade

Phytodéfrisant

Sebastian Laminates Hair Spray Finishing Polish

Kérastase Creme Nutri-Sculpt

BLOWOUT BASICS

Weekly blowouts at the salon will quickly drain your bank account. However, with powerful professional tools and high-performance styling products at your fingertips, there's no reason not to become the master of your own mane. There are lots of easy tricks for enhancing or transforming your hair, no matter what your natural texture or length is. And if your tresses don't look salon-perfect when you're finished? All the better. Quirky bends and uneven waves add personality.

HAIRBRUSHES

A good hairbrush is the little black dress of styling tools: Everyone should own one. The highest-quality brushes have a rubber base, which allows bristles to flex, so they won't irritate your scalp or yank your hair. To get the most bang for your buck, invest in a brush that is tailor-made for your needs.

FOR SMOOTHING AND STRAIGHTENING

An oversize paddle brush is perfect for polishing hair or getting short bobs to lie flat. It's also good for blow-drying very long hair because it can grab many strands at a time.

Mason Pearson

FOR VOLUME

Medium to large round brushes are the best for getting lift at your roots and curling your ends. Look for one with a metal base, which holds and conducts heat to make styling easier. If you have long hair, try a wooden brush with natural bristles, which is easier to maneuver and less likely to snag.

Spornette

FOR BANGS AND SHORT LAYERS

A tiny round brush assures great hold for styling and curling short hair. The shorter your hair, the smaller the barrel you need.

Frédéric Fekkai

BRISTLES BREAKDOWN

When choosing a hairbrush, bristles really matter. Here's a breakdown of the different kinds and who should use them.

BOAR

These are best for fine to normal hair, as well as African-American hair. They reduce frizz and help make hair shiny. They're gentle on your hair and your scalp.

NYLON

Best for very coarse, thick hair, nylon is strong enough to pull through even the most tangled strands. (Boar bristles are too soft.) Closer-set bristles give more control when smoothing and straightening hair.

METAL

If you have a lot of highlights, blow-drying hair with a brush with metal bristles can help bring back shine because they conduct heat from your hair dryer to seal cuticles flat (but they won't leave hair stick-straight).

HAIR DRYERS

When you shop for a dryer, look for one with at least 1,875 watts if you have thick hair and 1,500 watts if your locks are thinner. Other important features to consider are a cool-shot button to set hair and lock in a style, as well as multiple heat and speed settings to create specific looks (for details, see pp. 126–131). To pump up your volume, buy a dryer with a diffuser, which lifts hair and evenly distributes airflow underneath (you can also add a diffuser to an existing dryer). To straighten hair, look for a dryer with a narrow nozzle attachment, which concentrates airflow. For smoother, less staticky strands, try an ionic dryer, which cuts down on drying time by producing negative ions that reduce the size of water droplets and seal moisture into the hair shaft so it looks sleek, not frizzy.

KEEP YOUR BLOWOUT FRESH

A professional blowout should last three days; an at-home blowout should last two. If yours wilts within 24 hours, you may have used too much product when blow-drying. Whatever the cause, these expert tricks can breathe new life into fizzling—or frizzing—locks:

MAINTAIN	FRESHEN	PROTECT
To preserve volume and keep long, straight hair smooth while you sleep, put it in a ponytail on top of your head before bed. The next morning, wrap the top sections around Velcro rollers and blow-dry them on low heat. The warm air will smooth any bumps from the night and add bounce.	To liven up flattened curls, flip your head upside down; then massage the hair near your scalp in a circular motion or give it a quick blast with a blow-dryer. Go easy when adding styling gels and sprays on the second day; they can weigh hair down.	When you work out, use a headband with teeth or a coated elastic to pull hair loosely back, away from perspiration. Tying it up tight or high on your head will result in strange-looking bumps. Not to state the obvious, but . . . wear a shower cap in the shower.

STRAIGHT HAIR

Naturally straight hair can benefit from blow-drying in two ways: Hot air applied with a nozzle will render it as sleek as satin, and low heat and some tousling can inject it with lift and movement.

SHORT AND PIECEY

STEP ONE

Blot your hair with a towel. Mix a dime-size amount of styling cream with twice as much gel and work it through your hair.

STEP TWO

Set the dryer on low speed, low heat, with no attachments. While drying, add texture and movement by tousling and twisting sections of your hair with your hands and scrunching the roots for lift.

STEP THREE

Smooth the ends with pomade.

CATE BLANCHETT

THE QUICKIE

Rub a mixture of styling cream and gel between your palms and massage it into your hair. Blow-dry with your hair flipped upside-down to automatically create lift at the roots. When your hair is dry, flip your hair back up and style it with your fingers.

THE FULL TREATMENT

Work the styling cream and gel mixture through your hair. Separate small sections so they look piecey, and scrunch your roots to add volume. Blow-dry on low speed, low heat. When your hair is mostly dry, grab a small section next to your face between two fingers and flip the ends upward. Holding the ends between two fingers, blow high heat on the ends. Grab another small section and repeat, continuing all the way around your face. The heat helps set the style and also gives hair both movement and lift. For a modern, piecey texture, put a dime-size amount of pomade into your palm and use your blow-dryer on low speed to soften it. Rub your hands together to distribute the pomade evenly on your palms, then scrunch it into hair. Smooth your ends with any remaining product.

STRAIGHT AND SMOOTH

MISCHA BARTON

STEP ONE

Work a quarter-size amount of straightening balm through damp hair. Adjust your dryer to high heat and high speed, attach a nozzle, and use your hands to move hair around, lifting it at the roots, until it's 80 percent dry. Divide your hair into four or five sections, clipping up all but the bottom layer.

STEP TWO

Wrap one section once around a large, round boar-bristle brush. Slowly pull the brush down until the section is fully extended and taut, drying hair in a downward motion as you move the brush through the section. Run the dryer slowly down the length of the section several times (moving the dryer, not the brush). Repeat with each section.

STEP THREE

Rub a dime-size amount of shine serum between your palms and smooth it onto the surface of your hair; if that's too heavy, run a bit of styling lotion through your hair with your fingers, or dab it on the ends only.

THE QUICKIE

Blot your hair dry. Apply straightening balm from roots to ends and run a wide-tooth comb through your hair. Blow-dry with your hair flipped over, with the blower set on high heat and high speed until your hair is 80 percent dry. Use a large round brush to blow-dry just the top layer of hair smooth in sizable sections, and seal in the look with an all-over blast of cold air.

THE FULL TREATMENT

To create some lift at your crown after blowing it smooth, spritz your roots with volumizing spray, wrap several sections around large Velcro rollers, and clip them in place. Aim your dryer at them and spritz them again. When they're dry, remove the rollers and shake your head upside down to loosen the curls. Divide your hair into sections again. With the dryer on low heat and low speed, smooth each section using a flat brush with natural boar bristles to increase shine. Spread a small amount of shine serum onto the surface of your hair. For a supersleek finish, or if you have very curly hair, smooth the ends with a flatiron as well.

WAVY AND CURLY HAIR

Wavy, curly hair is by definition more fragile than naturally straight hair. To minimize breakage when blow-drying, let your hair air-dry for as long as possible. Most styling is achieved in the last 20 percent of drying time anyway.

LOOSE AND WAVY

STEP ONE

Shampoo hair and blot dry with a towel. Apply a quarter-size amount of styling gel with hands. (If you have naturally curly hair, use styling cream or lotion.) Twist large sections of hair from roots to ends to create waves, letting the ends hang loose.

STEP TWO

Set your dryer on high heat and low speed. Attach a diffuser. Cup the hair twists with your hands to keep them in place as you blow-dry them until each spiral is dry.

STEP THREE

Gently unwind twists one by one, then shake head from side to side to loosen them. Finish by spritzing a generous amount of shine spray into the air and walking through it. (Spraying it directly onto your hair will weigh it down.)

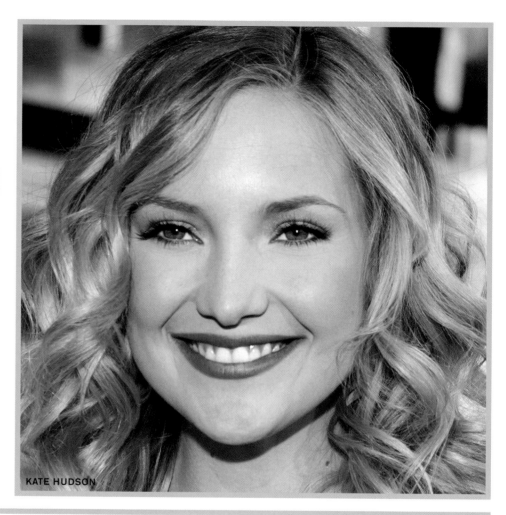

KATE HUDSON

THE QUICKIE

Run a dollop of styling gel (or cream, if you have curly hair) from roots to ends. Attach a diffuser to your blow-dryer. Scrunch large sections of hair in your hand and place them right inside the diffuser while they dry. For an even faster shortcut: Wash your hair before bed, weave it into a loose French braid, and sleep in it. The next morning, undo the braid and shake out hair.

THE FULL TREATMENT

After applying styling gel or cream, comb through your hair to distribute the product evenly from roots to ends. Separate and pin down any natural waves around your hairline before starting on the rest of your hair. Twist small sections and tie the ends of several together with an elastic. Blow-dry hair thoroughly with a diffuser (to make sure it's dried through, unravel a section to check that the interior strands are dry). Once your hair is totally dry, undo the twists and arrange the resulting waves with your fingers. Finish by walking through a mist of shine spray.

KERI RUSSELL

NATURALLY CURLY

STEP ONE

Apply gel to your roots and work in a pea-size amount of styling cream from mid-strand down to the ends. Take small sections of hair from the top of your head and twist them down the ends, letting them fall.

STEP TWO

Dry the sections with a diffuser from roots to ends. Don't scrunch the curls; it causes frizz and distorts hair's natural bends. Instead, cup hair from below with hand while drying it.

STEP THREE

When your hair is 95 percent dry, stop drying it and flip your hair upside down. Shake it slowly to loosen curls and massage roots in a circular motion to create lift at the crown of your head. Flip your hair back and finish styling the curls with your fingers.

THE QUICKIE

Apply gel to your roots and massage a dab of styling cream into the ends. Take a few large sections of hair and twist them, letting the ends fall. Dry the sections with a diffuser until your hair is 95 percent dry. Flip your hair over and tousle it with your fingers.

THE FULL TREATMENT

Work styling gel into your roots and styling cream into your hair from mid-shaft down to the ends. Twist small sections, let the ends fall naturally, and dry them with a diffuser. Once all the sections are mostly dry, loosen the twists and break them up into curls and waves with your fingers. Tip your head to one side and continue to blow-dry, slowly moving the dryer back and forth, then repeat on the other side. When your hair is totally dry, tip your head forward and do the same thing on the back of your head to set the curls. If your hair starts to get frizzy during this final step, spritz it with shine spray. If you want soft, romantic curls, stop here. If you prefer more defined curls, coat your palms with a small dollop of styling gel and run your hands through your hair.

AFRICAN AMERICAN

The main objective when styling African-American hair is preserving natural moisture and enhancing shine. That means using leave-in conditioner religiously. If you chemically straighten your hair, thoroughly rinse out relaxers to prevent hair dryness and scalp irritation.

NATURAL HAIR

STEP ONE

When hair is still wet, coat your palms with leave-in conditioner and thoroughly work it through your hair. Blot (don't rub) hair dry with a towel.

STEP TWO

Massage in a light, liquid-based styling gel. Scrunch your hair from the ends up to the roots to evenly distribute the product.

STEP THREE

Set your blow-dryer on low heat and attach a diffuser to help gently direct air all over your head as opposed to just one spot. Blow hair dry.

MICHAEL MICHELE

THE QUICKIE

Forget that this page is about blow-drying and skip the blow-dryer altogether; it's much healthier for your hair to air-dry. Apply leave-in conditioner to wet hair from roots to ends and then blot hair dry with a towel. Follow with a light, liquid-based styling gel. Scrunch hair with your hands to set curls in place, then let your hair dry naturally.

THE FULL TREATMENT

For really moist, lustrous curls, apply a deep conditioner containing shea butter, avocado oil or another rich, fatty botanical from the roots to the ends after shampooing. Sit under a hood dryer, which delivers gentler, more diffuse heat than a hand-held dryer, set on medium heat for 10 to 15 minutes. Thoroughly rinse out the conditioner. Blot hair dry with a towel and apply leave-in conditioner, then liquid-based styling gel. After blow-drying on low heat, spritz your hair with an oil sheen spray. This will replenish any lost moisture and add a healthy shine.

SMOOTH AND STRAIGHTEN CHEMICALLY RELAXED HAIR

AISHA TYLER

STEP ONE

Prepare tresses by applying setting lotion onto very wet hair and then rolling wide sections onto large rollers.

STEP TWO

Sit under a hood dryer until your hair is totally dry (45 to 90 minutes, depending on length and thickness). Unwind your hair from the rollers and let it cool for five minutes. Blow-dry the ends smooth using a big round brush.

STEP THREE

For a smooth, sleek finish, run a ceramic flatiron, which conducts heat evenly and seals in moisture, through sections and slightly flip or bend ends up or under, depending on your preference. Finish with a light mist of oil sheen spray (available at drugstores and beauty supply stores).

THE QUICKIE

Thoroughly blot your hair dry with a towel. Work through a small amount of leave-in conditioner, styling cream or both to keep hair hydrated and shiny. Blow-dry sections from the roots downward using a round, natural-bristle brush. If you have more time, polish just the ends with a ceramic flatiron. (Turn it on when you step out of the shower so it's ready when you are.)

THE FULL TREATMENT

Apply setting lotion to wet hair and roll large sections onto rollers. Sit under a hood dryer for 45 to 90 minutes until your hair is totally dry. Take out the rollers and let hair cool, then blow-dry it smooth with a round brush. For extra sheen, iron sections with a ceramic hair straightener. To maintain the style overnight, use a soft, natural bristle brush and, starting at the crown of the head, begin wrapping your hair in a spiral pattern around your head, securing each strand with bobby pins. In the morning, remove the pins and brush out your hair, or simply run fingers through your hair to loosen it. Add shine with a light spritz of oil sheen spray.

CURLY VS. STRAIGHT

The old adage that the grass is always greener on the other side of the fence is especially appropriate for hair texture. Just think about it. Women born with stick-straight tresses seem to long for full waves or a burst of curls; and those blessed with natural ringlets often want nothing more than smooth, silky manes. Here's the good news: With all the professional treatments and styling tools available today, achieving either extreme, at any time, is possible. If you yearn for a lasting change, the newest relaxers and perms are much gentler and more effective than their predecessors, so you can fine-tune your texture for months at time. If you're more of a chameleon, no problem: Once you're adept at curling and straightening your own hair, you'll possess the power to overhaul your entire look on the slightest whim. It's instant gratification at its finest. And the timing couldn't be better. Today, no single hairstyle or texture is a fashion "must." What's freshest and most modern is having fun with your hair, experimenting with different styles, and feeling confident, free and playful. The results, as demonstrated by the versatile stars on these pages, are bound to be gorgeous.

CATHERINE ZETA-JONES

At the 2004 Oscars, Zeta-Jones' natural waves are a refreshing alternative to a formal up do. The style conveys sexy, undone ease.

At the third annual Adopt-A-Minefield benefit in 2003, the actress' hair is straight and simple—and appropriate for a more serious affair.

BEYONCÉ KNOWLES

At the 2004 Brit Awards in London, Knowles exudes old-fashioned glamour with fluffy, Breck Girl-style curls that softly frame her face.

With her hair blown-out straight at the 2004 NRJ Music Awards, Knowles is free to play up her sultry makeup and ornate earrings.

SARAH JESSICA PARKER

At a Cartier party in 2003, Parker enlivens her natural ringlets even more by combining them with fresh, vibrant makeup colors.

Parker's hair is blown-out with a soft bend at a June 2003 party. Pale lips and stylized eyes are in sync with the more restrained hairstyle.

ROLLERS

You probably have a painful memory of sleeping with rollers in your hair at some point in your life. In the past decade, rollers have been revolutionized. Modern-day ones, which are lighter weight and—if electric—heat up much faster, give your hair volume or add waves and curls in a matter of minutes, freeing you to multitask (i.e., put on your makeup, get dressed and drink your morning coffee). Rollers are also available in the following user-friendly forms. Choose the ones designed to achieve your personal styling objective, and customize the size to your hair length: The longer your hair, the larger the rollers need to be.

	WHAT THEY ARE	HOW TO USE	PROS	CONS
HOT ROLLERS	Hot rollers come in an electric case and use dry heat to add wave or curl your hair. They're ideal for creating defined or tight curls (as opposed to loose waves).	Apply the appropriate styling product for your hair, then blow-dry hair or let it air-dry. Once the rollers are hot, roll sections of hair onto them and hold them in place with the clips. Leave them in for three to five minutes, until they're almost cool, to ensure a strong curl. (For looser curls, remove them while they're still warm.)	Curls from hot rollers last longer (and stay more defined) than those from Velcro rollers.	They can require a bit of patience: You have to wait five to 10 minutes for the rollers to get hot.
STEAM ROLLERS	Steam rollers come in an electric case with a compartment that holds water. They have a vented cores wrapped in sponge, so steam penetrates your hair shaft, producing long-lasting curls. As the steam evaporates, the curls set.	Wrap sections of dry hair around rollers and clip into place. Once the rollers are cool (five to 10 minutes), unwind your hair.	The steam keeps your hair moist and supple—and less prone to breakage.	If your hair frizzes easily, the steam may actually exacerbate the problem.
VELCRO ROLLERS	Nonheated, Velcro-covered rollers, which hold hair in place with their slightly prickly surfaces, are best for adding volume and smoothing hair.	They can be used on damp or dry hair. Apply the appropriate styling product to hair, then wrap sections around the rollers. For more curl definition, lightly spritz the rolled up hair with hairspray, and blow-dry to set.	They don't need to be plugged in, they stay in without a clip, they're less damaging than hot rollers and they're inexpensive (a six-pack costs as little as $3).	Hair snags easily on Velcro, so be careful when winding and unwinding the rollers. Also, curls take longer to set and don't last as long as ones from hot rollers.
MAGNETIC ROLLERS	These ultrasmooth, nonheated rollers are magnetic, so hair adheres easily to them. Because of their smooth surface, they create sleek, shiny curls.	Roll sections of wet hair onto rollers and sit under a hood dryer (or blow-dry it). Carefully unroll sections (rather than pulling them out).	Unlike Velcro rollers, they don't "grab" hair, so fine hair won't get snagged or break.	For flawless curls, hair must be totally dry, which takes at least half an hour under a hood dryer.

CURLING IRONS

Curling irons can reach temperatures of up to 250 degrees, and are therefore the most potentially damaging of all styling appliances. Never use one on damp or wet hair, and choose an iron with an adjustable heat dial. For loose curls, the lowest setting should do the job (save high heat for curls that need to stay tight). Protect your strands by applying heat-protectant spray before blow-drying. And remember that barrel diameter dictates curl size.

SPIRAL CURLS

A ¾-inch iron with a shortened clamp specially designed for spiral curls.

TIPS: Let hair air-dry. Separate out a section of hair about ½-inch wide and place the end of it in the clamp, winding the rest in a spiral up the length of the barrel. Hold for three or four seconds, unwrap, and repeat, varying the direction of the spiral. Don't touch your curls; they'll lose definition.

LOOSE WAVES

A medium-barrel iron (about 1¼-inches wide).

TIPS: Hold the barrel vertical and wrap 1-inch sections of hair around it. Hold three or four seconds, slide your hair off and stretch it with your fingers. Vary tension and direction of your curl for a natural look.

VOLUME

A 1½-inch large-barrel curling iron and large Velcro rollers.

TIPS: Spritz a 1-inch section with hairspray, wrap your hair around the barrel, hold it in place for five seconds, release and then reset in a roller. Continue around head. Let curls cool in rollers for five to 10 minutes.

SMOOTH HAIR

A large-barrel curling iron (about 1½-inches).

TIPS: Wrap a 2- to 3-inch section of clean, dry, product-free hair around the barrel, leaving out the ends so they don't curl. Roll it up, stopping a few inches from your roots, and release. Leaving the roots wavy or frizzy actually adds volume, and the final look is more natural than a stick-straight blowout.

STRAIGHTENING IRONS

In the late sixties and early seventies, girls desperate for straight, satiny locks pressed their hair with hot clothing irons—a dangerous (not to mention damaging) tactic. Thank goodness for modern technology. Straightening irons, used on dry hair, transform the curliest, frizziest hair into mirror-smooth strands within minutes. New variations, such as ionic straighteners and travel-size ones that slip easily into a toiletry kit, make it even easier to get the kinks out. Find one designed for your hair texture and flatten away.

LONG AND CURLY

Look for an iron that packs heavy-duty heat (up to 170 watts) and has long, wide panels to hold a lot of hair at once.

FINE AND FRIZZY

An iron with a flocked surface polishes hair without delivering too much heat. A low-wattage iron (around 40 watts) also eliminates frizz without scorching fine hair.

SHORT

Look for smaller, narrower panels that allow you to kick the ends out or smooth them under. Mini-irons are also good for straightening bangs and layers around your hairline.

STRAIGHTEN YOUR HAIR IN THREE STEPS

Super-sleek hair may come easy, but be warned: It doesn't come fast. If you plan to use a flatiron, allow plenty of time for blow-drying beforehand, and for straightening multiple small sections.

STEP ONE

Rub a quarter-size dollop of straightening balm into your hands and apply to damp hair; it will protect your hair and help hold the style straight. Divide your hair into four or five sections.

STEP TWO

Blow-dry each section, pointing the nozzle down the hair shaft to press cuticles flat. Dry your hair completely before ironing: Any residual moisturize will make it frizz.

STEP THREE

Divide your hair into one- or two-inch sections, clamp the iron and pull it down the length of each one. Rub a little silicone-based gloss between your palms and then work it through hair for extra shine. It will also help hold straightness.

THE QUICKIE

Apply a quarter-size dollop of straightening balm to damp hair and blow-dry hair thoroughly with your hair flipped over. Use an iron with long, wide panels to straighten 2- or 3-inch wide sections of hair, focusing on the top (outermost) layer of hair only. Optional: For extra glossiness, lightly pat a silicone-based gloss or styling lotion over your hair after straightening it.

THE FULL TREATMENT

Apply straightening balm from roots to ends and spritz your hair with heat protectant spray. Blow-dry your hair in 1-inch sections, starting with the bottom layers. To create an smooth foundation, use a brush with a metal base and bristles, which will conduct heat to the hair. Once hair is dry, seal the cuticles with a blast of cool air, and run a wide-tooth comb through your hair to work out any tangles or kinks. Next, go over each 1-inch section with the iron several times, starting with the underlayers: The thinner the section and the slower you move the iron, the sleeker the results will be. Lock in the shine with silicone-based hair gloss.

PERMANENT TREATMENTS

If you love having smooth, stick-straight hair, a permanent hair-relaxing session may be the way to go. If you long for curls, consider a perm. A tip: Don't shampoo your hair for three days before your appointment; not washing will help reduce irritation to your scalp.

GENTLE RELAXERS

WHAT IT IS: In this method, used by Tyra Banks and Naomi Campbell, ultra-rich conditioners are mixed with straightening agents like ammonia to minimize damage while taming the natural curl. You still need to blow-dry hair to get it completely straight, but it takes much less time and effort.

WHO IT'S BEST FOR: Untreated or minimally colored (highlights or single-process) African-American or Caucasian hair; it's too damaging to use on double-processed hair (which is much dryer than single-processed hair) or for correcting badly permed hair.

HOW IT WORKS: The relaxing solution sits on your hair for 10 to 25 minutes before it's thoroughly rinsed out. Neutralizer is applied, followed by a deep conditioner.

HOW LONG IT TAKES: About one hour.

HOW LONG IT LASTS: In three to six months, relaxed hair will eventually revert to its natural wave. If you want to keep re-growth smooth, you can safely relax all of your hair every four to six weeks—four weeks for coarser texture, six weeks for wavy hair.

THERMAL RECONDITIONING

WHAT IT IS: A Japanese treatment that uses heat to restructure the cuticle so it lies flat, giving you glossy, pin-straight hair that doesn't require blow-drying.

WHO IT'S BEST FOR: Untreated or minimally colored (subtle highlights or single-process) Caucasian hair. The irons are too damaging for most African-American hair and for Caucasian hair that has been heavily colored or permed.

HOW IT WORKS: First, hair is chemically softened with a solution that is milder than a standard relaxing solution. Then, individual ¼-inch sections are straightened with irons heated to 180 degrees. Some salons blow-dry your hair first so steam from damp hair won't burn your face; others keep it damp to minimize trauma to the hair. Afterward, a neutralizing formula is smoothed onto the hair to seal the cuticle closed.

HOW LONG IT TAKES: The relaxer sits on the hair for only 20 to 25 minutes, but the whole process takes about four hours, including ironing each quarter-inch section for three seconds, so bring a book.

HOW LONG IT LASTS: Six to 10 months. Thermally reconditioned hair will never be curly again; you won't have to repeat the process until new hair grows in. Root touch-ups can cost the same as full straightening treatments because they take the same amount of time.

PERMS

WHAT IT IS: A chemical process that breaks down your hair's natural structure and re-forms it in waves and curls. The treatment can be fine-tuned to deliver the result you want, whether it's tight ringlets, soft waves, one gentle bend in the hair or even extra volume at the roots only.

WHO SHOULD GET IT: Untreated or minimally colored (highlights or single-process) hair; the thicker it is, the better it will hold the wave. The chemicals are too harsh for double-processed or heavily highlighted hair.

HOW IT WORKS: A stylist applies one chemical solution to break the structural bonds in your hair and another, called a "neutralizer," to re-form the bonds and alter your hair's texture. Small rods result in tighter curls; large rods result in bigger, looser curls.

HOW LONG IT TAKES: One to two hours, depending on how quickly your stylist puts in the rods.

HOW LONG IT LASTS: Three to five months. After three months, re-perm your roots so that they match the rest of your hair.

UPDOS

There's something undeniably feminine about wearing your hair up. No matter how simple the gesture, you instantly feel a bit more graceful and a lot more polished. And if the setting is right (red carpet, black-tie soiree), you'll feel positively princess-like. But updos shouldn't be reserved for fancy affairs and frouffy gowns. The looks on these pages can be made more formal or casual with a few tiny details, depending on the occasion, your mood, or the amount of time you have to get ready.

French twists, topknots and chignons look equally chic worn sleek and ballerina-like or (if you unravel some curls or ruffle things up a bit) soft and unstructured. Ponytails, once seen primarily on the tennis court, add swing and banish stuffiness, no matter what you're wearing. And a well-placed part will give a traditional bun a fresh, modern finish. But don't forget the best reason for trying a hair-raising style: its unfailing ability to elongate your neck and highlight your bone structure and features, easily transforming you from average duckling to elegant swan.

JILL HENNESSEY

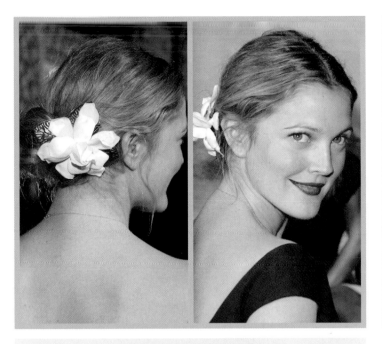

DREW BARRYMORE

A flower in the hair is both exotic and ultra-feminine, as demonstrated by Barrymore at the February 2004 première of *50 First Dates*.

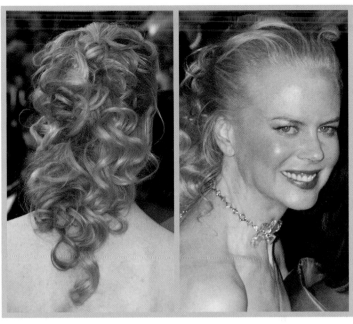

NICOLE KIDMAN

Kidman's half-up, half-down style at the 2004 Oscars works two ways: The front lifts and defines her features, and the curls add softness.

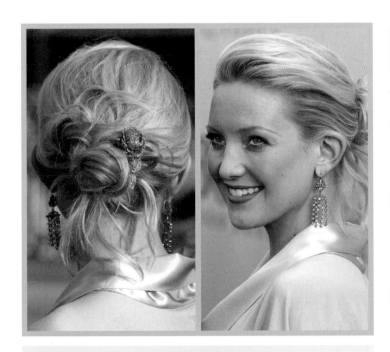

KATE HUDSON

A newly pregnant Hudson glows in a haphazard chignon and a sexy, loose-fitting dress at the June 2003 première of *Alex and Emma*.

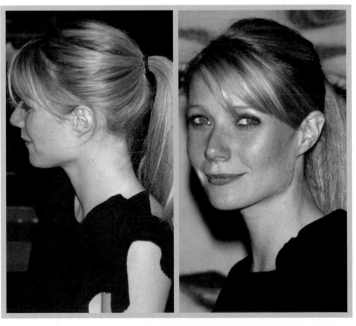

GWYNETH PALTROW

Ponytails can be playful and sophisticated. Paltrow looks both mod and modern at a *Sylvia* screening in 2003.

HAIR EMERGENCIES

Sometimes bad hair just happens. Uncooperative hair has an uncanny ability to sink your mood, and even your willingness to socialize. Don't fret—you have a choice of quick fixes for every glitch.

LIMP HAIR

1. Wash with baby shampoo. It has just the right amount of detergents, so it deep-cleans and gets rid of residue that weighs hair down without stripping away moisture.
2. Use large Velcro rollers around your hairline on hair that's 95 percent dry. Blow-dry for five minutes, remove rollers, and lightly comb through to loosen the curls.
3. After drying hair, spritz a salt spray (there are several on the market) into your roots to add texture and body.

SECOND- OR THIRD-DAY HAIR

1. If you have light-colored hair, sprinkle a bit of baby powder onto your brush and comb it through your roots. It should blend in and be nearly invisible.
2. Spritz hairspray onto your roots and rub hair with a towel. The alcohol will absorb oil.
3. Spray dry shampoo (the pros often recommend Klorane) onto your scalp and brush it through to absorb oil. (Like baby powder, it blends best into blond hair.) Avoid blow-drying. You may think it will fluff up your hair and make it appear cleaner, but it will actually make hair look dirtier.

RAGGED ENDS

1. Smooth down the ends of damp hair with a few drops of silicone-based serum before styling.
2. Camouflage split ends by adding wave with a curling iron or wrap ends around a medium-size brush and lightly blow-dry, flipping them up or down.
3. Create layers or get a trim to get rid of frazzled ends for good.

BURNED HAIR

1. If you've singed your hair with a dryer, apply a dab of styling cream to damp hair before blow-drying.
2. After hair is dry, add a tiny bit of pomade to scorched ends and along the hairline to keep flyaways in place.

FRIZZY HAIR

1. Before blow-drying, rub a smoothing silicone serum (the same kind you'd normally use to add shine after blow-drying) into hair to coax cuticles to lie flat.
2. Wait until hair is almost dry before you blow-dry, so your hair spends less time being blasted with frizz-inducing heat.
3. Use a flatiron on dry hair; it's similar to ironing wrinkles out of clothes.

VISIBLE ROOTS

1. Temporarily hide grays with a touch-up stick or powder eye shadow. Style hair first, then dab it onto roots.
2. Make sure your hair isn't too smooth. Wear it tousled, or apply volumizing spray at the roots before blow-drying to create plenty of lift at the roots.
3. Wear your hair with an uneven or zig-zag part.

HAT HEAD

1. Take preventative measures: To maintain volume under a hat, pin or pile hair on top of your head or reverse your part.
2. Keep your hair as clean as possible, since residue makes it more likely to go limp. Use a clarifying shampoo once a week and a mild shampoo the rest of the time.
3. Go easy on conditioners and styling products, which build up easily.
4. For an instant lift, bend over and mist your bottom layers with hairspray. Flip your hair as you straighten up and spritz the top layer to prevent static.

GREEN OR BRASSY HAIR

1. Rinse your hair with cool water before entering a swimming pool. Your hair cuticles will soak up the water, so less chlorine can get in.
2. Keep chlorinated pool water from damaging your hair by coating dry tresses with conditioner before taking the plunge. (You can also wear a bathing cap to keep pool water clean.)
3. Use a clarifying shampoo after swimming.

Is blow-drying really that brutal on hair?

Yes, overdrying hair depletes strands of moisture and makes them prone to breakage. If your style permits it, stop blow-drying when your hair is 80 percent dry, and skip it altogether whenever you can. Use heat-protectant sprays and moisturizing shampoos and conditioners to keep hair hydrated. Once a week, put in a deep conditioner and let it sit for 15 minutes before rinsing. If you're African American, treat your hair with pure avocado or almond oil, or with a store-bought hot oil treatment to keep it supple after blow-drying.

I can never get the back of my hair straight when I blow-dry. Any advice?

Concentrate first on the layers underneath, which tend to be the curliest. Flip your hair forward and blow-dry, tousling it with your hands, until it's 80 percent dry. Then make a horizontal part two inches from your neckline, clipping up the hair above it and drying the bottom using a round brush. Continue pulling sections down and drying until the whole back is dry.

I have an unruly cowlick. How can I smooth it down?

A cowlick is an area of hair that sticks up around your hairline or at the crown of your head and grows in a different direction from the rest of your hair. To tame it, use a round brush to blow it first to one side, then to the other; repeating this several times should help your cowlick to lie flat.

I love the look of a French twist. How do I do one?

This classic style is easiest to do with damp hair. If your hair is dry, apply gel or pomade from roots to ends. Gather your hair at the nape of your neck, pull it taut and twist it upward. Tuck the ends into the underside of the twist with your finger or the handle of a rat-tail comb and pin it into place. Set it with hairspray.

I've seen hair-relaxing kits at the store. Do they work?

Relaxing your hair at home is tricky (you can literally burn your hair off), but doable. Follow the directions closely. Be sure to apply the right amount of product in the correct manner and leave it on for the stated amount of time. Rinse it out thoroughly to avoid overprocessing. Experts recommend Dark and Lovely at-home relaxers because they contain a color tint that allows you to see any residue that's been left in your hair and a measuring device to keep you from using too much. If you have color-treated hair, look for a no-lye formulation. Lastly, don't try to save any leftover relaxer for your next session. Once it's been opened, the formula oxidizes and loses potency.

How do I take care of chemically straightened hair?

First, wait 48 hours to wash your hair after it's been relaxed. The chemicals need time to set. Then, once a week for the first month after the treatment, apply a deep-conditioning mask and cover your head with a shower cap to lock in heat. At night, protect your hair by sleeping on a satin pillowcase. When it comes to styling, cut back on blow-drying and curling; if you must do it, use the cool setting of your blow-dryer or curling iron, or use nonheated Velcro rollers. Apply hairspray and gel in moderation and wait 14 days after a relaxing treatment to get your hair colored.

I have double-processed hair. Is there any safe way to permanently straighten it?

You're out of luck. Thermal reconditioning and relaxing treatments are just too damaging for heavily processed hair. The only way to straighten your hair is to blow it out with a natural-bristle brush, making sure to coat your strands with a protective heat spray beforehand. Avoid flattening irons, too: Any heated device that comes into direct contact with your hair can cause breakage.

BRITNEY SPEARS

BODY

The skin is the body's largest organ, responsible for essential jobs like controlling temperature and protecting the internal organs from the outside world. Bare skin also radiates head-to-toe sensuality, regardless of your size, shape or skin color. From cleansing and moisturizing to shaving and waxing to sun protection and self-tanning, this chapter has every inch of you covered.

CLEANSE

Having skin that feels fresh, clean and supple—as opposed to squeaky and dry—can be a simple matter of using the right cleanser. When choosing this everyday product, a little education goes a long way. Most soap bars at the drugstore are made from sodium solids of fatty acids, such as beef tallow, lard and lye, which not only sound unappetizing but also leave a film that can be drying. Many high-lathering soaps and gels strip skin of natural oils. Others offer more hype (powerful deodorants, fancy fragrances) than actual hygiene. On the flip side, there are scads of gentle bars and liquids that feel luxurious, smell intoxicating and leave skin healthy and glowing. So before your next shower, take a few minutes to separate the quality suds from the duds.

LUCY LIU

145

GOOD SOAPS

Ideally, the soap you use on your body will remove dirt and oil without stripping moisture. The following types of soaps are your safest bets.

	WHAT THEY ARE	WHO THEY'RE FOR
HAND-MILLED	Hand-milled soaps, also known as French-milled, are vegetable soaps that have been shredded, blended with essential oils or fragrance, and pressed into dense bars. A variation, triple-milled soap, is pressed three times and therefore even more dense and long-lasting.	Everyone. Milled soaps are gentle and moisturizing. They also lather well and smell sweet (but not too strong).
GLYCERIN	These extremely mild, gentle soaps are made of oil and glycerin, both emollients. They produce a light lather and have a translucent appearance.	Women with dry or sensitive skin. (Also recommended for babies and children.)
SUPER-FATTED	These soaps are loaded with rich emollients like olive oil, milk, cocoa butter and shea butter. They lather less than vegetable or glycerin soaps and feel softer on your skin.	Because they're so creamy and gentle, super-fatted soaps suit women with dry, sensitive or itchy skin—or anyone seeking extra hydration.
EXFOLIATING SOAP	Gritty and rough, these soaps wash and exfoliate skin at the same time. Some common scrubbing ingredients are jojoba beads, oatmeal (which also soothes by giving water a slightly milky consistency that softens and moisturizes skin), and crushed lava and pumice stone.	Anyone who wants to slough off dry, flaky skin. They're also effective for women with oily skin because they can help loosen the blackheads and ingrown hairs caused by excess sebum. (For more on body exfoliation, see p. 148.)
CLEANSING BAR	Nonsoap bars containing highly moisturizing ingredients such as glycerin and lanolin. Most of these are unscented and non-comedogenic.	People with extremely sensitive skin who are prone to allergic reactions from other kinds of cleansers.
BODY WASH	Creamy, nonsoap liquids contain moisturizing ingredients such as glycerin and lanolin. When massaged onto skin, they lather like crazy but rinse clean.	Anyone who prefers the texture of liquid soap to that of a bar.

SOAPS TO SKIP

As uninspiring as it sounds, the best body cleansers are pure, plain and simple. Other options may seem more effective but are, for the most part, unnecessary.

DEODORANT SOAPS	**ANTIBACTERIAL SOAPS**	**SHOWER AND BATH GELS**
They contain bacteria-killing chemicals that can irritate and dry out skin. A regular soap should squelch odor just as well.	Unless you're a doctor, a nursery school teacher, a mother whose kids get sick frequently, or you have persistent acne on your back, a normal soap will keep you clean.	Most of these contain sodium laurel sulfate, a detergent used in shampoos that is very drying to skin. (Despite rumors that SLS, when applied directly to the skin, is carcinogenic, dermatologists say it's safe, since it is diluted and quickly rinsed off.)

SOOTHING SOAKS

Few things erase the stresses (and muscle strains) of a long, hard day better than an old-fashioned bath. So make the most of a long, soothing soak. The first step: Skip the bubbles or foams, which suck out moisture. Instead, sit in plain water for a few minutes to allow your skin to absorb some moisture, then add a few drops of bath oil or essential oil to seal it in. Soothe dry, itchy skin by tossing in a handful or two of raw oatmeal (or add a bath product containing oatmeal) while you are filling the tub. To relieve tense, sore muscles, pour in two handfuls of Epsom salts; they contain magnesium, which helps reduce inflammation. Regular bath salts are often infused with essential oils, so they moisturize and work as physical exfoliators if you massage the moistened salts into your skin in soft, circular motions before they dissolve.

A winter tip: To keep your skin as hydrated as possible during colder, drier months, try to limit your bath time to 15 minutes, and opt for warm water over scalding hot. If you can't imagine bathing in tepid water, go for the heat— but make up for it by applying a thick body cream or oil immediately afterward.

BODY BASICS

Bathing is only the first step toward fresh, healthy skin. It's just as important to scrub off dead, flaky cells, replenish lost moisture, and prevent perspiration and unpleasant odors. Here's everything you need to know.

EXFOLIATE

A solid, head-to-toe scrubbing with a loofah invigorates skin, leaving it glowing and ultrasmooth. Body exfoliation also has several major health benefits: It stimulates blood flow, increases circulation, and sloughs off dead skin cells, which prevent moisturizer from being absorbed, clog pores and can lead to ingrown hairs.

To keep your skin consistently soft and fresh, exfoliate at least once a week with a physical scrub or chemical wash. Physical exfoliants include brushes (with which you stroke dry skin before bathing), pumice stones (which work well on heels and calluses), loofahs, sea sponges, nylon puffs, facecloths, granular scrubs containing synthetic microbeads and coarse bath salts. Chemical exfoliants such as glycolic and salicylic acid are found in body cleansers; lactic acid can be found in lotion form and helps soften rough spots such as elbows and knees.

Beyond your weekly scrubbings, remember these additional guidelines: Always exfoliate right before applying self-tanner to ensure seamless, even color. Exfoliate between waxings to prevent ingrown hairs. And avoid doing it right after you shave. It will sting and irritate already vulnerable skin.

MOISTURIZE

Once you're scrubbed smooth, apply a body oil, lotion or cream while you're still damp (if you leave your bathroom door closed, the shower steam will keep you moist). The most effective moisturizers contain both a humectant, such as glycerine or sorbitol, to attract water, and an emollient, like petrolatum or lanolin, to prevent evaporation.

A simple, straightforward product will keep your skin hydrated, but you can also benefit from a number of powerful active ingredients on the market. Moisturizers containing alpha-hydroxy acids or retinol enhance the skin's exfoliation process so it feels exceptionally silky. Products formulated with lactic acid, hyaluronic acid or urea draw moisture to the skin's surface and are particularly potent on extra-scaly areas like your knees, elbows and feet. And those containing antioxidants like vitamins A, C and E minimize free-radical damage (i.e., wrinkles) caused by sun exposure.

Don't put too much faith in so-called firming lotions, which promise to tighten sagging skin. They may feel tingly and refreshing right after you put them on, but they'll have no effect on the tautness of your skin nor on stretch marks or cellulite.

The richer the consistency, the more hydrating a lotion or cream will be, so choose a texture based on your skin's level of hydration. Also, remember to switch products as the seasons change: A light, water-based lotion may suffice in summer, while a thick, oil-based cream may keep you better covered in winter. Body oils work year-round to seal in moisture. Smooth a few drops onto still-damp skin and let your body air-dry for a few minutes before dressing; for extra hydration, smooth lotion on top.

DEODORANT AND ANTIPERSPIRANT

Perspiration and body odor are natural biological functions: When you get overheated from physical exertion or anxiety, your sweat glands secrete perspiration to cool you down. When perspiration reacts with bacteria on your skin, especially in confined areas like under the arms, odor occurs.

Prevention is easy. Use a deodorant or antiperspirant—most people opt for a product containing both—every day. The active ingredient in most deodorants is triclosan, a potent antibacterial and antifungal agent. The majority of antiperspirants contain aluminum chloride, which plugs your sweat glands to block secretions. (Despite rumors that the aluminum in antiperspirants causes cancer, there's no scientific evidence—and studies that initially indicated a link between aluminum and Alzheimer's disease have since been called into question.) These products come in roll-on, spray and stick forms; use whichever feels and works best for you.

If you prefer natural ingredients, try an aluminum-free deodorant, but keep in mind that such products only kill odor-causing bacteria; they won't slow sweat production. The same applies to deodorant crystals, which contain mineral salts that inhibit bacterial growth. If you notice redness under your arms, use hypoallergenic products that are free of common irritants like propylene glycol or perfume.

HAIR REMOVAL

Five million years ago, long before central heating and fleece, body hair was a necessity. In today's society, it's anything but. A small percentage of women are hirsute and happy about it, but the majority of females strip themselves of any superfluous fuzz in the pursuit of sleek, satiny skin. Before delving into the following hair-removal guide, think about your personal needs. If you have fine, fair hair and care only about your underarms and shins, a razor should meet your requirements. If you need to shave every single day—or don't feel polished without a pristine bikini line, a monthly waxing appointment might be a better choice. And if you dream of abolishing body hair for good, look into permanent removal methods. Regardless of your situation and preferences, options abound.

WHAT WORKS WHERE

In the realm of hair removal, all body parts are not created equal. Different methods work better on different areas and skin tones. (Women with darker complexions may risk skin discoloration from laser treatments and should consult a dermatologist.) These are the best ways to keep every area in check (for more details on each, see the chart on pp. 150–151).

FACE
BROWS, UPPER LIP, CHIN

Tweezing, waxing, cream depilatory or threading. Electrolysis and laser treatments can be effective, but electrolysis can also hurt. And because facial skin is thin, you run the risk of scarring. Also, if you choose laser therapy and notice that your hair grows back even thicker than before, consult a doctor. It could indicate a hormonal imbalance.

UNDERARMS

Shaving, waxing or cream depilatory. Electrolysis, laser and pulsed light work here too, and scarring risk is low. To prevent pain, treat the area beforehand with a topical analgesic, such as the prescription cream Emla, the over-the-counter ointment Anbesol, or LMX, a nonprescription cream containing the anesthetic lidocaine.

ARMS

Waxing, cream depilatory, laser or pulsed light. Pain isn't a big factor, because your arm skin is thicker than more sensitive areas like your face. To avoid hyper/hypopigmentation (dark or light spots), women with naturally dark complexions should opt for waxing or using a depilatory.

STOMACH

Waxing or cream depilatory. Laser, pulsed light and electrolysis are also options, but doctors discourage those methods for pregnant women, just to be on the safe side. Never shave: It leads to five o'clock shadow and potential irritation. When you wax or use a depilatory, hair has a softer, blunter tip and grows back with less irritation.

BIKINI AREA

Waxing, laser or pulsed light. If you choose waxing, go to a pro—this area is very sensitive and tricky to do at home. With shaving, the chance of ingrown hairs is high. If you use a cream depilatory, restrict it to the bikini line: The ingredients may be irritating if you get any more intimate than that. (See pain-relief advice in "Underarms" above.)

LEGS

Shaving, cream depilatory, waxing, laser or pulsed light can cover large areas quickly. Regrowth varies greatly from person to person. Always apply moisturizer afterward, since leg skin has few oil glands and tends to be dry.

HOME AND SALON HAIR-REMOVAL TECHNIQUES

	SHAVING	CREAM DEPILATORY	WAXING AND SUGARING	TWEEZING AND THREADING
THE LOWDOWN	Razors cut hair at the skin's surface. Shaving wet with a manual razor and a cream or gel will give you the closest shave. And contrary to what you learned in junior high, shaving won't make your hair grow back thicker; it just appears stubbier because you've cut it off mid-shaft. For smoothest results, use a clean, rust-free razor; opt for models with lubricated strips, pivoting heads and spring-mounted multiple blades.	Available in lotion, foam or cream form, depilatories chemically dissolve the hair shaft slightly below the skin's surface. (Be warned: They have a powerful chemical odor.) Apply to clean, dry skin with fingers or with the spatula provided in many kits. For best results, wipe off with a wet washcloth in the shower.	Waxing is the application of a sticky resin that binds hair to the surface of a strip of cloth that then gets pulled off (in the opposite direction to hair growth), removing hair from the roots. Sugaring, an alternative to waxing that works the same way, uses a mixture of lemon juice, sugar and water.	Both methods pull out hair from the root. Tweezing employs pincers. Threading, an ancient Middle Eastern technique, is performed by aestheticians who twist a doubled-up strand of cotton thread around hairs, then pull them out from the roots.
BEST FOR	Larger areas, like legs and underarms. Shaving may cause small white bumps (also known as folliculitis, which is an infection of the hair follicles caused by perspiration or using a dirty razor) and ingrown hairs in the bikini area.	Legs, bikini line, arms and face. Don't use on brows or anywhere else near the eyes.	Hair between a $\frac{1}{4}$-inch and a $\frac{1}{2}$-inch long, so the wax has something to which it can adhere. If you plan to go for a bikini wax—or a Brazilian bikini wax, in which the aesthetician leaves a narrow strip of hair, or takes it all off down below—pay a professional; it's simply too difficult to do on your own.	Upper lip and brows.
PAIN FACTOR	None, unless you cut yourself (so go slow) or shave dry (hello, razor burn!).	Practically none, though some people, especially those with sensitive skin, feel some stinging.	High. Apply Emla cream (prescription required), Anbesol or LMX, or take two aspirin two hours before waxing underarms or bikini area. Never schedule a bikini wax right before your period; skin is extra sensitive then.	Like a tiny pinch. The pain lessens with each session. Soothe skin afterward with ice.
TIME IT TAKES	Three to eight minutes. The more time you spend, the smoother the results.	Most products call for a five- or 10-minute wait before rinsing.	10 to 30 minutes for the bikini area; about 20 minutes per leg.	Your first time, it will take about 20 minutes to tweeze brows. Threading takes five to 10 minutes.
LASTS	One to three days.	One to four days.	Two to six weeks.	Daily maintenance (with tweezers at home) is advised.
COST	$5 to $10 per packet of disposable razors; $10 to $20 for a non-disposable.	$5 to $10.	Salons charge $10 (for upper lip) to $75 (for legs).	Tweezing costs $10 to $50 a pop. Threading starts at $5.

PROFESSIONAL HAIR-REMOVAL TECHNIQUES

	ELECTROLYSIS	LASER AND PULSED LIGHT
THE LOWDOWN	An aesthetician inserts a needle that carries an electric current beneath the skin into one hair follicle at a time to destroy it. Because hair grows in stages and can only be stopped in one of those phases, multiple sessions are required for permanent results.	Lasers emit light on a wavelength that destroys hair follicles. New, nonlaser light sources (also referred to as Intense Pulsed Light technology; Epi-Light is the most common brand name) are less effective but also arguably less dangerous, and remove hair by beaming light of multiple wavelengths into follicles. Both methods require multiple sessions, spaced two or three weeks apart.
BEST FOR	Small areas, since the needle zaps only one hair at time.	Both lasers and Epi-Light work best on light skin and dark hair (because of the stark contrast in tones). Neither is precise enough for brows.
PAIN FACTOR	Tiny pinpricks. To alleviate swelling and pain, apply prescription Emla cream, over-the-counter Anbesol ointment or LMX cream, or take two aspirin two hours before your treatment.	Mild discomfort. If you are extra sensitive, take aspirin or apply Emla, Anbesol or LMX beforehand.
TIME IT TAKES	It varies for everyone, but a general time frame is one to two 15-minute sessions per area (upper lip, brow) every two weeks for six months.	Four to six treatments spaced a month apart. Brows take 10 minutes per session; the upper lip takes 10 to 15 minutes; the bikini area takes 20 minutes; and one arm takes 20 to 25 minutes.
EFFECT	Once the treatment is done, results should be permanent.	Once a series of treatments is complete, results should be permanent.
COST	A 15-minute session costs from $15 to $100, depending on the size of the area being treated.	Sessions run from $150 to $3,000 each, depending on body part.

Unless you've been living under a rock for the past few decades, you're savvy about the dangers of sun exposure and protect your skin diligently. But if you head out every day without a stitch of sunblock on, this section is required reading. First off, there are three kinds of dangerous rays. UVB, or "burning," rays are the primary cause of skin cancer and are most intense in summer. UVA, or "aging," rays pose a risk in any season and penetrate deeper into the skin, causing wrinkles, sagging, sunspots and cancer. A third kind of light, infrared radiation (IR), can also cause both premature aging and cancer. To protect yourself from all three, you must wear sunscreen every single day, even when it's cloudy. It may sound like a chore, but once you've become an expert on everything from SPF to the powers of vitamin C, safeguarding your skin will—and should—become second nature.

SUN PROTECTION FACTOR

How long can you stay in the sun without burning? Do the math. Multiply the SPF, or Sun Protection Factor, number on the label by the number of minutes it takes you to start burning without protection. For example, if you start to burn after ten minutes of exposure, SPF 15 has been shown in lab tests to protect you for 150 minutes. If you burn in five minutes, SPF 15 will shield you for 75 minutes. Also, keep in mind that SPF refers only to protection from UVB rays. The FDA has not yet set standards for UVA rays, but make sure your product contains a UVA block such as Parsol 1789 or titanium dioxide. A rough guide to protection from UVB rays: If you plan to be outside briefly, SPF 15 should suffice. If you're going to be in the sun for more than an hour, use SPF 30 or higher. (Incidentally, the higher you go, the thicker and tackier the formula, too.) As SPFs go beyond 30, the difference in effectiveness is less dramatic, but since most people don't apply as much they should, a higher SPF is always a safe bet.

SIX FORMS OF SUNSCREEN

	GOOD FOR	BENEFITS	TO USE
LOTIONS AND CREAMS	Face and body.	These are ideal for daily use because of their light, smooth texture and fast absorption. Moisturizing ingredients such as shea butter and aloe prevent dryness and peeling and also allow products to glide on easily, providing uniform coverage. You can use a body product on your face (alone or under makeup), but look for an oil-free version. *Coppertone Sport Sunblock Lotion SPF 48 (for body) and Anthelios XL SPF 60+ (for face)* ▶	
GELS	Face and body.	Most gels are oil-free and won't clog pores the way rich creams might, making them perfect for oily or acne-prone skin. (Avoid them if you have dry skin; most contain alcohol, which dries out skin.) They're easily absorbed, which is a plus if you're in a hurry. An added bonus: They're non-greasy, which is handy if you're holding a tennis racket or volleyball. *Peter Thomas Roth Oil Free Hydrating Sunscreen Gel SPF 20* ▶	
SPRAYS	Hard-to-reach places.	Great for protecting out-of-the-way spots like between your shoulder blades, shoulders, and backs of legs. Sprays are ideal on hairy areas and for protecting the scalp if you have thinning hair. Parents like how quick and easy they are to spritz on a squirming child. You've applied enough when you can see a sheen on the skin. *Kiehl's Vital Sun Protection Face and Body spray SPF 15* ▶	
SOLIDS	Burn-prone spots.	SPF sticks offer precise application, perfect for small, vulnerable areas such as the lips, around the eyes, the rims and backs of ears, and the nose. It's also no-fuss: You can swipe it on directly and don't have to rub it in. And with the portable, pocket-size packaging, reapplication throughout the day is a cinch. *Hawaiian Tropic Ozone oil-free sunblock stick SPF 50+* ▶	
WIPES	Anywhere, when you're on the go.	Wipes deliver mess-free application with a single swipe. Many brands come in resealable, pocket-size pouches—perfect for hikes or bike rides. One drawback: Sometimes it's hard to tell if you've applied enough. *Dermalogica Full Spectrum Sunscreen Wipes SPF 15* ▶	
MOUSSES	Face and body.	Mousses are easily absorbed and work well as sports sunscreens because they have a dry finish that doesn't leave a slick residue on your hands or skin. But shake well before applying—ingredients tend to settle at the bottom of the can. *Sea and Ski All Day sunscreen foam SPF 15* ▶	

KEY INGREDIENTS

To ensure that your lotion protects skin from both UVA and UVB rays, read the ingredients. (All sunblocks guard against infrared rays.) The best products contain physical and chemical sunblocks and antioxidants.

PHYSICAL SUNBLOCKS	CHEMICAL SUNBLOCKS	WATER-RESISTANT AND WATER-PROOF	ANTIOXIDANTS
Micronized titanium dioxide and zinc oxide (Z-cote) block out dangerous rays upon application by literally covering the skin. They're particularly good for sensitive skin.	These interact with the skin and must be applied 30 minutes before exposure. Common ones are avobenzone (Parsol 1789) for UVA rays, and octyl salicylate and cinnamates for UVB.	These contain ingredients that make them stickier than regular sunblocks so they stay on in the water, but neither type is completely foolproof. Always reapply after swimming.	Topically applied antioxidants such as vitamins C and E, green tea and grapeseed extract neutralize the free radicals that damage healthy skin cells and lead to premature aging and cancer.

THE BEST SUNSCREENS FOR YOUR SKIN TYPE

Sunscreen is like any other product you massage into your face. If it isn't formulated to complement your complexion, it can irritate your skin. Here's some healthy advice for five specific skin types.

ULTRA-FAIR

Sunblocks with an SPF of 30 or higher that contain a physical block like titanium dioxide or zinc oxide.

TREATED WITH RETINOIDS

Since retinoids such as Retin-A, Renova and over-the-counter retinol creams rapidly cause skin to peel, the new skin underneath is extra-sensitive and burns easily. Use a broad-spectrum sunscreen of SPF 30 or higher. Physical UVA blocks like zinc oxide and titanium dioxide are less likely to irritate skin than chemical ones.

OILY

An oil-free, noncomedogenic and fragrance-free gel or spray. These formulas are light and nongreasy, so they're less likely to clog pores.

SENSITIVE

Physical sunscreens like titanium dioxide and zinc oxide. They're less irritating than chemical ones.

DARK

A transparent spray or gel with chemical sunscreens such as Parsol 1789. Physical sunscreens like titanium dioxide and zinc oxide can look chalky on dark skin.

ALL ABOUT APPLICATION

The average person applies only half the amount of sunscreen required to safeguard skin, which translates to only about a third of the protection stated on the product label. It takes the equivalent of two shot glasses (at least) to cover your entire body from head to toe. Apply sunscreen half an hour before you go outside, and put it on while naked, not forgetting spots like the ears, the base of the neck, the tops of feet, and the backs of knees and upper arms. Reapply every two hours, or immediately after swimming, regardless of SPF. Moisturizers and makeup with SPF aren't strong enough, especially if you're going to be in direct sunlight. Keep in mind that UVA rays can penetrate many fabrics, as well as glass, so apply sunscreen onto your shoulders and torso if you sit near a window or spend a lot of time in a car.

SUNSCREENS FOR SPORTS

Sport sunscreens are non-oily gels, mousses or sprays that dry quickly without residue. Most are also designed to be waterproof and sweat-resistant, but since some product may run into your eyes, dermatologists recommend using a nonstinging children's formula on your face when you expect to sweat profusely. Waterproof products are designed to protect your skin for up to 80 minutes in water; water-resistant products for up to 40. Both are stickier than regular sunscreens so they stay on longer; however, some of the product is bound to come off in the water—and when you dry off with a towel—so always reapply after swimming.

KATE HUDSON

SUNBURN S.O.S.

Even the most fastidious sunscreen user slips up sometimes, forgetting to reapply after swimming or falling asleep on the beach after one too many mojitos. (And by the way, drinking and sunbathing are a dangerous combo: Alcohol dehydrates your skin and causes the blood vessels to dilate, so you look doubly red and wrinkled.) If you get a sunburn, take aspirin every four hours to lessen inflammation, and apply a soothing lotion or gel with aloe or menthol to cool your skin. Gels with lidocaine, a topical anesthetic, can ease the pain as well.

FACE FACTS

When selecting a sunscreen, make sure that the product you put on your face complements your complexion. These are the best choices for different skin types:

ACNE-PRONE

Oil-free gels, sprays and water-based formulas are less likely to clog pores. But apply a toner first so the sunscreen doesn't slide right off your skin.

DRY

Use a creamy lotion that contains moisturizers like vitamin E and dimethicone. Dry skin is prone to wrinkles, so for additional protection, add antioxidants. (If you're afraid a creamy formula will make you break out, look for a noncomedogenic one.)

SENSITIVE

Choose fragrance-free formulas with physical blocks like titanium dioxide. These are less irritating than chemical blocks such as Parsol 1789.

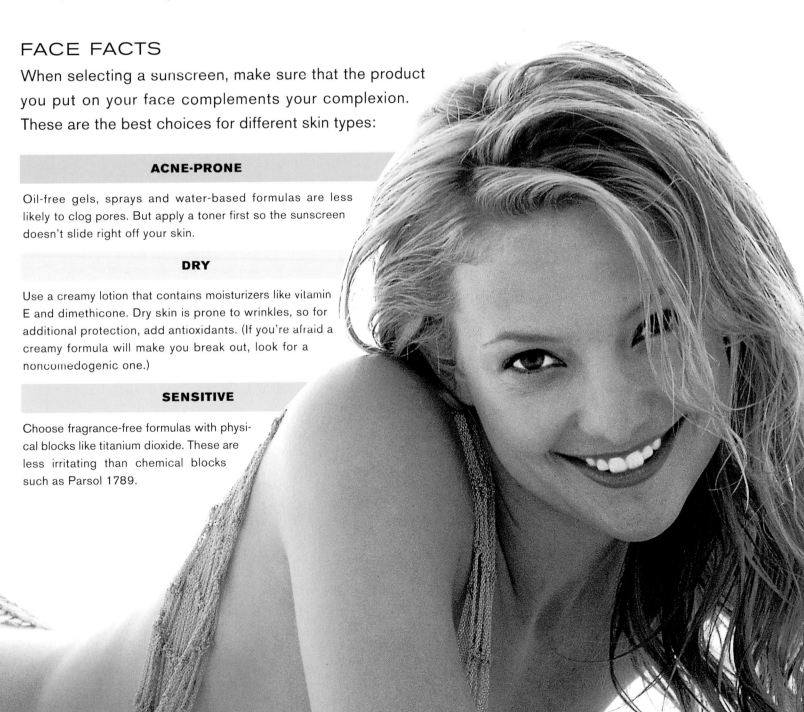

If you're educated about UV rays, you've sworn off sunbathing, but there's no denying that being tan feels wonderful. That's why self-tanners, which darken skin for up to a week with a chemical called dihydroxyacetone (DHA), are manna to beauty mavens.

For mistake-free coverage, go to a salon or spa, where treatments include a full-body exfoliation and expert application of self-tanners. Many spas also offer airbrush bronzing, in which an aesthetician sprays you with a fine mist of DHA formula. Both start at about $40. Many celebrities are addicted to a third, professional but less precise, self-tanning option: spray-tanning salons, where you step into a booth for about 60 seconds and get sprayed from all sides (about $25 per session). Hollywood Tans, hollywoodtan.com, and Mystic Tan, mystictan.com, are two chains.

SELF-TANNERS BY SKIN TONE

For the most realistic self-tanning results, choose a formula suited to your complexion. Tinted self-tanners provide extra insurance because you can clearly see the spots you've missed, and lighter formulas (as opposed to darker ones) are a good idea if you're new at this. And remember: You still have to use sunscreen!

MENA SUVARI

FAIR

Use a creamy self-tanner. It helps hydrate dry skin, and the emollients dilute the DHA (the tanning agent), so the resulting shade is lighter and more natural-looking.

MISCHA BARTON

MEDIUM

You can choose from several different formulations, depending on the degree of color you want. For a light tan, try a cream or spray. For a deeper bronze, use a gel.

MONICA BELLUCCI

OLIVE

Gel formulas are drier than creams, so the DHA is more concentrated. The resulting colors are warmer, which offsets the green undertones in olive skin.

BRONZE YOUR BODY IN FOUR STEPS

STEP ONE

Prepare skin by shaving your legs, exfoliating and moisturizing, and apply extra moisturizer to knees, ankles, toes, elbows, knuckles and around your underarms, which are drier and tend to absorb too much tanner. Allow skin to dry thoroughly.

STEP TWO

Wearing latex gloves, apply a quarter-size dollop of self-tanner (if you're using a spray, hold it eight inches away from skin; if you're using mousse, use an egg-size amount) to cover the shin and calf of one leg. Sweep it down over the ankle, foot and toes (avoiding the nails). Glide another quarter-size dab onto your thigh from front to back. Use excess to cover your knee in a light, circular motion. Repeat on the other leg.

STEP THREE

Apply the same amount to hips, tummy (avoid your belly button; it tends to gather there and can grow darker than the surrounding area), and torso. Blend excess up your neck. Then apply a quarter-size dollop on both shoulders and upper arms, blending in excess on the undersides of your arms and very lightly on your elbows. Apply a nickel-size amount onto forearms, and have a friend do your back.

STEP FOUR

Take off the gloves and smooth a smaller dab from your wrists over the backs of your hands. Go lighter on your fingers so the self-tanner doesn't gather in your knuckles. Remove any self-tanner from your nails and cuticles with a cotton swab dipped in nail polish remover. Wash your palms with soap and water and wait 30 minutes before getting dressed. Once your skin is dry, lighten any excessively dark areas by rubbing them with a wet face-cloth, a granular scrub or a cotton ball soaked in nail polish remover.

JENNIFER LOPEZ

BRONZE YOUR FACE

It goes without saying that applying self-tanner to your face is a tricky business. Take your time and smooth it on in light, uniform strokes.

STEP ONE

Pull your hair out of the way and exfoliate your face, then moisturize. With bare fingers, apply a pea-size dab of self-tanner to your nose, cheekbones, forehead and tip of chin—all the areas the sun hits first.

STEP TWO

Dilute a pea-size dab with equal part moisturizer; apply it everywhere else (but avoid the immediate eye area and the brows).

STEP THREE

Smooth any remaining diluted mixture onto your earlobes, upper ears, behind ears, around the jawline and neck. Wash your hands, scrubbing nails and cuticles.

THE QUICKIE

Nix the two-tone effect. Create a subtle glow by mixing a dime-size amount of tanner with equal part facial moisturizer and applying it evenly from the center of your face outward, as you would a regular lotion or liquid foundation. Scrub your hands.

THE FULL TREATMENT

For seamless color, use a wedge-shaped makeup sponge instead of your fingers. After exfoliating and applying a pea-size dab of tanner to your forehead, cheekbones, nose and chin, start at the center of your face and sweep the remainder out to the sides of your face, up to your hairline and out over your jaw line. Mix another pea-size amount of tanner with equal part moisturizer and smooth it on under your cheekbones, around your eyes (but not too close) and on your temples. Brush excess onto your upper lip, earlobes, upper ears, behind ears, jawline and neck. Wash your hands, scrubbing nails and cuticles. Hold your head as high as possible while tanner dries to avoid creases on your neck.

AFRAID TO FAKE THE BAKE?

It's not surprising, considering the bad rap self-tanners have gotten in the past. These answers to four common concerns should dispel any remaining anxieties.

UNPLEASANT ODOR

Back in the dark ages of self-tanning, there was no way to escape the lingering, unpleasant scent of DHA. But manufacturers have made great strides, camouflaging the smell with essential oils like rosemary, peppermint and orange, as well as hazelnut and pecan oil.

SELF-TANNER STAINS CLOTHES AND SHEETS

Not if you wait long enough for your skin to dry. Apply tanner (preferably a gel or oil-free spray, both of which are less likely to stain) in an airy, not humid, room; try to wait at least 30 minutes; and don't get into bed, or good clothes, before time's up. If you can't wait that long, wear loose, dark clothing and avoid nylon. Any tanner that does end up on fabric should come out in the wash.

UNEVEN STREAKS OR PIGMENT OVERLOAD

Most self-tanners fade in three to seven days, so no error is too serious. Exfoliating can speed up the fading process because DHA darkens only the top layer of skin. Use a granular scrub on streaky areas daily, and within two days, they should be less noticeable. If color is blotchy and isn't fading as quickly as you'd hoped, consider a professional exfoliation or reapply tanner, blending over any uneven areas. (For a quick fix, smooth cream or gel bronzer on light streaks.) Schedule a self-tan two days before a big event to allow time for fixing any goofs.

SELF-TANNER CAUSES FACIAL BREAKOUTS

It's unlikely that the tanning ingredient DHA causes breakouts, but other ingredients in the lotion, such as mineral oils, might clog pores. If you're acne-prone, look for a light, oil-free self-tanner that's made for face and is noncomedogenic (won't clog pores or cause blackheads or whiteheads) and nonacnegenic (won't irritate the skin's tiny hair follicles and cause inflammation). To exfoliate acne-prone skin before application, slough off dead skin cells with toners containing alpha-hydroxy or salicylic acid.

Q&A

What causes cellulite, and how can you get rid of it?

Cellulite is caused by clumps of fat cells pushing up against surrounding fibrous connective tissue. Contrary to popular belief, the condition is not directly related to excess weight; it's hormonal, which is why even skinny women sometimes suffer from it. Unfortunately, there's little you can do about it. Caffeine, the active ingredient in most cellulite creams, tightens blood vessels, which can temporarily give skin a slightly smoother appearance, but it has no effect on the fatty deposits that cause cellulite in the first place. Endermologie, a deep-tissue massage designed to break up fatty deposits, is slightly more effective, but it's expensive (about $150 per treatment) and time-consuming (you have to do it twice a week to maintain the results), and most doctors dismiss it as pure nonsense. Some dermatologists believe that applying a topical retinoid every day can thicken up skin so cellulite becomes less noticeable. An easier way to camouflage it: Apply self-tanner. The color will help hide any unsightly lumps.

In the summer, I get dark patches on my skin that I think are sunspots, but I've also heard about a skin condition called melasma. What's the difference?

Sunspots are small brown spots on any part of the body caused by overactive pigment production due to sun exposure; they may be as small as a piece of confetti or as large as a dime. Melasma patches occur only on the face and can be as large as a quarter. Melasma is triggered by changes in estrogen levels (from pregnancy or birth control pills) in combination with sun exposure. If you think you have melasma, avoid the sun and wear a broad-spectrum sunblock of SPF 30 or higher to prevent the patches from getting darker. See a dermatologist for a cream with 4 percent hydroquinone, a lightening agent. (If you're pregnant, doctors suggest that you wait until after you've given birth for further treatment.) One such cream, Tri-Luma, combines hydroquinone with tretinoin (an exfoliant) and cortisone (to soothe skin). An over-the-counter option: A 2 percent hydroquinone serum. Do a patch test, then apply nightly. You can expect results in about eight weeks.

In addition to hurting like crazy, bikini waxes always cause little bumps on my skin. How can I prevent this?

For smooth results every time, try these tricks of the waxing trade: Before waxing, clear out clogged, infected pores by wiping the area with a toner containing salicylic acid (to prevent future infections, use the toner every other day between waxing appointments). Afterward, soothe skin with over-the-counter hydrocortisone, and prevent ingrown hairs by exfoliating every few days. (If you develop ingrown hairs, they'll need to be extracted manually—see your dermatologist.)

What causes "bacne?"

Back breakouts usually occur when tight-fitting clothes trap perspiration against the skin. To combat it, wear loose, breathable cotton, use a noncomedogenic sunscreen, and shower with an exfoliating salicylic-acid cleanser right after working out or spending time in the sun. Use antibacterial soap and apply a benzoyl peroxide treatment on any affected areas.

My dark skin rarely burns. Do I really need to wear sunscreen?

Yes, you do. It's true that African Americans, Asians and Hispanics don't burn as fast as people with paler complexions and have a lower risk of skin cancer. The darker your skin, the more pigmentation, and the greater the built-in sun protection factor. But you'll burn at some point, and UVA rays can still penetrate any skin (not all sun damage is visible), so protect yourself.

Are tanning salons safe?

No! Tanning booths are dangerous. Studies have shown that they increase the risk of cancer. Tanning lights contain mainly UVA and sometimes also UVB rays. Both those wavelengths can contribute to melanoma and the intensity of energy from those light bulbs is many times stronger than natural sunlight.

How can I prevent and treat stretch marks?

Stretch marks develop when the body grows and hormone levels simultaneously increase (such as during pregnancy). As a result, collagen and elastin fibers in your skin become dehydrated and brittle, then rip. To prevent stretch marks, stay well hydrated, inside and out, by drinking water and moisturizing faithfully. To treat new stretch marks, try applying Retin-A, a prescription cream that may stimulate production of new collagen and elastin and help fade marks. A mark detected in its early stages can also be treated with a pulsed dye laser for three or four sessions (about $300 each). Laser treatment during pregnancy, however, is not advisable. If your stretch marks are older and whiter, try Strivectin-SD, an over-the-counter cream that is clinically proven to decrease the length, depth and discoloration of stretch marks (you have to apply it three times a day for four to six weeks). If that doesn't work, ask your dermatologist about the new FDA-approved Excimer laser, which stimulates melanin production and therefore darkens mature, white marks. It takes six to 10 treatments (about $300 each) to see results, with possible maintenance treatments every six to nine months. It's a relatively new treatment, however, so the jury's out on how dramatic the results are.

Is there any way to prevent a scar from forming—or to make one go away?

Keeping a wound moist and clean can minimize the chance of scarring. Immediately, and once a day after the injury, gently wash your wound with warm, soapy water, rinse, and apply an antibiotic ointment such as Neosporin. Then cover the wound with a bandage. If you do scar, there's no way to make it totally vanish, but you can minimize its appearance. Scars on darker skin are at risk for hyperpigmentation, so avoid exposing them to the sun and apply hydroquinone cream to lighten them. Red scars can be treated with a laser by your dermatologist. And if you develop a keloid scar, which has a thick, raised surface, give it a daily 20-minute fingertip massage; the repeated pressure can help break up the fibrous bands. You can also ask your dermatologist for a cortisone injection, which will help dissolve the built-up scar tissue.

How can I keep my upper lip from getting irritated by waxing?

Waxing pulls off the skin's top layer, so the pain and irritation should come as no surprise. To minimize the pain, stop using products that contain Retin-A or glycolic acids several days beforehand; both ingredients can thin your skin. (Accutane users should never wax.) Use cold or warm wax with azulene, a natural anti-inflammatory. Afterward, apply ice to reduce swelling, followed by a 1 percent hydrocortisone cream like Cortaid. And because waxing weakens the skin's UV barriers, always wear sunscreen.

I've seen ads for creams claiming that soy minimizes body hair. Is that true?

Studies show that body moisturizers containing soy protein help reduce the appearance of hair on the arms and legs. Dermatologists have long known the ingredient, found in many over-the-counter facial creams, can penetrate the skin and soften and even out skin tone, decreasing the appearance of age spots or other mottled pigmentation. But researchers now believe that soy works the same way on hair follicles, effectively lessening the transfer of pigments to the follicle. The result is softer, lighter hair. You can expect to see results—which means you can shave less frequently—in two to four weeks. Another cream to consider is Vaniqa, which doesn't actually eliminate existing hair but slows down the development of fine, downy facial hair by blocking the enzyme that stimulates hair growth. This FDA-approved cream is available only by prescription (a two-month supply costs about $50), and dermatologists recommend that you apply it twice a day for three or four months and once a day thereafter. Consistent use is crucial, since regular hair growth resumes if you stop. Because Vaniqa doesn't remove existing hair, you'll have to continue waxing or using a depilatory on your upper lip or chin—but the process will be much quicker because your hair will grow in finer and sparser.

ANANDA LEWIS

NAILS

Walk into a nail salon in a cranky mood, and chances are that you'll leave in a much sunnier frame of mind. That's because there's something wonderfully restorative about treating yourself to a manicure or pedicure. Groomed nails make you feel ultrafeminine and—pardon the pun—truly polished. Need a visual aid? Imagine yourself in a plain white tank top, your oldest jeans and

flip-flops. Add perfectly shaped, pale pink finger- and toenails to the picture, and suddenly you're the height of minimalist chic. No wonder so many women kick off the weekend with fresh coats of paint.

NAIL SOLUTIONS

Do-it-yourself manicures and pedicures aren't as social as salon ones, but they can be as rewarding. And, if you stock up on the best tools and polishes, the results can be as beautiful as anything you'll get from a professional. Remember that it's possible to pamper yourself at home, too: Add essential oils or rose petals to your soak, and use the richest, most luxurious creams you can find whenever possible.

Whether you keep your nails meticulously polished (which, despite the rumors, is perfectly healthy and actually prevents nails from drying out, as long as you use a base coat) or find yourself scrambling for a nail file minutes before a party or job interview, these tips will take your nails from ragged to refined in no time.

CONNIE NIELSEN

TOOLS

Manicures and pedicures are two beauty treatments that do require a full tool kit. If you skimp on one, you'll skip a crucial part of the cleaning, shaping and polishing process (which, of course, may be the case if you're in a hurry; just don't expect the results to last as long). Here's what to have on hand.

NAIL POLISH REMOVER

Alcohol- and acetone-free removers are less drying, but they aren't as effective at wiping off polish, especially dark shades. Use acetone-free remover for pale shades and "nourishing" acetone remover (containing vitamin E or aloe) for deeper colors.

Cutex Nourishing Acetone Nail Polish Remover

NAIL CLIPPERS

If you do your own nails often, invest in quality clippers; they stay sharp longer and provide consistently clean cuts. If not, any drugstore pair will do, as long as you replace them every year or two (depending on how frequently you use them).

Tweezerman Stainless Steel Fingernail Clippers

EMERY BOARDS

Fine-grade surfaces smooth the nail edge, while a slightly coarser surface shortens and shapes nails. Don't use metal files; they rip your nails. Replace cardboard files when they get dull (too smooth to cause friction), or they'll tear your nails, too.

Revlon Emery Boards

NAIL BUFFER

There are two kinds: classic, chamois-covered ones, which gently polish nails to a satiny shine, and newer, textured ones that have two more surfaces designed to smooth bumps, remove tiny ridges and polish the surface of the nail.

Lippman Collection Smooth Operator Buffer

ORANGEWOOD STICKS

These push back cuticles and remove polish from the crevices around your nails. To protect cuticles, wrap the tip of the stick in a tuft of water-moistened cotton. To remove polish, moisten cotton with remover.

Tweezerman Manicure Sticks

CUTICLE NIPPERS

Use these to snip away hangnails. Try not to clip your cuticles unless there's an obvious peeling piece; otherwise it can retard nail growth and lead to infections. To sterilize nippers, place them in boiling water for 10 minutes and then wipe them with alcohol.

Mehaz Nippers

CUTICLE REMOVER AND CUTICLE OIL

Cuticle remover softens and exfoliates cuticles; apply it before soaking your nails. (In a pinch, you can use an alpha-hydroxy acid cream.) Cuticle oil moisturizes cuticles, but doesn't remove them. (For specifics, see the step-by-step manicure and pedicure on pp. 168–169.)

Creative Nail Design Solar Oil

BASE AND TOP COATS

Base coats prevent pigment from seeping into nails, which leads to yellowing; prevent polish from drying nails; smooth the surface and help polish adhere so it won't chip. If you have weak nails, use a strengthening formula. Top coats add shine and help polish last.

Nailtiques Formula 2 Base Coat *Seche Vite Dry Fast Top Coat*

PEDICURE EXTRAS

FOOT RASP AND PUMICE STONES

Foot paddles (embedded with fine crystals) and pumice stones slough off dead skin from heels and calluses. Use them on damp skin only, and stop if your foot turns bright red (you've scrubbed too hard).

Diamancel No.10 Foot File

TOE SPACERS

They prevent toes from bumping—and polish from smudging.

Ricky's Toe Spacer

A CLASSIC MANICURE IN SIX STEPS

STEP ONE

Remove existing polish with a cotton ball, and use a cotton-wrapped orangewood stick on tough spots. Clip nails straight across—the more pointed they are, the weaker and more likely to tear they will be.

STEP TWO

File your nails until the corners are slightly rounded: Professionals call this universally flattering shape a "squoval." Use a fine-grade file and work from the outsides in, stroking the file in one direction, not sawing it (which can cause microscopic tears).

STEP THREE

Apply cuticle remover to your cuticles, then soak your fingertips in a small bowl filled with warm water for three or four minutes. (To lighten yellow stains on nails, add a teaspoon of hydrogen peroxide or lemon juice to the water.)

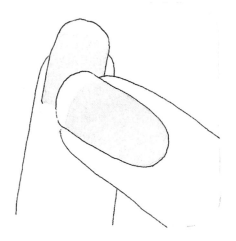

STEP FOUR

Wrap cotton around an orangewood stick and use small, circular motions to clean your nails and gently push back your cuticles. Clip off hangnails (but don't cut the cuticle). Exfoliate hands with a body scrub, rinse, and apply hand cream; then remoisturize cuticles with cuticle oil. Use a cotton ball soaked in remover to clean the nails again.

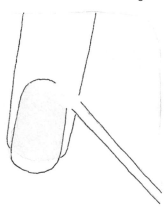

STEP FIVE

Starting with your pinkie, apply base coat and let it dry for one minute. Then apply color polish. When applying color, wipe one side of the brush against the bottleneck to get rid of excess polish; then use the other side to apply. For even color, apply polish in three strokes (down the center, then one down each side) from the base to the tip.

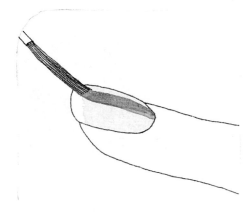

STEP SIX

Wait two minutes and apply a second coat. Prevent chips by brushing polish over the top edge and slightly underneath the nail to "wrap" polish around the tip. Clean up errors with an orangewood stick wrapped in a wisp of cotton moistened with remover. Finish with clear top coat and let nails dry for at least 20 minutes.

THE QUICKIE
Wipe off old polish and file your nails into clean-looking squovals. Apply one coat of fast-drying polish in a sheer, shimmery color that will easily camouflage any errors.

A CLASSIC PEDICURE IN SIX STEPS

STEP ONE

Take off old polish with a cotton ball soaked in remover, and clip nails straight across to avoid ingrowns. The white tips should be no longer than an eighth of an inch. File nails from the corners in toward the center, in single, one-way strokes. Buff the surfaces with a thin, flexible buffing file or disk to remove ridges.

STEP TWO

Apply cuticle remover and soak feet in warm water for two to five minutes. (To lighten yellow stains, add a teaspoon of hydrogen peroxide or lemon juice to the water.)

STEP THREE

Wrap cotton around the end of an orange-wood stick and use it to gently push back cuticles and clean under the edges of your nails. Massage your feet with rich, granular body scrub. Rinse feet. Soften calluses and remove dead skin on damp feet with a buffer or pumice stone. Rinse again.

STEP FOUR

Dry feet thoroughly, including between the toes, and rub in a rich foot cream. Rehydrate cuticles by rubbing in a dab of cuticle oil. Wait two to three minutes.

STEP FIVE

Wipe off cuticle oil from the nail surface with nail polish remover. Trim tough, peeling cuticles. Apply base coat and let it dry for one minute. Add one coat of color, applying polish in three strokes (down the center, then one down each side) from the base to the tip.

STEP SIX

Wait two minutes and then apply a second coat of color, painting any polish remaining on the brush over the front nail edge (this prevents chipping). Clean up any errors with an orangewood stick wrapped with a wisp of cotton moistened with remover. Finish the job with a top coat and let nails dry for at least 20 minutes.

THE QUICKIE
Remove old polish and trim and file your nails. Apply one coat of fast-drying polish in a sheer, shimmery shade that forgives any errors.

CHOOSING COLORS

Now that you've gotten through the nitty gritty, it's time to explore the sexy side of nails: the eye-popping and softly elegant polish colors. When narrowing down your selection from rows of little bottles, use your skin tone as a guide. (For specifics, see the chart below. For information on how to determine your skin tone, see p. 36.) Once you've customized your color palette, pick specific shades to match your mood. Most women wear pale shades on their fingers and deeper or brighter ones on their toes, but there are no hard and fast rules. Sheer nude or shell pink broadcasts feminine sophistication. Juicy pinks and tropical oranges are striking and sassy (and contrast well with tan skin). Metallic coppers and silvers are ultramodern, while a rich red is as classic as it gets. The bottom line: When you put on the perfect shade, it will enliven your skin—and your spirits. As far as texture is concerned, shimmery and iridescent polishes are considered more playful than opaque ones, which are more traditional. All that really matters, though, is what looks beautiful on your nails, and what is most appropriate for your lifestyle.

THE BEST SHADES FOR YOUR SKIN TONES

WARM	COOL	DARK
Avoid cool undertones. Try deep browns, warm pinks, corals with yellow undertones (they do exist) or white-pink sheers; for a bright boost of color, choose an orangey shade, which contrasts well with olive skin.	Look for colors with blue undertones. If you want to wear red, opt for a cool berry shade. If you prefer pale pink, look for one with bluish, not beige, undertones.	Warm browns, creamy beiges, vivid pinks and deep purple shades will be flattering on you. Just make sure the polish is darker than your nail beds, so the nail beds don't show through.

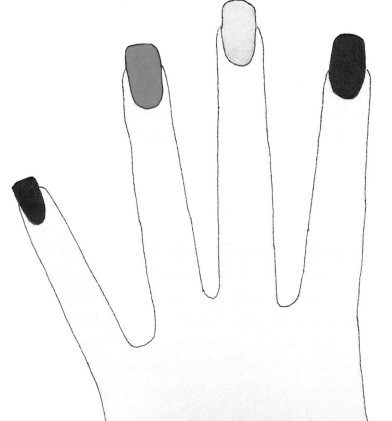

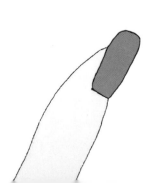

MAKE IT LAST

Experts say a manicure should last one to two weeks; a pedicure two to four weeks. The first step toward staying power: Allow plenty of time for your nails to dry. Their surfaces will feel dry to the touch after 10 minutes, but don't be fooled. It actually takes an entire hour for polish to dry completely, so have a good book handy—or wear flip-flops. The following tips will also prolong the look of manicures and pedicures.

MAINTENANCE

ADD A FRESH LAYER of top coat every other day.

MINIMIZE CONTACT WITH WATER and cleansers (in other words, wear gloves when you do the dishes, and keep hands above water when you soak in a bath).

WRAP THE TIPS of your nails with polish. Don't forget, when applying polish, be sure to bring it over the front edge of the nail and slightly under the tip in order to prevent chipping.

BE EXTRA CAREFUL when handling keys and coins.

DON'T PICK AT YOUR CUTICLES. They'll look horrible within days, and the manipulation can lead to infection.

SMOOTH FEET with a pumice stone or buffing paddle in the shower two to three times a week.

MOISTURIZE FEET THOROUGHLY every day after bathing. Once a month or so (especially in winter), cover them with petroleum jelly or a strong lactic acid lotion before bed and sleep in cotton socks.

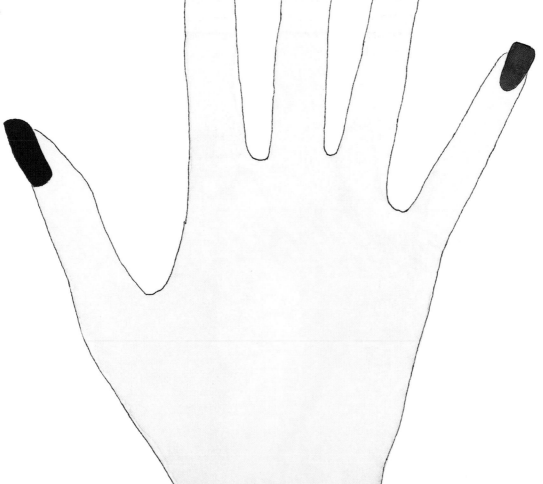

NAIL HEALTH: PROBLEMS AND SOLUTIONS

Nails can be flirty and feminine, but they deserve to be taken seriously, too. Made up of the protein keratin, nails grow from living tissue in the nail bed (the curve of skin at the base of the nail also known as the matrix or "moon") at the rate of about an eighth of an inch a month. In addition to protecting the tips of your fingers and helping you pick up small objects, nails are indicators of your overall health; for instance, brittle, peeling nails often result from basic dryness. (Brittle nails can be a sign of vitamin deficiencies, and peeling nails can be a symptom of thyroid disease.) Here are the most common (and admittedly less life-threatening) nail problems and their treatments:

	CAUSE	SOLUTION
FUNGUS	This happens more to toenails than fingernails, and occurs when nails are infected by a fungus called tinea, which thrives in warm, moist environments like public showers, swimming pools and unsanitized pedicure sinks. The result is thick, crumbly, discolored nails.	An over-the-counter anti-fungal liquid such as Lotrimin or Lamisil may suffice. If not, ask your doctor for a prescription cream such as Loprox, or an oral antifungal, which you take for three to four months. (Oral antifungals can cause liver irritation, however, so your doctor will have to monitor your bloodwork while you take the medication.)
PEELING	Some people are born with peeling nails; others acquire them through excessive washing of their hands, exposure to detergents, or overfiling and overbuffing. In rare cases, peeling is caused by protein or vitamin deficiencies.	Protect nails by keeping them polished and take daily biotin supplements (2.5 milligrams). Once a week, change polish. While nails are bare, massage nail oil into the surfaces and apply a single coat of nail hardener.
WHITE MARKS	White spots are most frequently caused by trauma or too much pressure applied to the nail matrix (during a manicure, for example). They can also result from nail dehydration if you use polish remover containing too much acetone.	You can't get rid of spots; you have to let them grow out. Bear in mind, though, that glossy neutral or clear polishes will highlight them. Wear an opaque polish instead. If the entire nail bed appears unusually pale, it could be a sign of anemia or liver disease, so see your doctor.
RIDGES	Picking or pushing at the base of the cuticle can result in grooves and depressions. Chronic disease, aging and taking certain medications, such as chemotherapeutic agents used to treat cancer, over a long period of time, can also cause ridges. Genetics also play a role, so no matter how well you treat your nails, they'll always be a little uneven.	If ridges really bother you, you can gently buff them smooth (be careful to buff only the raised ridges, not the surfaces in-between). Afterward, wipe away the dust and apply one coat of ridge filler.
INGROWN NAILS	Found most frequently on toes, these are caused by rounded corners on nails. Pain can also occur if tight shoes cause skin to thicken around ingrown areas.	To prevent them, always cut toenails straight across. Once you have an ingrown nail, a podiatrist can trim the skin around it to relieve pain (you'll get a shot of local anesthesia first). Note: Some people are prone to ingrowns even though they take proper care of their nails. An operation can correct a severe condition.
BLACK TOE	This results from blood that has collected under the nail, caused by a toe jamming against the inside of a shoe (it's a common problem for runners).	The toe needs to be drained by a doctor right away. The toe nail can fall off if blood accumulates beneath it. Prevent black toe by keeping your toenails clipped and wearing properly fitting shoes.

Are acrylic nails safe?

No. Acrylic nails not only increase the chance of infection, but they also weaken nails because the glues and chemicals used to make them adhere are so strong. A safer alternative is the Custom Blended Manicure by Creative Nail Design, a new service offered in salons across the country (call 800-700-4939 to find a salon near you). An aesthetician blends pigmented powders to match your natural nail color, and then mixes it with a liquid to form a "breathable" coating that bonds naturally with the keratin that makes up your nails. The treatment costs $65 to $90. For a quick fix that is totally safe, try Kiss 1 Easy Step (about $4 at drugstores). They don't look quite as realistic as salon acrylics, but these stick-on nails adhere easily and are removed by soaking nails in warm water for 10 minutes.

I want to get rid of the age spots on my hands. What are my options?

Sun damage and aging cause melanin, the pigment in skin, to concentrate in brown spots. The first step: Stop further sun damage by wearing a hand cream containing sunblock every single day. A cream containing a bleaching agent such as hydro-quinone or kojic acid can lighten existing spots. As a last resort, you can try vascular laser treatments. During the treatment, which feels like a rubber band snapping your skin, the pigment absorbs pulses of light from the laser, causing it to heat up, darken and shatter. The process costs between $200 and $400, and typically requires four to six treatments.

Is it true that eating gelatin or taking calcium will strengthen my nails?

Gelatin is a protein, and a severely protein-deprived diet weakens nails. But gelatin will only benefit nails if you have a deficiency. Calcium strengthens bones, but it isn't an integral part of nail structure. A 2000 New Zealand study involving 690 women showed that calcium supplements had no effect on nail growth. Your best bet: Take 2.5 milligrams daily of biotin, a supplement that has been shown to strengthen nails.

How can I stop biting my nails?

Try the Pavlovian approach: Use Don't Bite, an extremely bitter, waterproof solution that you paint on your nails. If you can't stomach that, try to keep your nails polished at all times—the brighter the color the better. Applying cuticle oil daily can also inhibit biting, because it's hard to get a grip on a slippery surface. To up the ante, keep a weekly standing appointment with a manicurist and tell her you're trying to kick the habit. You'll be less likely to destroy a perfect manicure (that you paid for), and she can offer you moral support.

How do I know if I have a nail infection? What can I do to prevent one and make sure that my manicure is hygienic?

If you have redness, swelling and pain around your nails, you probably have a bacterial infection. Infections are caused when bacteria gain entry to tissue through nail or skin damage. Acrylic nails are a common culprit: Air pockets between the real and synthetic nail can trap moisture and encourage bacterial and fungal growth. Even regular manicures can cause infections if they're not performed hygienically. Make sure your manicurist always uses a new emery board. Any salon tools that are not brand new (such as clippers) should be kept in a sterilized auto-clave in the salon. To feel totally secure, bring your own kit to the salon; some salons let you keep them there. At home, sterilize your own tools after every use by placing them in boiling water for 10 minutes, then wiping them with alcohol. To avoid fungal infections, be sure salon soaking basins are disinfected between each use.

How do I make my short fingers and wide nails look longer and more elegant?

Avoid red polish, which will accentuate short or pudgy fingers. Neutral shades will elongate them. To bolster the illusion of length, if you wear colored polish, leave thin, unvarnished lines down either side of your nails.

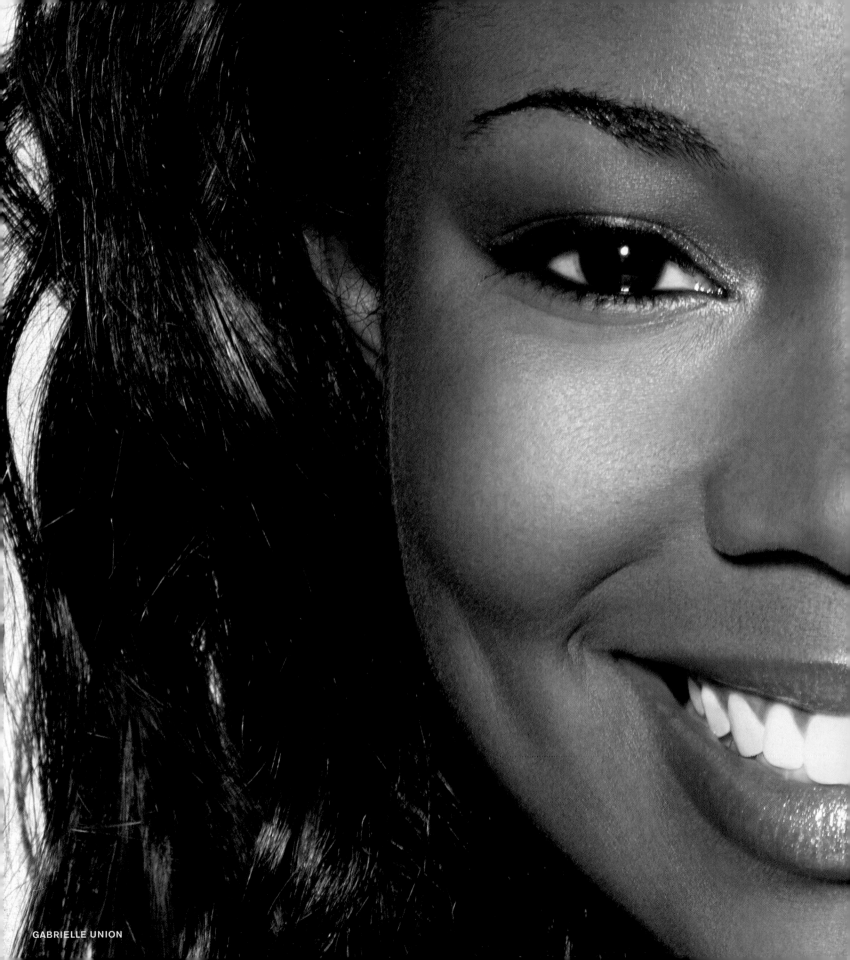

GABRIELLE UNION

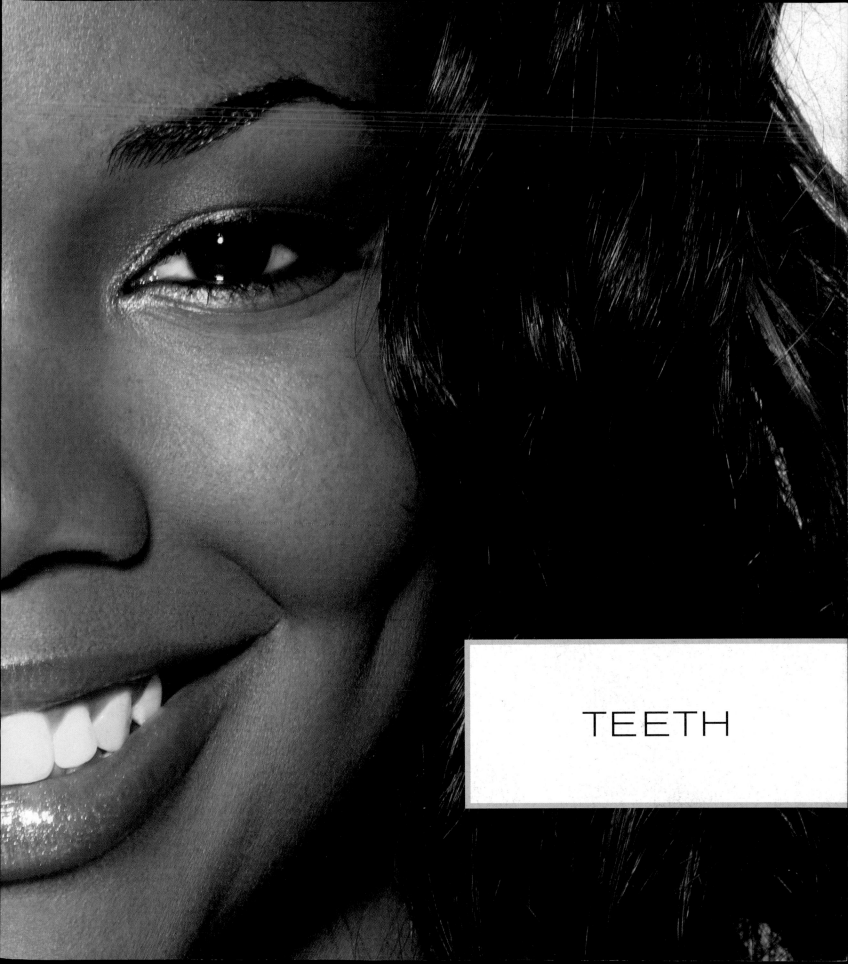

TEETH

Dreading a dentist appointment is so passé. Granted, there isn't much to smile about if your reason for going is a toothache or root canal. But if your goal is to brighten, whiten and straighten your teeth, you should be grinning from ear to ear. Speedy in-office teeth-whitening procedures and a host of other options are making a sparkling smile more attainable than ever.

Cosmetic dentistry and its at-home alternatives (including whitening toothpastes, strips and one-size-fits-all bleaching trays) are as quick and convenient as putting on a facial mask or having your hair colored, and the results are equally tangible. But keep in mind that, depending on the treatment you choose, improving the appearance of your teeth can be incredibly, even prohibitively, expensive. One session of in-office power bleaching will set you back up to $2,000, and veneers cost up to $2,500 per tooth. Before you put a huge chunk of money where your mouth is, you might want to try whitening strips or gel at home: A subtle brightening may be all you need (or want).

Whatever route you choose, begin by taking stock of your basic dental hygiene. Healthy teeth and gums (with fillings firmly in position and no open decay) form the foundation of a gleaming smile, and besides—let's get some perspective here—strong teeth are much more important than pretty ones. The ground rules haven't changed since you first picked up a tooth-brush, but a refresher never hurts. Brush twice a day with a fluoride toothpaste and a soft-bristled brush (and replace your brush every three or four months). Floss daily to remove decay-causing bacteria (AKA plaque) that toothbrush bristles can't reach. Eat a balanced diet: Avoid excessive sugar and starch; they cause acids to form on the teeth, which leads to decay. And see your dentist every four to six months for a professional cleaning and oral exam. There. Now that wasn't so bad, was it?

LISA KUDROW

OVER-THE-COUNTER BRIGHTENING/WHITENING SOLUTIONS

At-home whitening treatments are affordable and accessible, but don't expect miracles. They contain only 6 percent peroxide, while professional treatments contain up to 35 percent. The effects of over-the-counter treatments last six months, while professional bleachings can last up to three years. At-home kits are ideal for maintaining teeth after they've been lightened by a dentist.

TRAYS

These are similar to the trays from your dentist (see p. 179), but they contain less peroxide, and the trays aren't custom-fit. They cost $12 to $25 and come with gel-filled syringes that you squeeze into the trays. Wear them 30 minutes, twice a day, for two weeks. Another, slightly more expensive option is pre-filled trays that mold comfortably to your teeth (and cost about $100). Tray systems lighten teeth several shades.

STRIPS

Whitening strips work well for people with mildly discolored teeth who want a quick boost. Like gels, strips should be worn for 30 minutes twice a day for two weeks. They're more effective than gels because the peroxide-covered strips press a thick layer of bleach onto your teeth. Once they're in place, try not to talk or move your mouth around. Strips cost $30 and up, and in most cases lighten teeth several shades.

PASTES

Some whitening toothpastes contain abrasive silica and baking soda. Others contain a bleaching agent like peroxide, which helps break up plaque, the main source of superficial stains. And some are formulated with both. Although the peroxide content of bleaching pastes isn't high enough to whiten your smile dramatically, peroxide pastes are safer than abrasive ones, which wear away at your enamel. Most whitening pastes cost between $3 and $8 and cause subtle changes in two weeks.

GELS

Peroxide gels, which you paint directly onto your teeth once or twice a day for one to two weeks, can subtly lighten mildly discolored teeth. Avoid drinking or eating for at least 30 minutes afterward to allow the gel to work. And be careful not to lick your teeth, or you'll wipe the bleach off. Gel kits cost about $15 and lighten teeth a shade or two, in part by removing stains.

PROFESSIONAL TEETH LIGHTENING: PICK THE RIGHT WHITE

Watch television for five minutes, and you'll be tempted to take teeth bleaching to the extreme. Resist the urge. While a megawatt smile is required for talking heads and sitcom stars, it can appear fake or even cheesy in real life. Here's how to figure out how much lighter you can go while still looking natural.

YOUR CURRENT COLOR

Stained teeth are either yellow or brown (from coffee, tea, red wine, grape juice, cola or tobacco) or gray (from trauma, such as a root canal, or antibiotics). Your dentist should have a shade scale showing up to 16 hues to help identify your existing tooth color. Find your perfect match before proceeding. It will have an impact on not only how light you decide to go, but also on the ideal whitening technique for you.

YOUR AGE

The older you get, the duller and more discolored your teeth become. And though bleaching can brighten, it can't turn back time. Don't try to re-create a shade you had 10 or 15 years ago—it's a dead giveaway that your teeth have been artificially lightened, and the too-bright color will clash with your current features. Instead, stay within three to five shades on the dentist's scale; you'll still look like yourself, only more dazzling.

YOUR COMPLEXION

If you have yellow or olive undertones, try to retain some ivory or yellow in your teeth. If you have pink undertones, your teeth should have a hint of blue or gray in them. A dentist with extensive whitening experience will match your new undertones to your old ones. (Ask how long he or she has been doing these procedures, and whether you can see before and after shots or speak to a former patient.)

MAJOR LIGHTENING AND RE-SHAPING METHODS

Whether you want to upgrade your smile a few shades, correct misalignment without more aggressive orthodontic methods, or cover a crack in your tooth, one of these procedures will suit your needs. But be warned: You may pay a high price for a perfect smile.

BLEACHING TRAYS

BEST FOR: People with yellow and brown stains.

HOW THEY WORK: Your dentist takes an impression of your teeth, creates custom trays, and gives you a bleaching gel of up to 35 percent peroxide. Each day for two weeks, you fill the trays and wear them for 45 minutes or overnight depending on the kind you get.

PAIN FACTOR: Very low, if the trays fit properly. If not, the gel will irritate your gums. You may experience heightened sensitivity for a day or two; if so, take ibuprofen or wear the trays every other day.

PROS: You control how white your teeth become gradually.

CONS: Bleaching trays won't work on veneers or intrinsic stains. Intrinsic stains lie beneath the tooth enamel and are commonly caused by genetics, taking the antibiotic tetracycline, having a root canal (because blood seeps into the tooth and stays there) or having excessive fluoride in your water supply.

COST: $300 to $500

STAYING POWER: Three-and-a-half to five years. Brush with a peroxide toothpaste after consuming coffee, tea, red wine, colas, beets and artificially colored foods. Maintain with drugstore products.

BLEACHING LAMPS

BEST FOR: People with yellow or brown teeth who want fast results.

HOW THEY WORK: After covering your gums with a protective wax, a dentist or hygienist applies a gel to your teeth. The gel contains up to 24 percent peroxide and is activated with a high-intensity light.

PAIN FACTOR: Be prepared for mild discomfort, especially if you have cavities or cracked teeth. If the gel gets on your gums, it will sting; be sure to tell your dentist so he or she can adjust the protective covering. About 30 percent of people experience tooth sensitivity, but it shouldn't last longer than 24 hours. If it does, call your dentist.

PROS: In one hour, you can lighten your teeth up to eight shades.

CONS: You can't control how light your teeth will get, so you risk ending up with an unnaturally white smile. Also, the treatment won't whiten veneers, and it isn't very effective on intrinsic stains.

COST: $450 to $1200

STAYING POWER: Three-and-a-half to five years. Brush with a peroxide toothpaste after consuming coffee, tea, red wine, colas, beets and artificially colored foods. Maintain with drugstore products.

VENEERS

BEST FOR: Anyone who wants to reshape teeth or cover intrinsic stains that are impervious to bleach.

HOW THEY WORK: Your dentist sends an impression of your teeth to a lab, which creates wafer-thin porcelain laminates that are then bonded to the surface of your teeth (teeth are shaved down first to facilitate adhesion). The process requires three office visits.

PAIN FACTOR: The sting of a needle—local anesthesia (usually novocaine) is used before any shaving is done.

PROS: You get perfect teeth that resist permanent staining.

CONS: Veneers are irreversible. Ask to see photos of veneers your dentist has done on other patients before committing.

COST: $1,000 to $2,500 per tooth. Some people opt for top front veneers only. A full set—eight to 10 on the upper arch and six to 10 below—runs $20,000 and up.

STAYING POWER: Ten to 20 years.

BONDING

BEST FOR: People who want to correct minor flaws such as chips, cracks and gaps without spending a lot.

HOW IT WORKS: After matching the shade of a composite resin to your enamel, the dentist molds the resin onto the tooth and hardens it with an ultraviolet light. Then the bonded tooth is polished, so its coated surface matches the rest of your teeth.

PAIN FACTOR: A quick pinch from a shot of local anesthesia.

PROS: In the majority of cases, bonding is a much less expensive alternative to veneers and requires just one visit to the dentist.

CONS: It isn't as resilient and stainproof as veneers, and you could end up with bulging, Chiclet teeth. Ask your dentist to show you photos of past bonding.

COST: $300 to $1,200 per tooth

STAYING POWER: Eight to 10 years, with annual checkups to make sure they're still firmly in place.

BREATH

Bad breath is embarrassing and off-putting, whether you're on the giving or the receiving end. But if you bone up on the causes and cures of this social scourge, you can rest assured that you'll never offend anyone again. The first matter of business? Knowing whether you have bad breath to begin with. You've probably heard of all kinds of tricks, from blowing in your hand and sniffing to asking a close friend or partner for candid feedback. According to dentists, the former isn't an accurate gauge. And the latter is simply too humiliating a prospect. The most effective method, according to the pros: Lick your hand and smell the saliva. It's far from ladylike, but it really works. Now, the nuts and bolts.

CAUSES

Coffee, tobacco and foods spiked with garlic and onions can give you bad breath, but the primary cause is plain old bacteria built up on the back of your tongue. Odor-causing microbes like to breed on the tongue and in crevices caused by cavities, gum disease or ill-fitting bridges and crowns. Other culprits include alcohol, antihistamines, nasal sprays and certain antidepressants, all of which dry up your saliva. And in people who are chronically undernourished (because of long-term dieting, for example), the body may begin to metabolize its own fat—and emit a foul-smelling waste product in the process.

CURES

To keep bad breath at bay, drink plenty of water and brush and floss at least once a day (after every meal is optimal but not always feasible). This is especially important at night, since the production of saliva, which helps to wash out odor-causing bacteria, slows down when you sleep. In addition, always use your brush or a tongue scraper (available at drugstores or from your dentist) to scrape any bacteria or food off of your tongue. If you still have less-than-fresh breath, a chlorine dioxide mouthwash can help squelch an unpleasant odor for a few hours. Choose one that is colorless and alcohol-free, since alcohol will dry out your mouth, and a bright color can stain your teeth if you use it regularly. (For a quick homemade fix, mix a teaspoon of salt into a glass of water and gargle; the salt will kill bacteria on contact.) No time to rinse? Chew sugarless gum, which, surprisingly, does an excellent job of cleaning the cracks and crevices between your teeth.

Q&A

I've heard that kissing can spread gum disease. Fact or fiction?

Icky as it sounds, it's true. Periodontal disease is bacterial, and if you're swapping saliva, you can catch it. Before smooching, check out your partner. Does he or she have bad breath or red, puffy, bleeding gums? If so, you're probably not interested in mouth-to-mouth contact anyway. Luckily, gingivitis, the fledgling stage of periodontal disease, is totally reversible. Start flossing right away, and you won't have to worry about gum diseases—or bad breath, for that matter. If you are diagnosed with periodontal disease, your dentist will most likely deep clean your gums and then administer an antibiotic (Arestin is a common one) or use a laser to kill bacteria in the pockets formed in your gums when the tissue and bone break down. In advanced cases, surgery is also a possibility.

What should I look for in a toothbrush?

Experts say the best toothbrushes have small heads and soft bristles, since hard bristles can wear down your enamel. For turbo-charged teeth cleaning, try an electric toothbrush, which mimics the rotary motion of polishing machines used by dentists. Their built-in timers encourage you to brush for two full minutes, as dentists recommend, and they're designed to clean hard-to-reach places such as the backs of your molars.

My teeth are crooked, but I can't bear the thought of getting metal braces at my age. Do the clear ones work?

Yes. Clear braces, which consist of porcelain brackets and clear wires, move teeth just as effectively. An even more convenient option is Invisalign, a set of clear, custom-made retainers that slip right over teeth. You take them out only to eat and brush your teeth. Every two weeks, as your teeth move into place, you switch to a new retainer. As with regular braces, it takes six months to two years to straighten a bite. Two caveats: Both transparent braces ($5,000 to $6,000) and Invisalign ($3,000 to $5,000) cost more than metal braces (about $2,500). Invisalign is not recommended for fixing major bite problems or severely overcrowded teeth.

I confess: I don't floss! What are the basics?

Floss either before you brush, or between brushing and using mouth rinse, to remove food particles and plaque from between the teeth and under the gum line—areas a toothbrush can't reach. Neglecting to floss is the surest way to develop gingivitis, an inflammation of the gums that can ultimately lead to periodontal disease and, eventually, gum, tooth and bone loss. Use floss made from natural fibers, which are gentler on the gums than synthetic fibers. Break off about 18 inches, winding most of it around the middle fingers of both hands. Start between your upper molars. Using your thumbs and forefingers, slide about an inch of taut floss between your teeth, curving the floss around the tooth in a C shape at the gum line. Slide the floss gently up and down between each tooth surface and gum, making sure you go beneath the gum line. Repeat on the rest of your teeth with clean sections of floss. For extra scrubbing action, you can double up the floss so you're using two strands instead of one.

How much do tooth-colored fillings cost?

A resin composite costs 20 to 30 percent more than a regular metal filling (about $150 to $300 per filling replacement), but many people feel it's worth the investment. Not only are they invisible but they also bond better to the tooth, so you're less likely to get cracks, which lead to cavities. Another option is porcelain inlays, which are a bit more complicated. They require two visits and cost $750 to $1,000 each. Inlays last from 10 to 20 years; white resin fillings last between five and seven years. Another reason to trade in your metal: The safety of mercury in amalgam fillings has been called into question by many dentists and public health groups, including the International Academy of Oral Medicine and Toxicology (the American Dental Association and the FDA still claim it's safe). Regardless, if you have the same fillings you had as a kid, it's probably time to have them replaced because silver fillings expand over time and can cause tiny cracks in your teeth.

JEWEL

FRAGRANCE

Coco Chanel once said, "Perfume is the unseen, unforgettable, ultimate accessory of fashion." It's also the most personal beauty product you'll ever wear, so no book can tell you which one to choose. Finding the right scent requires a lot of sniffing—and a bit of soul searching. So take your time. Stop and smell the roses, lilies and peonies, and pay attention to the emotions they stir.

On the surface, fragrance seems simple: a scented liquid that you dab or spray onto your skin with the straightforward goal of smelling good. But it's much more complex than that. Fragrance is invisible yet all-powerful, triggering specific memories (both happy and heartbreaking) and arousing a spectrum of moods (romantic, sexy, sophisticated) on impact. To further complicate matters, scent is totally subjective: What makes you swoon will make another woman cringe; what reminds you of a blissful love affair will call to mind a bossy mother-in-law for someone else.

As intangible as fragrance is, try to approach the shopping process with your feet planted firmly on the ground. The reality is that buying perfume can be confusing and even frustrating. Who hasn't wandered through a department store, fending off pushy spritzers and looking for any minute detail— a pretty bottle, a pretty spokesmodel—to help narrow down the field? Instead, arm yourself with useful information and treat the search like a treasure hunt. The more fun you have, the more likely you are to discover a scent that truly makes you happy.

Now for that useful information. The following pages will explain the common ingredients and building blocks (or notes) that make up different kinds of fragrances. They will spell out techniques for homing in on the types of scents you like and testing them without overloading your sensory system. And, since this book doesn't include scent strips, it will provide you with names of fragrances, both classic and modern, for each category, so you can go to the store and test them for yourself.

Most important, remember that the right scent for you will express your original beauty and personality and make you feel alluring, confident and comfortable in your skin. And you can certainly fall for more than one. Rather than stick with one signature perfume, spritz something different for every occasion and facet of your character: a crisp, grassy scent for lunch with friends; a lush oriental for an intimate nightcap; a sweet floral for an afternoon alone. The only requirement? That it makes your heart sing.

COURTENEY COX ARQUETTE

THE STRUCTURE OF A SCENT

The vast majority of fragrances are formulated in a pyramid structure, which consists of three layers, or notes. The top note, which is your first impression of a fragrance, is usually a fresh, bright and zesty scent that quickly evaporates, although elements of it linger. A few common top-note ingredients are lemon, bergamot and black currant. The middle note, or "heart," tends to be warmer (as opposed to crisp) and heavier, often thanks to a combination of rich florals, and lasts between two and four hours. The bottom notes, also known as the dry-down, emerge 10 or 15 minutes after you've applied the fragrance and deepen in intensity as the day goes on. It often features sexy, earthy ingredients like musk, sandalwood and vetiver, and stays on your skin for five or six hours. Perfumers compare this traditional, evolving structure to listening to a chord, as opposed to a single note. The other, much less common fragrance form is linear. These straightforward scents emit the same odor from the top note through the dry-down, so they smell exactly the same when you spray them on as they do hours later. A classic example is CK One.

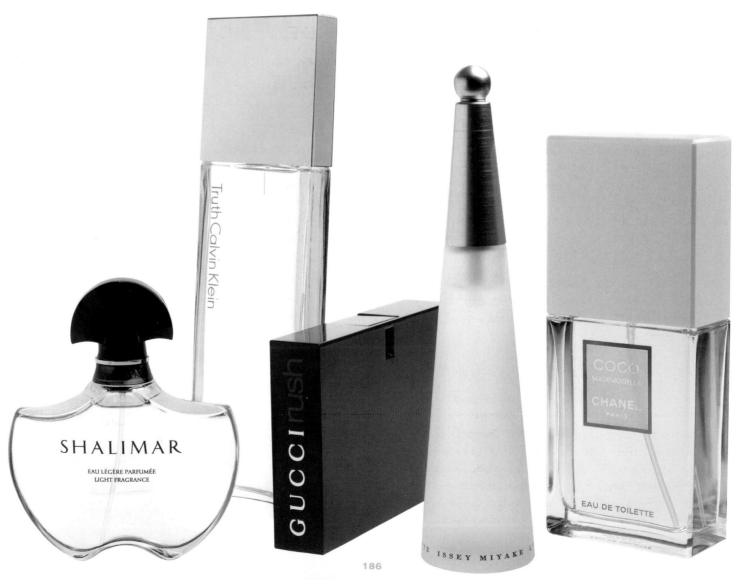

FRAGRANCE FORMULATIONS

Fragrances comes in a variety of concentrations, from faint to bold and brazen. Before buying, consider where you plan to wear the scent. Office or nightclub? PTA meeting or cocktail party? One guideline: Avoid wearing strong scents at work, in restaurants, and anywhere else you might offend a captive audience.

THE FOUR BASICS

PERFUME OIL This is the purest form of fragrance. Rather than being diluted in alcohol, oils are mixed with solvents. A dab of the slightly viscous fluid smells less intense, but lasts longer than, regular alcohol-based perfume, so smooth it on sparingly.

PERFUME Of liquid (non-oil) fragrances, perfume is the most potent. Pure fragrance oils constitute up to 40 percent of the formula. Within 45 minutes, half of the scent evaporates, but the other half stays strong all day. Reserve these for special occasions.

EAU DE PARFUM Slightly more subtle than perfume, eau de parfum consists of 7 to 15 percent pure oils, and only 30 percent of the scent lasts all day. These are ideal for occasions when you want to smell lovely but not make your scent the center of attention.

EAU DE TOILETTE These are typically 85 percent alcohol, so the fragrance is light when you first spritz it on and faint a few hours later. Wear eau de toilette during the day, either to work or on the weekend—any time you plan to dress simply or casually.

TEST THE WATERS: FINDING YOUR IDEAL SCENT

You'd never buy a car without taking it for a test drive. Fragrance may cost a fraction of the price of a four-door sedan, but the same philosophy applies. Here's how to shop smartly.

STEP ONE

Think about fragrances you've loved wearing in the past and figure out which family (or families) they fall into (see pp.188–189). Chances are, you'll still like the same kinds of scents. Look through magazines and sniff scent strips to get a sense of what's new on the market. Maybe something wonderful will leap out at you.

STEP TWO

Shop in the middle of the day, when, according to olfactory experts, your sense of smell is strongest. Don't wear any fragrance, and don't wear any wrist jewelry (including leather watch bands); they can distort scents.

STEP THREE

Take time to browse. Pay some attention to names and bottles: After all, fragrance makers put a lot of effort into making sure the packaging of a perfume reflects the fragrance inside. (For instance, a green bottle probably indicates that the perfume will be crisp and fresh, with leafy ingredients.) To help narrow down your selection, tell a salesperson what kinds of fragrances you like and have five or six perfumes spritzed onto blotter papers. To clear your head between whiffs, sniff coffee beans (many fragrance counters supply them).

STEP FOUR

Choose three to try on your skin; any more will overwhelm your nose. Apply the first to your inner wrist (don't rub your wrists together; the friction heats up your skin and alters the scent), another on your inner elbow, and the third onto an opposite wrist. Allow 15 minutes for the scents to develop—and remember that they smell slightly different on everybody because they react with individual body chemistry.

STEP FIVE

Determine your favorite(s) and ask for samples to take home. Live with each fragrance as it develops fully: This can take hours or even days, and you may not like what happens over time (a fresh, light scent can deepen into a cloying, powdery finish, for example). Ask friends and significant others for feedback. If you feel pleasantly surprised and genuinely happy every time you smell the scent over the next few days, congratulations! You've picked a winner.

FRAGRANCE FAMILIES

Fragrances are grouped into several major categories, and chances are you'll respond much more positively to one (or two) of them than to others. Identifying your favorites will quickly narrow the scope of your perfume search and provide you with some useful terminology when talking with salespeople.

	FLORALS	FRUITY SCENTS
WHAT THEY ARE	These scents have existed since the early days of the perfume industry, when jasmine, rose and lavender were the most commonly used ingredients. Florals smell like fresh bouquets or gardens and convey a sense of romance. Some have a sweet accent or a hint of powder. They range from subtly feminine to exotic, depending on the kinds of flowers used.	A newer category, fruity scents are sweet and refreshing (much like real fruit) and tend to be lighter and more playful than other kinds of fragrances. Citrus-based scents are considered to be clean and exhilarating.
COMMON INGREDIENTS	Rose, orchid, sweet pea, freesia, lilac, lily, hyacinth, orange blossom and many others.	Grapefruit, orange, lemon, lime, bergamot, peach.
CLASSICS	Joy by Jean Patou, Fragonard, L'Air du Temps by Nina Ricci, Paris by Yves Saint Laurent.	Calyx by Prescriptives, Amor Amor by Cacharel, Amazone by Hermès.

Joy by Jean Patou

Calyx by Prescriptives

	FLORALS	FRUITY SCENTS
MODERN	Marc Jacobs Eau de Parfum, Estée Lauder Beyond Paradise, Celine Dion by Coty.	DKNY Perfume, In Love Again by Yves Saint Laurent, Tommy Girl by Tommy Hilfiger, Happy by Clinique.

Marc Jacobs Eau de Parfum

DKNY Perfume

GREENS	CHYPRES	ORIENTALS
These crisp, invigorating scents typically set the tone with a top note of fresh-cut grass or new green leaves. Green scents are clean and sporty, as opposed to florals, which are lush and romantic.	Fragrances that smell like a cool, autumnal forest—woodsy, mossy, earthy.	Sultry, exotic, spicy and sophisticated. These warm, intoxicating scents are the aphrodisiacs of the fragrance world.
Bamboo, juniper, green tea, sage, rosemary and other green herbs.	Oakmoss, sandalwood, cedar, vetiver and fern.	Vanilla, cinnamon, cardamom, musk, amber.
Vent Vert by Balmain, Aliage by Estée Lauder, Bulgari Eau Parfumée.	Mitsouko by Guerlain, Halston Cologne, Miss Dior by Christian Dior, Calèche by Hermès.	Opium by Yves Saint Laurent, Shalimar by Guerlain, Youth Dew by Estée Lauder, Must de Cartier.

Vent Vert by Balmain

Mitsouko by Guerlain

Opium by Yves Saint Laurent

GREENS	CHYPRES	ORIENTALS
Truth by Calvin Klein, Elizabeth Arden Green Tea Intense Eau de Parfum, Frederic Malle Angeliques Sous La Pluie.	Gucci Rush, Narciso Rodriguez For Her, Paloma Picasso Parfum by Paloma Picasso, Clinique Aromatics Elixir.	Coco Mademoiselle by Chanel, Burberry Brit by Burberry, Carolina by Carolina Herrera, Trouble by Boucheron, Sensi by Giorgio Armani.

Truth by Calvin Klein

Gucci Rush

Coco Mademoiselle by Chanel

WEAR IT WELL: DO'S AND DON'TS

Once you've discovered a wonderful, mood-boosting fragrance, your journey is nearly complete. Now, all you have do is share it with the world. The following tips spell out the smartest ways to store and apply perfume (including advice on how to keep from overdosing on it—and overwhelming everyone around you). As soon as you figure out the best places on your body to spritz, and the right amounts to smell amazing all day, do yourself a favor and don't hold back. A bottle of perfume only lasts a couple years before turning acidic. So rather than saving fragrance for special occasions, make it a natural part of your beauty routine. Whether you wear one signature scent or several different ones, allow fragrance to enhance your overall image. It may be invisible, but it's just as strong a statement as lip gloss or shiny hair.

APPLYING FRAGRANCE

DAB OR SPRITZ ON FRAGRANCE AFTER A SHOWER when your skin is clean. (If you want to apply body lotion first, use an unscented or very lightly scented one that won't clash with your perfume.) This gives it ample time to develop before you get dressed and go out.

DON'T OVERDO IT. If you use true perfume, in liquid or oil form, dab it on just one set of pulse points (behind the ears or the inner wrists). If you use eau de parfum, dab or spray it onto a couple, from a distance of two feet. Eau de toilette, the least concentrated of the three, can be spritzed on your ankles, inner wrists and the base of your throat, also from two feet away. If you have dry skin, you might need to reapply fragrance before going out at night; however, fragrance lasts longer than average on oily skin.

USE A BATH GEL AND BODY LOTION infused with the same scent to make a fragrance last longer. This method is referred to in the fragrance industry as "layering," and it ensures hours and hours of your favorite scent.

CHANGE YOUR SCENTS WITH THE SEASONS. Because heat and humidity intensify fragrance, wear a lighter, fresher scent in summer and switch to a richer, heavier one in cooler weather. (Similarly, lighter fragrances are more appropriate for daytime, while sexier, more exotic ones work best at night.)

DON'T RUB FRAGRANCE INTO YOUR SKIN; the pressure will crush the chemicals and damage the odor.

DON'T SPRAY FRAGRANCE ONTO YOUR HAIR unless it's freshly shampooed and *not* dry or brittle or oily. The chemicals and alcohols can dry out your tresses, and the oils on a dirty scalp can intensify a scent.

DON'T SPRAY FRAGRANCE ON CLOTHES. It may stain fabrics and furs.

DON'T APPLY FRAGRANCE ONTO JEWELRY. The chemicals can damage the surfaces of costume pieces and deteriorate the surface of pearls, eating away at the luster.

CARE AND STORAGE

Store fragrance in a cool, dry place, away from strong sunlight, humidity and extremes in temperature, which disrupt the chemical balance and alter the scent (heat and humidity can also cause it to evaporate). In summer, store eaux de toilette and colognes in the refrigerator. They last longer and feel refreshing and cool when you spritz them onto your skin. (Perfumes are too concentrated for cold storage; cold can change the odor of perfume oils.) Wherever you keep your scents, make sure you always shut the tops tightly to prevent evaporation. Fragrance should last three to five years from the time you buy it. After that, it will break down and begin to smell vinegary.

Q&A

What can I do if I put on too much perfume?

Wash your skin thoroughly with soap and water right away. If that doesn't do the job, rub the offending areas with a cotton ball soaked in alcohol.

Help! My favorite fragrance has been discontinued. What can I do?

A handful of companies specialize in tracking down, and even re-creating, obscure and discontinued perfumes. The owner of Parfumelle (800-874-1118), a boutique in Fort Worth, Texas, hunts down rare European scents, and, failing that, re-creates them himself. The Web sites thefragrancefactory.com and longlostperfume.com provide similar services. To stock up on rare (but not discontinued) fragrances, try Fragrances Unlimited, Inc. (734-434-0692) in Ann Arbor, Mich., or Boyd's of Madison Avenue (212-838-6558) in New York City. To find favorites from decades past, check out discount stores such as T.J. Maxx, K Mart and Wal-Mart, all of which have expanded their collections of designer scents in recent years. (Supplies are unpredictable, though, so if you spot an old favorite, stock up.) Sears is a great source for classics like Chloe, L'Air du Temps and White Shoulders. In drugstores, you can pick up oldies but goodies such as Coty Wild Musk and Revlon Charlie.

Is it true that the same perfume smells different on everyone?

Absolutely, although the scents won't diverge wildly. The chemical makeup of your skin is influenced by your genes, diet, skin type, environment and even by any medication you may be taking. It makes sense, then, that a fragrance will react with your specific body chemistry and result in a unique odor. This is why it's crucial that you smell a perfume on your skin (and not on a friend, scent strip, or straight from the bottle) before buying it.

Is it all right to wear men's fragrances?

Of course, as long as they don't smell too strong and masculine. A few scents with great crossover appeal are Acqua di Giò for Men by Giorgio Armani, Acqua di Parmi Colonia, and Route du Thé. Although citrusy, watery scents are the easiest men's fragrances to adopt, vetiver- and fig-based scents can also be unisex. As with any perfumes, try a few, for a day or two each, before you buy.

Do certain fragrances appeal more to men than others?

Fragrance is subjective, so it's hard to speak for the entire male species. However, according to recent studies by the fragrance company Givaudan, men prefer "gourmand" scents such as vanilla (some popular ones are L'Occitane Vanilla and La Maison Vanille Fleurie de Tahiti), or fresh-from-the-shower fragrances like Clean by Dlish. The reason? These scents are comforting, unintimidating and approachable, says the company.

Why are some perfumes so much more expensive than others?

What's in a perfume is the driving force behind cost. Natural ingredients, particularly rare flowers such as tuberose and jasmine, can significantly increase the price of a fragrance. Launched in 1930, Joy, which is laced with jasmine and natural Bulgarian rose, has long been known as the costliest perfume in the world. Another factor is packaging. The most expensive new fragrance of 2004, Shalini, comes in a limited-edition Lalique crystal bottle. The scent also happens to be made with pure tuberose, the fragrance equivalent of liquid gold.

Acknowledgments

TIHE THANKS
Bozena Bannett, Alexandra Bliss,
Bernadette Corbie, Peter Harper, Robert Marasco,
Brooke McGuire, Jonathan Polsky

JENNIFER TUNG THANKS
Lisa Airan, M.D., Tina Alster, M.D., Leslie Baumann,
M.D., Linda Cho, Jim Crawford, Patrick Evan, Veronique Ferval,
Roy Geronemus, M.D., Annette Green, David Leffell, M.D.,
Jan Linhart, DDS, Jeffrey Miller, M.D., Patricia Murphy, Stephen
Nilsen, Renée Patronik, Gita Reddy, Lana Rozenberg,
M.D., Richard K. Scher, M.D., Susan Taylor, M.D., Nia
Terezakis, M.D., Roxanne Valinoti, Sherri Worth, DDS,
Jessica Wu, M.D., Bryan Yasko

IN STYLE THANKS
Steve Cadicamo, Betsy Castillo, Bari Cayne,
Rey Delgado, Corinne Griffith, Laurie Kratochvil, Lisa Martin,
Patrick Moffitt, Anthony Moore

MELCHER MEDIA THANKS
Alessandra Bocco, Duncan Bock, David Brown, Nicole Cosby,
June Cuffner, Octavio Gonzalez, Jessica Harrison, Andrea Hirsh,
Julia Joern, Nomi Joy, Lauren Nathan, Emily Oberman, Lia
Ronnen, Nathan Sayers, Bonnie Siegler, Denise Sommer,
Shoshana Thaler, Megan Worman

NUMBER SEVENTEEN THANKS
Andrew James Capelli, Wade Convay, Nomi Joy, Allison Henry

Photo Credits

The photographs on the following pages are © Nathan Sayers: 14 (first row: fourth from top); 15 (first row: top, third from top, bottom; second row: second from top through bottom; third row: top, fourth from top); 37 (bottom); 38 (third from left); 39 (left and middle); 40; 41 (top, second from top); 42 (right); 43 (right); 45 (right); 47 (second row: bottom, third row: left); 59 (top); 63 (all); 66 (middle); 71 (third from top); 87 (top, third from top, fifth from top); 100; 101 (first row: top, second from top, third from top, bottom); 104; 122 (left, third from left, right); 123 (fourth from left, right); 147; 149; 153 (top left); 165; 167 (top row: second from left, third from left; bottom row: fifth from left, right); 186; 188–189.

The photographs on the following pages are © Svend Lindbaek: 14 (first row: top, third from top); 15 (first row: fourth from top; third row: second from top and third from top); 38 (left, second from left, right); 41 (third from top); 43 (bottom left); 45 (left); 47 (second row: top); 58 (bottom); 71 (top, second from top); 87 (sixth from top, bottom); 101 (first row: third from top, fourth from top; second row: fourth from top); 122 (second from left, fourth from left); 123 (left, second from left); 124 (left, middle); 153 (top left); 167 (top row: left; bottom row: second, third, and fourth from left).

The photographs on the following pages are © their respective owners: 2–3: Ruven Afanador; 10–11: Wolfgang Ludes; 14 (first row: second from top, bottom): Nigel Cox; 15 (first row: second from top; second row: top): Nigel Cox; 18 (both): Steve Granitz/WireImage.com; 19 (left to right): Gregg DeGuire/WireImage.com, Randy Brooke/WireImage.com; 20, 30: Guy Aroch/Corbis Outline; 32–33: Wolfgang Ludes; 34–35 (left to right): Jeffrey Mayer/WireImage.com; Gregg DeGuire/WireImage.com; Lester Cohen/WireImage.com; Gregg DeGuire/WireImage.com; Jeff Vespa/WireImage.com; Ron Galella/WireImage.com; Kevin Mazur/WireImage.com; Steve Granitz/WireImage.com; Kevin Mazur/WireImage.com; Gregg DeGuire/WireImage.com; 36: Devon Jarvis (4), John Lawton (1), Mark Platt (11); 37 (top right and left): Mark Platt; 39 (right): Nigel Cox; 41 (bottom): Todd Huffman; 42 (left): Nigel Cox; 42 (middle): Courtesy T. Le Clerc; 43 (top): Nigel Cox; 44: Carlo Dalla Chiesa/Corbis Outline; 45 (middle): Nigel Cox; 46: Mark Platt; 47 (first row: both, third row: right): Nigel Cox; 48 (left): Jeffrey Mayer/WireImage.com; 48 (right): Tony Barson/WireImage.com; 49 (left): Jeff Vespa/WireImage.com; 49 (right): Ken Goff/WireImage.com; 50 (top to bottom): Steve Granitz/WireImage.com; James Devaney/WireImage.com; Gregg DeGuire/WireImage.com; Steve Granitz/WireImage.com; Gregg DeGuire/WireImage.com; 52–53: Guy Aroch/Corbis Outline; 55: Ruven Afanador; 58 (top): Devon Jarvis; 59 (middle): Peter Meretsky; 59 (bottom): James Wade; 60 (top left): Ron Galella/WireImage.com; 60 (top right): Gregg DeGuire/WireImage.com; 60 (bottom left): Jeff Vespa/WireImage.com; 60 (bottom right): Jean-Paul Aussenard/WireImage.com; 61 (top left): Dimitrious Kambouris/WireImage.com; 61 (top right): Kevin Mazur/WireImage.com; 61 (bottom right): Gregg DeGuire/WireImage.com; 61 (bottom right): Steve Granitz/WireImage.com; 62: Andrew Macpherson; 66 (top): Nigel Cox; 66 (bottom): James Wade; 67: Carlo Dalla Chiesa/Corbis Outline; 68: Guy Aroch/Corbis Outline; 69: David Ferrua; 71 (bottom): James Wade; 72 (all): Mark Platt; 74 (top left): Vera Anderson/WireImage.com; 74 (top right, bottom left): Steve Granitz/WireImage.com; 74 (bottom right): Dimitrious Kambouris/WireImage.com; 75 (top left): Jean-Paul Aussenard/WireImage.com; 75 (top right): Jim Spellman/WireImage.com; 75 (bottom left): Alan Davidson/WireImage.com; 75 (bottom right): Theo Wargo/WireImage.com; 76: Steve Granitz/WireImage.com; 77: Gregg DeGuire/WireImage.com; 78: Jim Spellman/WireImage.com; 79: Jeff Vespa/WireImage.com; 82–83: Ruven Afanador; 85: Yariv Milchan/Corbis Outline; 86: Andrew Macpherson; 87 (second from top): James Wade; 87 (fourth from top): Nigel Cox; 88 (top left): Tony Barson/WireImage.com; 88 (top right): Kevin Mazur/WireImage.com; 88 (bottom left and right): Steve Granitz/WireImage.com; 89 (top left): Alessandra Benedetti/WireImage.com; 89 (top right): Alan Davidson/WireImage.com; 89 (bottom left and right): Jim Spellman/WireImage.com; 90: David Ferrua; 91 (top left): Maury Phillips/WireImage.com; 91 (top right): Tony Barson/WireImage.com; 91 (bottom right): Jeff Vespa/WireImage.com; 91 (bottom right): Kevin Mazur/WireImage.com; 93 (top left): Steve Granitz/WireImage.com; 93 (top right and bottom right): Gregg DeGuire/WireImage.com; 93 (bottom left): Kevin Mazur/WireImage.com; 94 (all): Mark Platt; 96–97: Christian Witkin; 99: David Ferrua; 102–103: Sante D'Orazio; 105 (top to bottom): Kurt Vinion/WireImage.com, Tony Barson/WireImage.com, Jim Spellman/WireImage.com, Steve Granitz/WireImage.com, Ron Galella/WireImage.com; 106: Guy Aroch; 107 (top left, bottom left and middle): Jeff Vespa/WireImage.com; 107 (top middle): Gregg DeGuire/WireImage.com; 107 (top right): Mark Sullivan/WireImage.com; 107 (bottom right): Theo Wargo/WireImage.com; 108 (top left): Jeff Vespa/WireImage.com; 108 (top middle and right): Gregg DeGuire/WireImage.com; 108 (bottom left and right): Steve Granitz/WireImage.com; 108 (bottom middle): Chris Walter/WireImage.com; 109 (top left): Jean-Paul Aussenard/WireImage.com; 109 (top middle and bottom middle): Steve Granitz/WireImage.com; 109 (top right): Gregg DeGuire/WireImage.com; 109 (bottom left): Jon Furniss/WireImage.com; 109 (bottom right): Alan Davidson/WireImage.com; 110 (top left and right): Steve Granitz/WireImage.com; 110 (top middle and bottom right): Kevin Mazur/WireImage.com; 110 (bottom left): Theo Wargo/WireImage.com; 110 (bottom middle): James Devaney/WireImage.com; 111 (all): Gregg DeGuire/WireImage.com; 114–115: Sante D'Orazio; 118–119, 121: Ruven Afanador; 123 (third from left): Nigel Cox; 124 (right): John Lawton; 126: Alan Davidson/WireImage.com; 127: Jim Spellman/WireImage.com; 128: Lee Celano/WireImage.com; 129: Gregg DeGuire/WireImage.com; 130: Jeffrey Mayer/WireImage.com; 131: John Sciulli/WireImage.com; 132 (left): Ron Gallela/WireImage.com; 132 (right): Jeffrey Mayer/WireImage.com; 133 (top left): Mike Marsland/WireImage.com; 133 (top right): Frank Danielson/WireImage.com; 133 (bottom left): Dimitrious Kambouris/WireImage.com; 133 (bottom right): Jim Spellman/WireImage.com; 138: Yariv Milchan/Corbis Outline; 139 (top, left to right): Lester Cohen/WireImage.com, Steve Granitz/WireImage.com (2), George Pimentel/WireImage.com; 139 (bottom, left to right): Steve Granitz/WireImage.com (2), Jim Spellman/WireImage.com (2); 142–143: Mark Liddell; 145: Kenneth Willardt; 153 (second from top to bottom): Todd Huffman; 154–155: Sante D'Orazio; 156 (left to right): Steve Granitz/WireImage.com, Jean-Paul Aussenard/WireImage.com, Steve Granitz/WireImage.com; 157: Sante D'Orazio 158–159: David Ferrua; 162–163: Troy Word; 166: Andrew Macpherson; 167 (top row: fourth from left): Mark Platt; 167: (top row: right; bottom row: left): Todd Huffman; 174–175: Guy Aroch/Corbis Outline; 177: James White/Corbis Outline; 182–183: Wolfgang Ludes; 185: Andrew Macpherson; back flap (left to right, top to bottom): Kevin Mazur/WireImage.com; Jean-Paul Aussenard/Wireimage.com; Steve Granitz/WireImage.com; Tony Barson/WireImage.com; Theo Wargo/WireImage.com; Arnaldo Magnani/Getty Images; Steve Granitz/WireImage.com; Gregg DeGuire/WireImage.com (2); Alessandra Benedetti/WireImage.com; Mark Sullivan/WireImage.com; Kevin Mazur/WireImage.com.